ALASKA

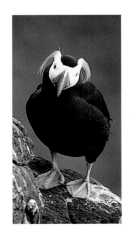

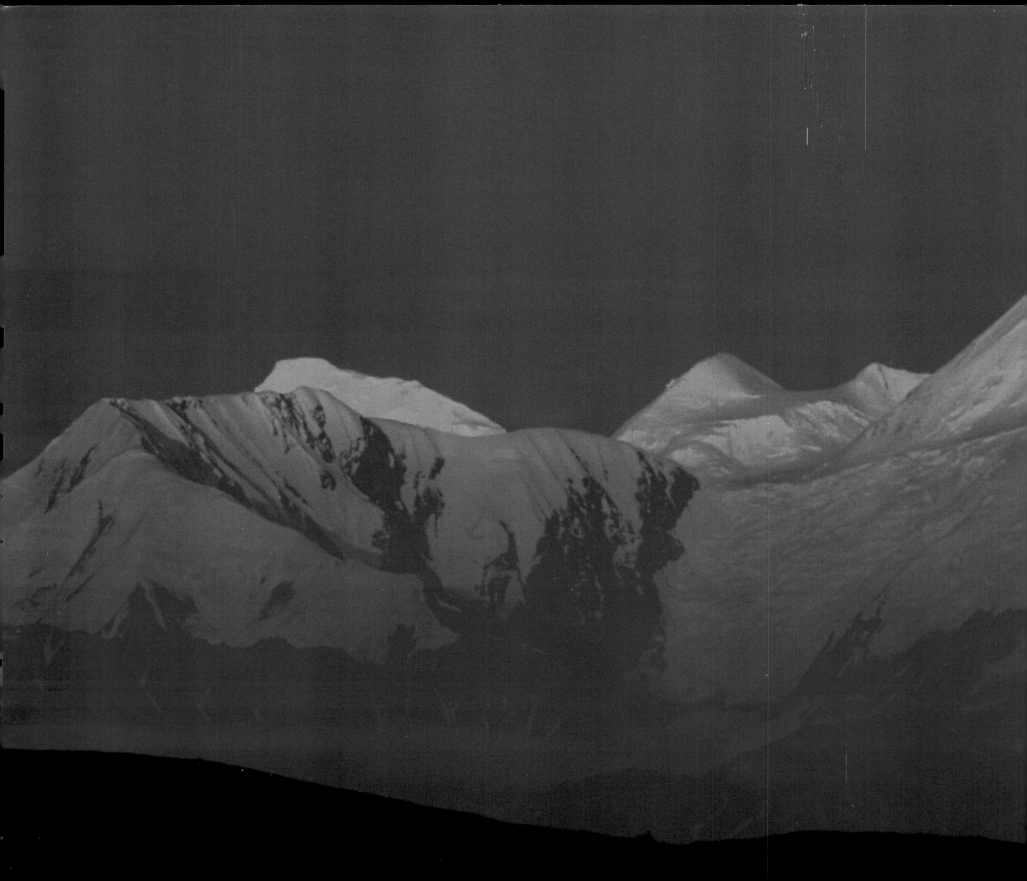

ALASKA

ART WOLFE

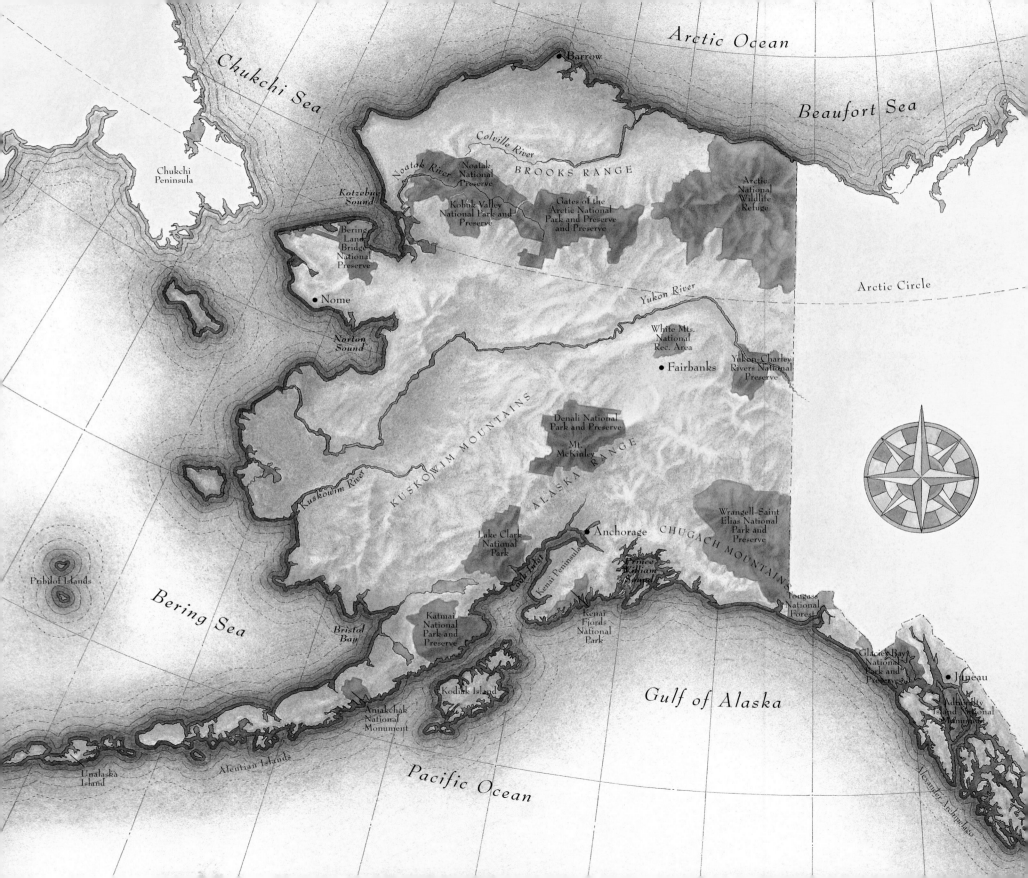

CONTENTS

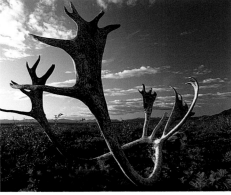

DEDICATION & ACKNOWLEDGMENTS

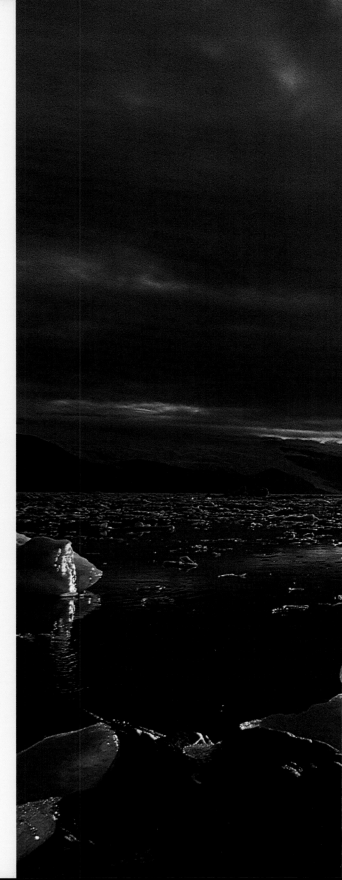

To all those working everywhere to save the wilderness and the animals that call it home—and especially to those who are staying vigilant in Alaska.

I wish to thank everyone at Sasquatch Books for their incredible support, especially Gary Luke, Karen Schober, Linda Stark, and Novella Carpenter; Gary Stolz, Refuge Manager of the Lower Rio Grande Valley National Wildlife Refuge for so willingly lending his expertise once again; Ann Brown, Lisa Morrehead, and Bob Dittrich for invaluable assistance on so many of my trips to Alaska; Michelle Gilders for her ongoing input; the University of Washington Elisabeth C. Miller Library at the Center for Urban Horticulture; Kai Davis, Bryan Hood, and Deana Perry, our interns; and of course my staff—Colin Brynn, Mel Calvan, Chris Eckhoff, Erin Johnson, Ray Pfortner, Craig Scheak, Deirdre Skillman, and Lisa Woods—for making books like this more than just a twinkle in my eye.

— A.W.

For Hallie

I'd like to thank Marlene Blessing for connecting me with Sasquatch Books, and Gary Luke, my editor, for his patience and good humor. I also appreciate the support of *Alaska* magazine, especially from Andy Hall. I'm honored to be a part of this project.

—N.J.

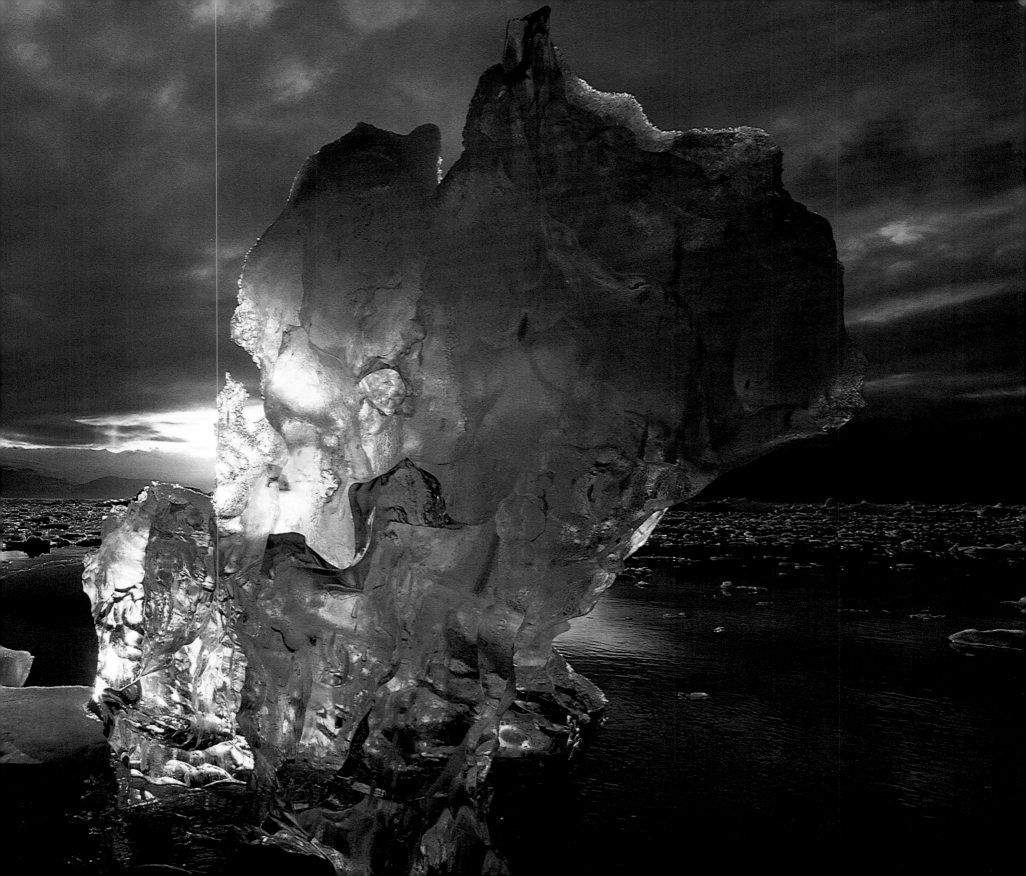

INTRODUCTION

PEOPLE OFTEN ASK ME IN INTERVIEWS: What is the area or where do you travel in the world that you like and keep going back to? To me Alaska is the obvious answer. Alaska is a state that is difficult to think of as a state; it is more of a country in and of itself, with its vastly different geographical regions, its sheer immensity, and its pristine wilderness. Over the years Alaska has provided me with many, many opportunities to photograph the natural world.

Living in the northwest corner of the Lower 48, I have had quick access to Alaska. Thus I traveled there early and often in my career, and I continue to do so to this day. Much of my skills as a photographer and naturalist were honed by walking through the tundra in Denali National Park and Preserve or kayaking in Kenai Fjords National Park.

Alaska is more than just destinations. It is breathtaking in its unparalleled range of wild areas and wildlife. From the comical puffins that live along the Aleutian and Pribilof Islands, to wolves and grizzly bears, gyrfalcons and snowy owls in the wild tundra of the Arctic slope, it is possible to see wildlife in all its glory in Alaska. No small, bedraggled remnants of once great herds here, no sorry reminders of what the wilderness once was like.

However, even in a place of such biological abundance, the wildlife can play coy. I keenly remember spending forty-eight hours sealed in a tent within about 100 yards of a wolf den. For the first thirty-two hours there was absolutely no sign of life, and I was very much demoralized with the prospect of coming away from this solitary endeavor with nothing to show for it. Finally, with the helicopter due to pick me up within hours, four wolf pups came out of the den. Being able to look into this private world, as the pups howled and frolicked about, made all the wait and discomfort worth it.

Of course, some of the most memorable occasions of my many trips to Alaska revolve around bears. In certain river locations the brown bears have been habituated over the years to the presence of both photographers and fishermen. The bears feed heavily on salmon and are quite content. In these situations it is rare that a bear would act aggressively toward people. For a photographer, or anyone for that matter, it is absolutely incredible to be standing so near to bears that are catching salmon as they always have.

Another year I was working out of a fishing lodge in Glacier Bay National Park and Preserve, and during my stay we ventured into Dundas Bay. It is a steeply cut inlet that winds into the coastal mountains. There I found a glacier bear that was eating grass along the shoreline. The glacier bear is a rare color morph of the black bear; its fur is a beautiful silvery grey, and very few people actually have photographs of these bears. I was very fortunate I found it two days in a row. Over a period of several hours,

I managed to get myself in a fairly close position. The bear knew I was there, and since I had eliminated the element of surprise, it did not feel threatened. Surprising an animal is what gets people into trouble. Coming across this bear, though, was just one of those serendipitous moments.

Alaska is a rafter's paradise. Floating nine to ten miles a day through the barren, rugged terrain of the Brooks Range, at long last spilling out onto the great tundra plain of the North Slope, is a tremendous way to travel through a roadless land. One year we encountered over 30,000 caribou, just a part of the great Porcupine Herd; it seemed like the Serengeti West, with such a magnitude of mammals all moving in the same direction with the same goal in mind. As they flooded into the river and rushed out the other side, the caribou looked like the wildebeest migration that occurs every year in East Africa—all that was missing were the crocodiles.

I have also floated the Alsek and Copper Rivers at the southern end of the state. The Copper is famed for its bright, orange-fleshed salmon, a great delicacy, and the Alsek for its magnificent glacier. Both of these rivers flow through wild, wild mountains—the Chugach and the Saint Elias—and ultimately empty into the waters of the northeast Pacific Ocean. All along the way is not only spectacular wildlife but also the grandeur of the glaciated mountains.

Alaska is a land of tremendous scenic variety. Each area of the state, whether it is the rainforested southeast or the treeless island havens of the southwest, the interior mountains or the tundra barrens of the north, provides incredibly dramatic, powerful imagery. One of the reasons I think of Alaska when I think of wilderness is that Alaska is so sparsely populated by people. Paired with Antarctica, Alaska remains in my mind a place you can go and not expect to see people. We live in a highly mechanized, technologically driven society, and the knowledge that you can escape to a place like Alaska is very comforting. This is a place of grizzly bears, a place where wolves still hunt in packs and walruses haul out on remote island beaches. It is reassuring to know that such a place continues to exist. But only with vigilance will it stay this way.

—ART WOLFE

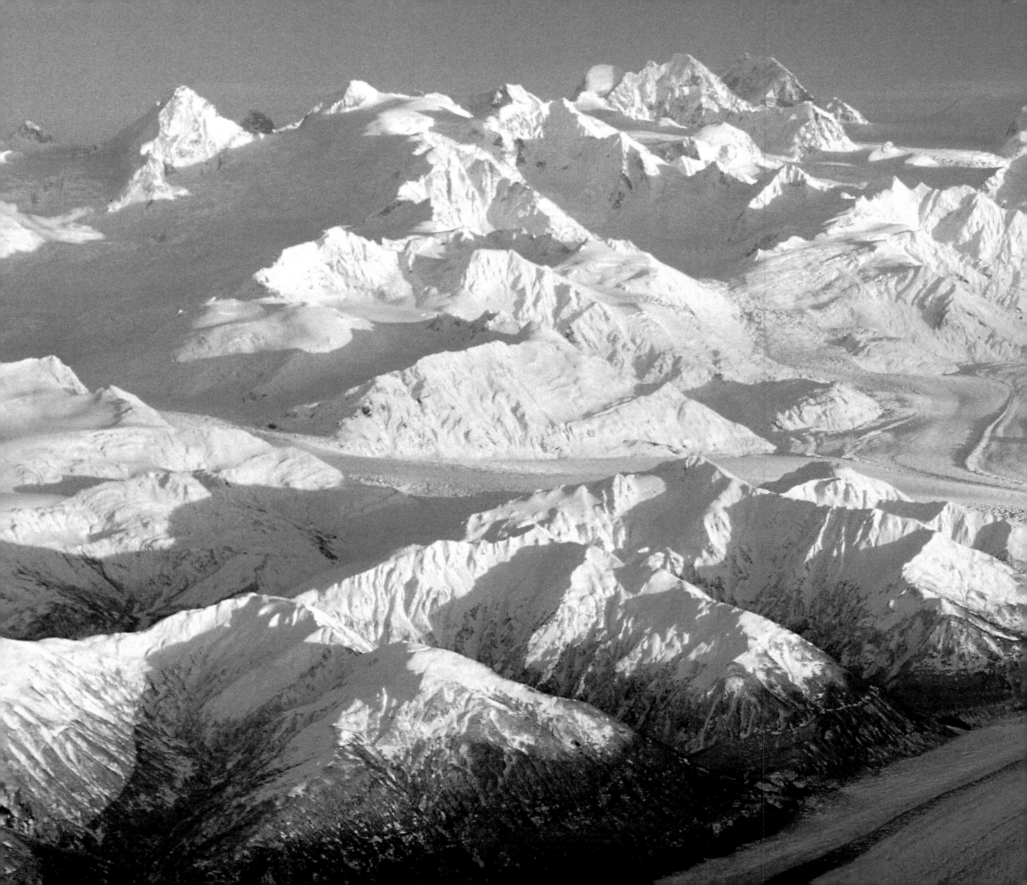

MOUNTAIN

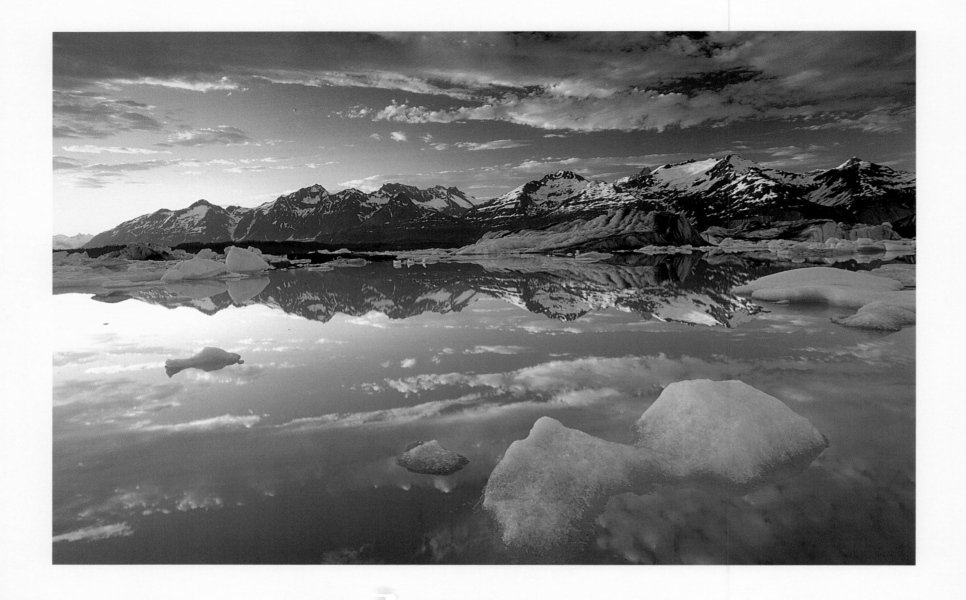

Alaska's mountains are the bones over which the land's skin is stretched. From the steps of the governor's mansion in Juneau to the northern shores of the Chukchi Sea, there are few regions of the state—the edges of the Arctic coastal plain and the Yukon-

Kuskokwim delta come to mind—where one can stand and not see mountains. Skirting the horizon like distant sails, rising abruptly from the ocean's edge, or literally filling the sky, they define the course of rivers, enclose huge basins of forest and tundra, and shape the weather. Only Alaska's incomprehensible vastness dwarfs them—and only to the extent that any one peak or subrange is lost in all the others. Alaska. Mountains. The two are the same.

Think of Alaska as a huge chin jutting out into the North Pacific and Arctic Oceans. Three major ranges sprawl across the state: the six-hundred-mile Brooks Range running east to west above the Arctic Circle; the massive Alaska Range curving through the south-central region; and the great chain that rims the southern coast, beginning with the Aleutian Range in the far west through the Kenai, Chugach, Saint Elias, and Fairweather Ranges, and culminating in the Coast Mountains of the southeastern panhandle. This shorthand catalog excludes a dozen major uplands, including the White, Ray,

Kilbuck, and Kuskokwim Mountains, the Yukon-Tanana Uplands, the Zanes, the Darbys, the Nulato Hills, the Kodiaks, and more. When you look at elevation maps and unravel all the convoluted brown lines, you see hundreds of unnamed four- to six-thousand-foot peaks spread out across the state, an area nearly as large as the United States east of the Mississippi. It all seems to be an undivided, scarcely marked, and unspeakably huge wilderness.

Given its rugged expanse, it's no surprise that Alaska claims all but three of the twenty highest peaks in the United States. Tallest of all is Denali, The Great One, a twin-turreted fortress of granite and ice rising nearly four miles above sea level, one of the world's coveted mountaineering summits. Seen from a distance, it towers over a front range as high as the Appalachians. To locals, it's known as simply The Mountain. Drawn by its mystique, each year dozens of climbers brave hidden crevasses and some of the harshest storms on earth. And each year, some pay with their lives.

Overleaf: Glacier Bay National Park and Preserve

Left: Alsek Glacier, Saint Elias Mountains

Right: Gray wolf (*Canis lupus*) track in snow

Equally godlike are the Wrangell and Saint Elias Mountains, just above the southeastern panhandle, the highest coastal ranges in the world, with four ragged peaks—Saint Elias, Bona, Sanford, and Blackburn— soaring from near sea level to over sixteen thousand feet. Each peak has a vertical relief, base to summit, greater than Everest's. Ice

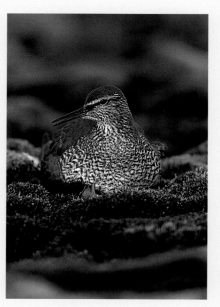

fields the size of some European countries drape over these ranges' rough, cold shoulders.

As astounding as the sheer scale of Alaska's mountains is their variety. Rumbling volcanoes; verdant rainforest slopes rising into ice fields; ancient coral mesas and barren limestone canyons whose rock once formed the floors of primeval seas; pure alpine spires; ragged, upfolded sheets of shale; smooth, rolling glacier-polished domes; abruptly rising naked granite pinnacles like Arrigetch—all can be found within the expanse of Alaska.

Not surprisingly, flatlands and plains are rare here. Nothing in the state matches the Pampas, the Great Plains, or the steppes of Central Asia. The great peninsula that is Alaska juts out into one of the most tectonically active zones on the planet. The Aleutian chain and the southwestern coast are, in fact, part of the North Pacific's ring of fire. Shoved by eruptions and earthquakes, chunks of oceanic plate have been sheared off and upthrust to form mountains (including parts of the Brooks Range), or simply folded under lighter continental rock, heaving it skyward to form behemoths like Denali and the Saint Elias Range. In many places, twisted, tilted strata bear witness to the pressures of birth.

From Kodiak through Prince William Sound and on down the coast through the panhandle, Alaska's coastal mountains cradle dozens of glaciers—flowing rivers of ice, remnants of the vast Pleistocene ice sheets that once covered much of the northern hemisphere. With their vast snow fields nourished by walls of moisture-laden air sweeping in off the Pacific, some glaciers advance and others recede—a complex process incompletely understood.

Some researchers claim that runaway global warming is at work; others argue the approach of the next ice age. North of the Alaska Range, most glaciers vanished thousands of years ago, but their marks remain on the land in the form of massive U-shaped valleys carved by ice. High up in the central and eastern Brooks, a few relic mountain glaciers remain, dwindling bits of the heavy sheets that once ground over the land.

No matter where in Alaska's mountains we travel, the landscape stretches our capacity to comprehend. Dozens of Yosemites and Rainiers lie scattered across the state, unmentioned in any guidebook, a lifetime of destinations spilling off into a blue-white distance: ragged ridgelines walked by sheep and grizzlies, steaming volcanic caldera, tundra hills, vertical granite faces, and eternal fields of snow. There's a quality to the light and air, a clarity that glows from within to illuminate the mountains, trees, tundra, and sky. We become suffused in the same glow, absorbed and included in the land, transported, for a time, beyond our own smallness.

Fortunately, much of Alaska's best land—including a huge handful of mountain country—is included in sprawling national parks and monuments, in some cases millions of contiguous acres, almost all of it undeveloped.

Still, far up jagged, empty valleys where wolves howl and gyrfalcons nest, in places you'd guess no one has ever gone, geologists' stakes and surveyors' flaggings mark out rich deposits and claims whose development, pretty much everyone agrees, is inevitable. In the coastal rainforests of the south-central and southeast regions, swaths of centuries-old trees are felled every year. Across the Arctic expanse of the Brooks Range, subsistence gatherers, sport fishermen, ecotourists, big-game hunters, and photographers elbow each other for room during the caribou migration. There's no reason to expect human pressure will decrease. I'm not sure which is worse: mining companies, careless young men on hundred-mile-an-hour snowmobiles, or little old ladies in floppy hats.

Left: Wandering tattler (*Heteroscelus incanus*) on its nest, Wrangell-Saint Elias National Park and Preserve

Right: Wandering tattler (*Heteroscelus incanus*) chick, Wrangell-Saint Elias National Park and Preserve

The only way to begin to understand any of Alaska's mountains is to live in their shadows, to travel their slopes and passes over many seasons, through winter storms and autumn light, until you see them in your sleep. Twenty years ago, I came to the Brooks Range, drawn by the mystery of shapes on a map and the music of ancient names I couldn't even pronounce: Igikpak, Maniilaq, Amakomanak, Arrigetch. After spending half my life here, having navigated thousands of miles through these stark, surreal crags, all I know is that words are useless. Maps are best left at home.

And the mountains sing back, an old Eskimo man once told me, whatever you wish to hear. A lost person might hear the sound of motors; a lonely one, the sound of children. But what rises most often through the wind and silence, I think, is the beating of our own hearts.

Right: Alsek Glacier, Saint Elias Mountains

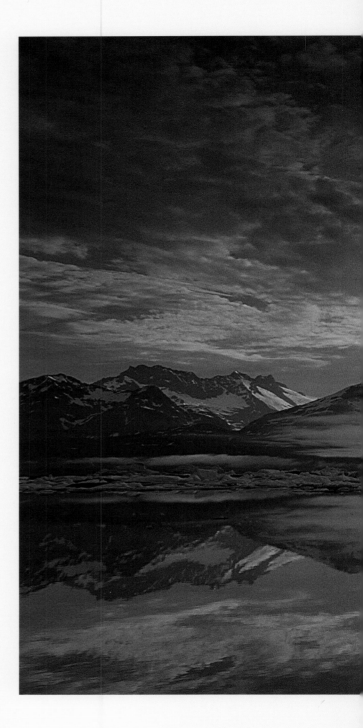

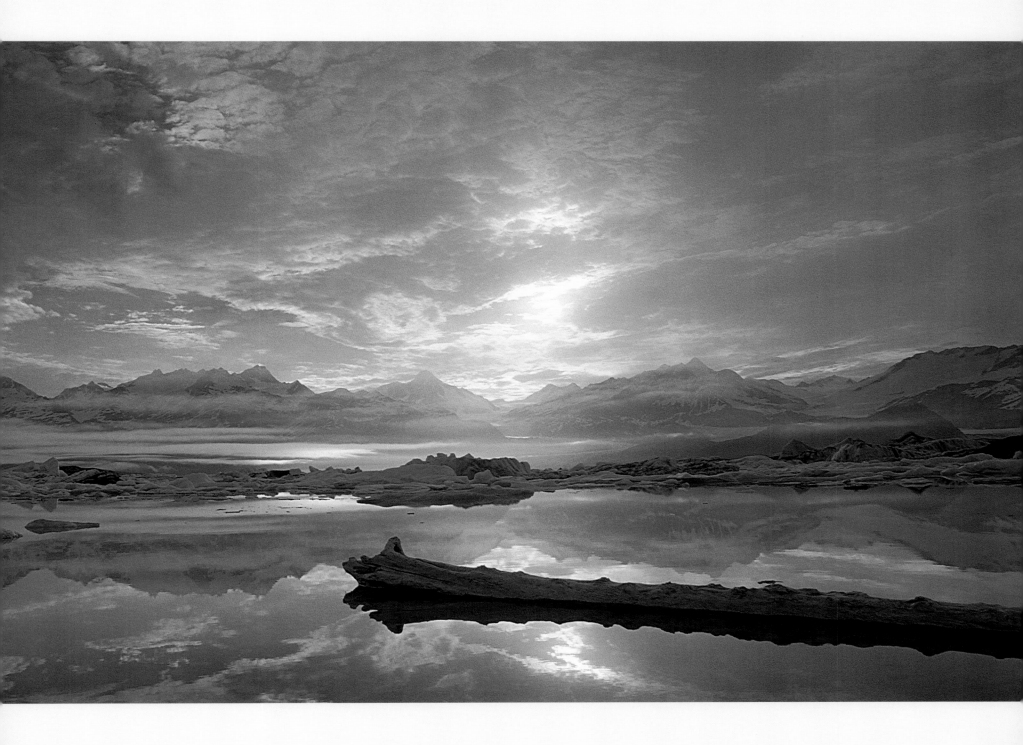

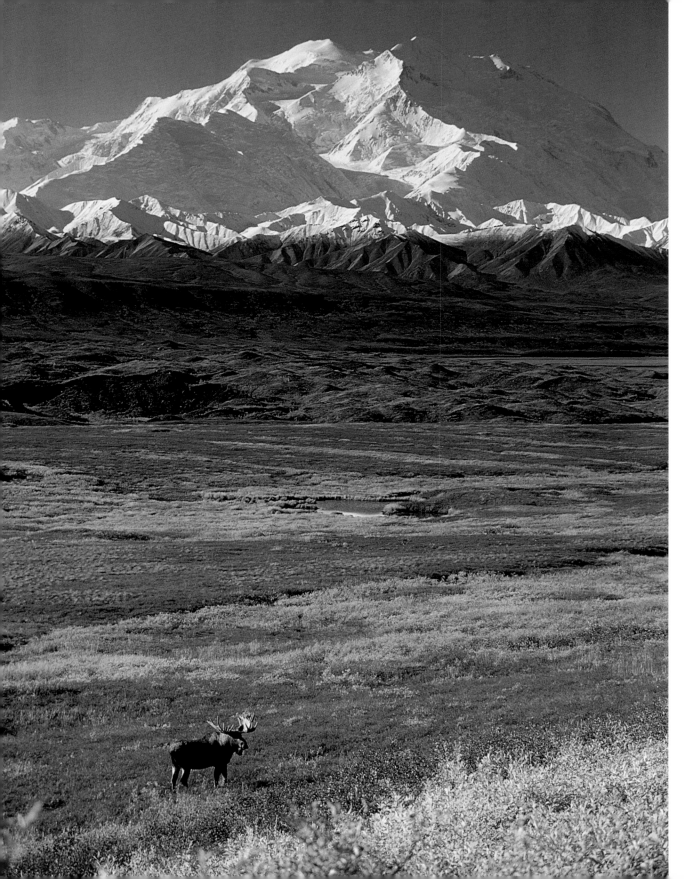

Left: Bull moose (*Alces alces*), Denali National Park and Preserve

Right: Dall sheep (*Ovis dalli*), Denali National Park and Preserve

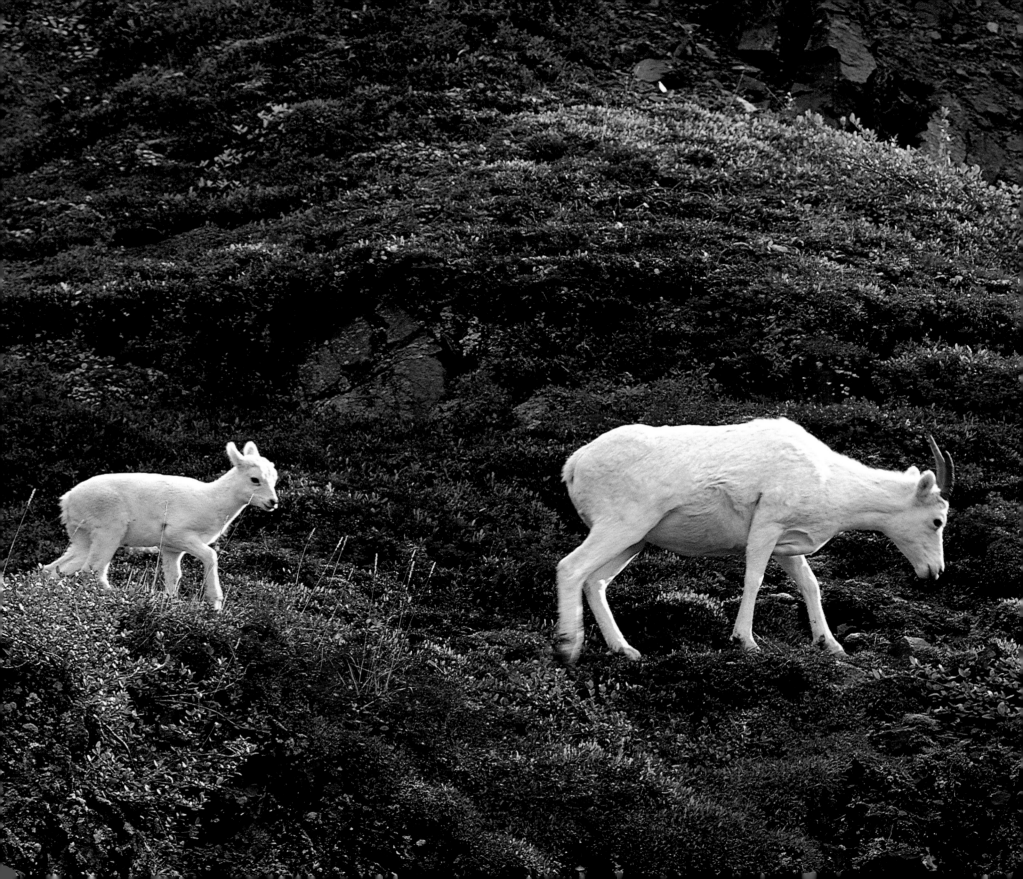

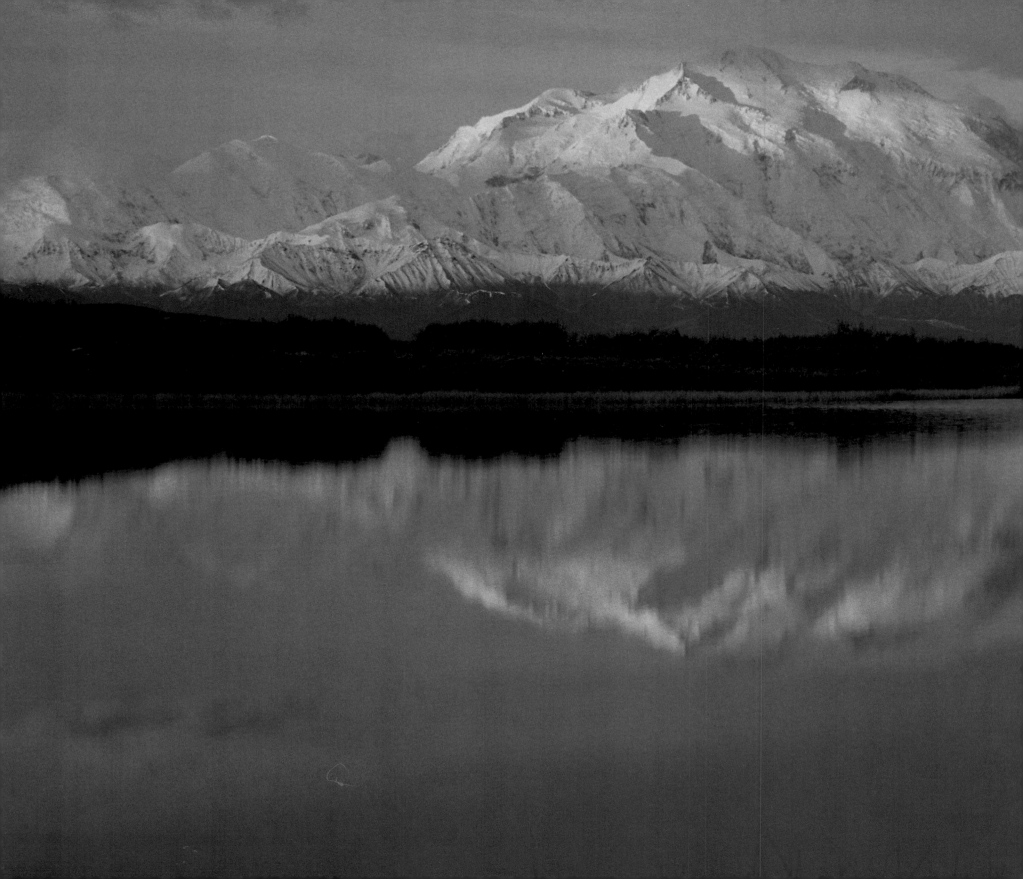

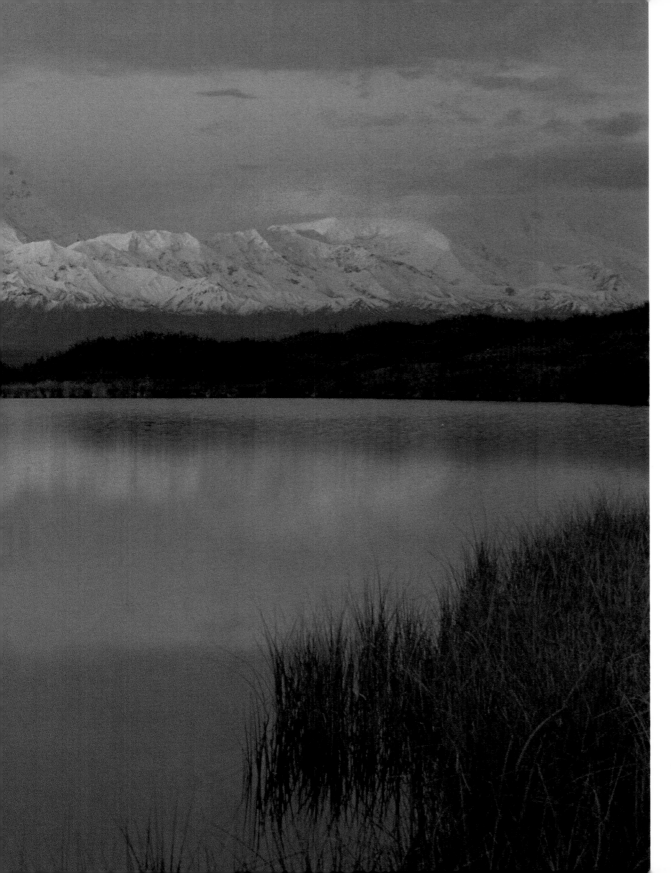

Sunrise, Mount McKinley, Denali National Park and Preserve

Left: Ice cave, Glacier Bay National Park and Preserve

Right: Aerial view of Jefferies Glacier, Wrangell-Saint Elias National Park and Preserve

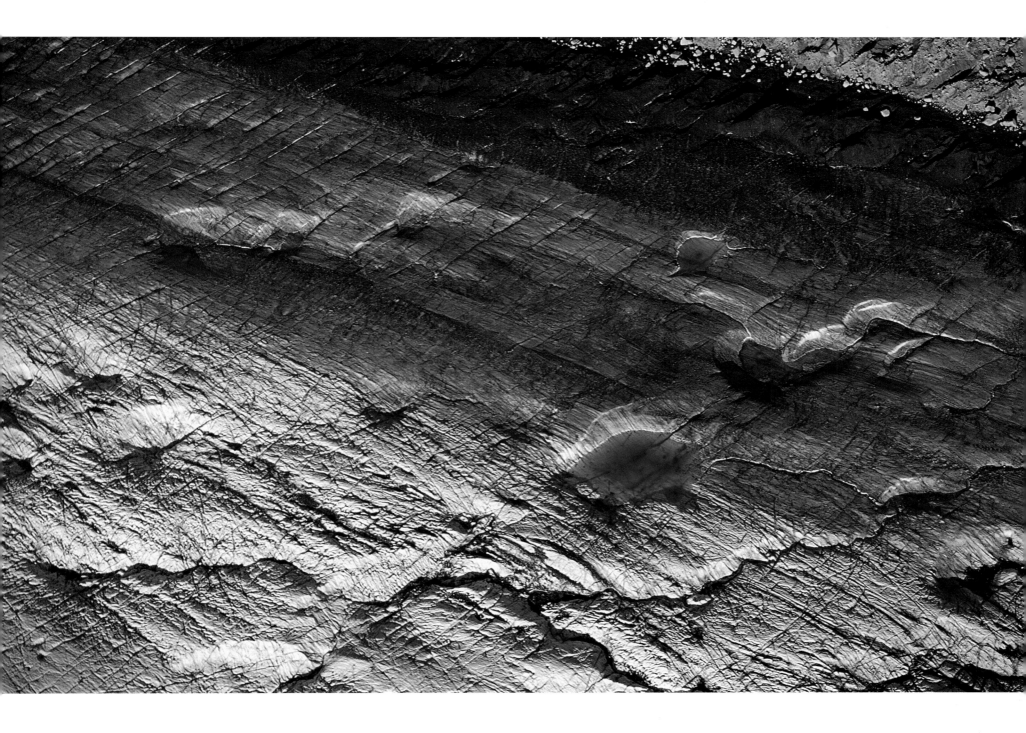

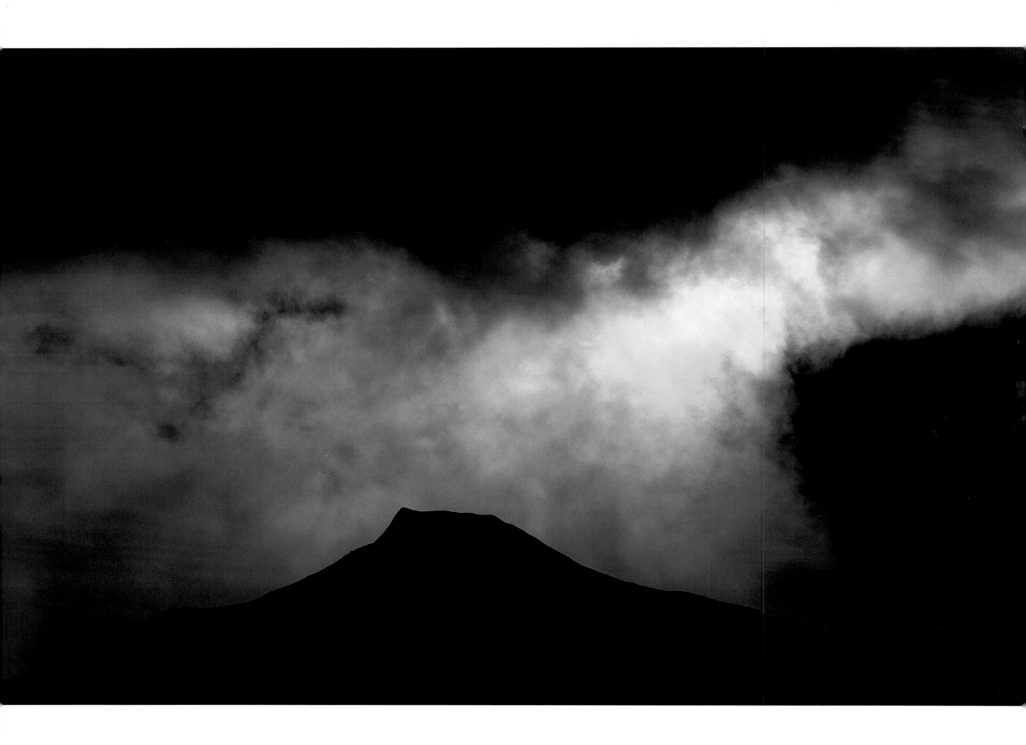

ALASKA

Left: Aerial of Alaska Range

Right: Aurora borealis

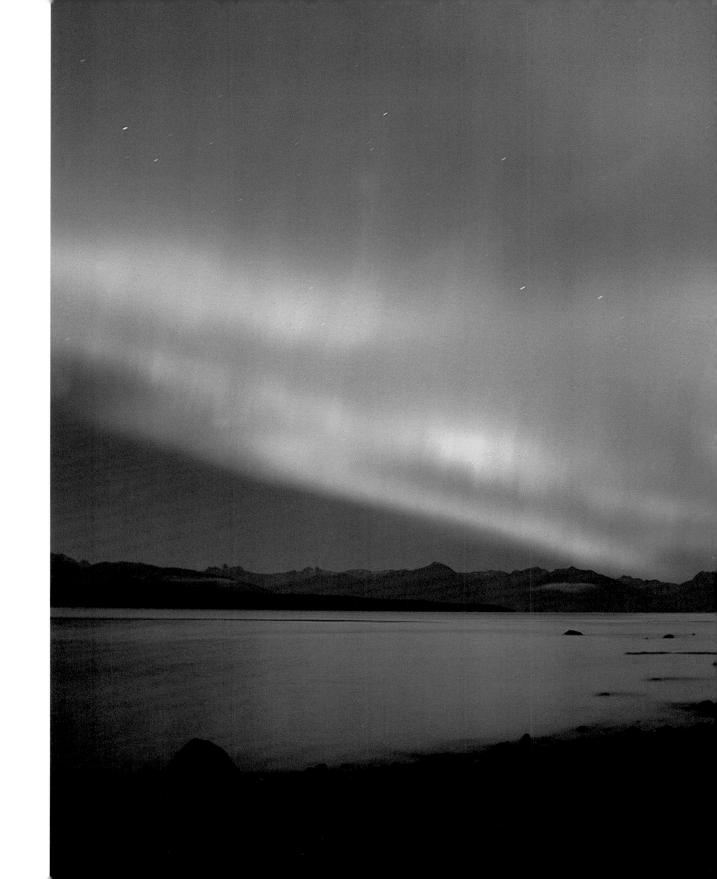

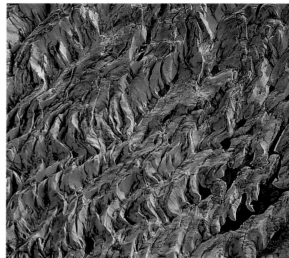

Aerial views of Jefferies Glacier, Wrangell-Saint Elias
National Park and Preserve

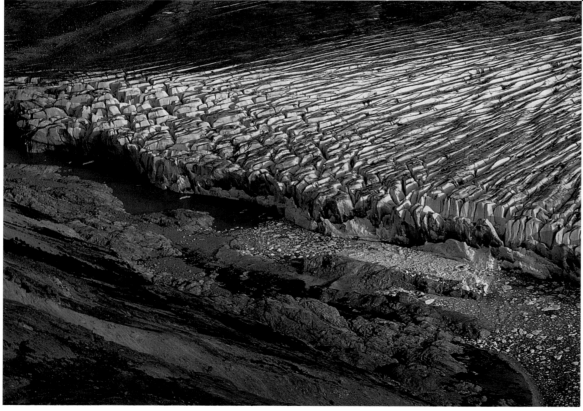

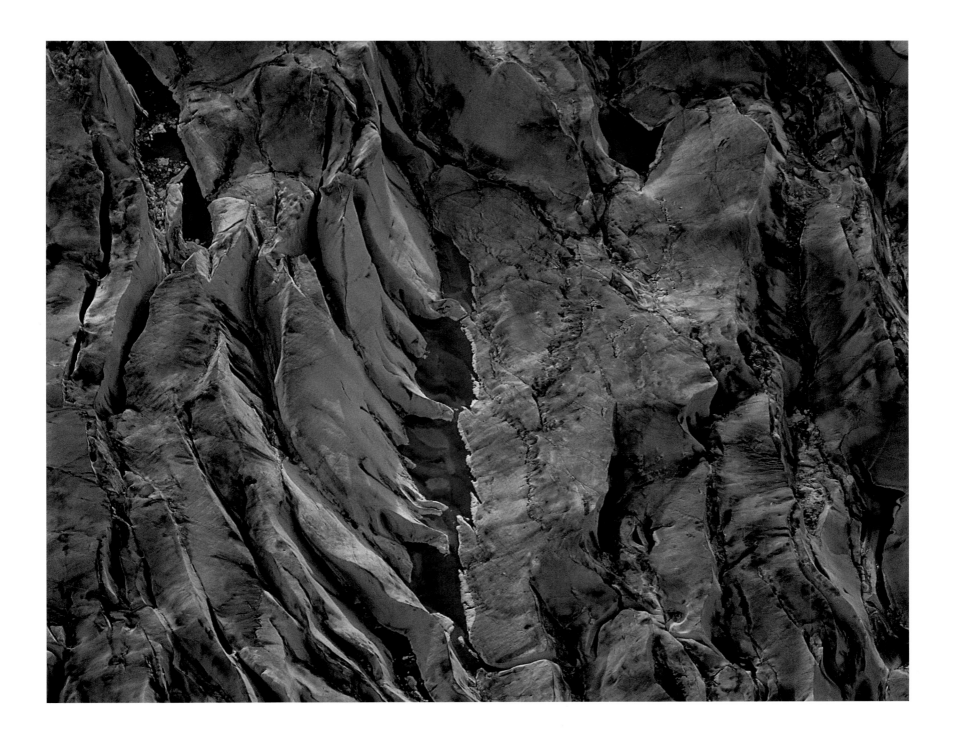

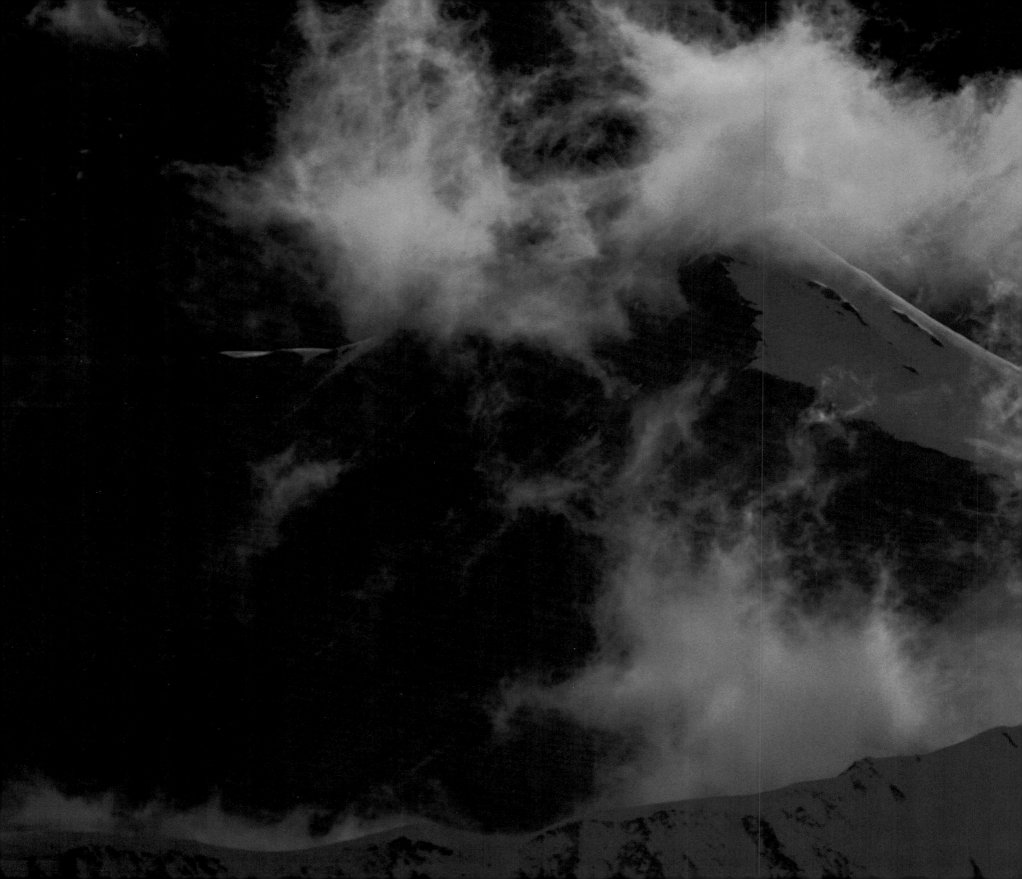

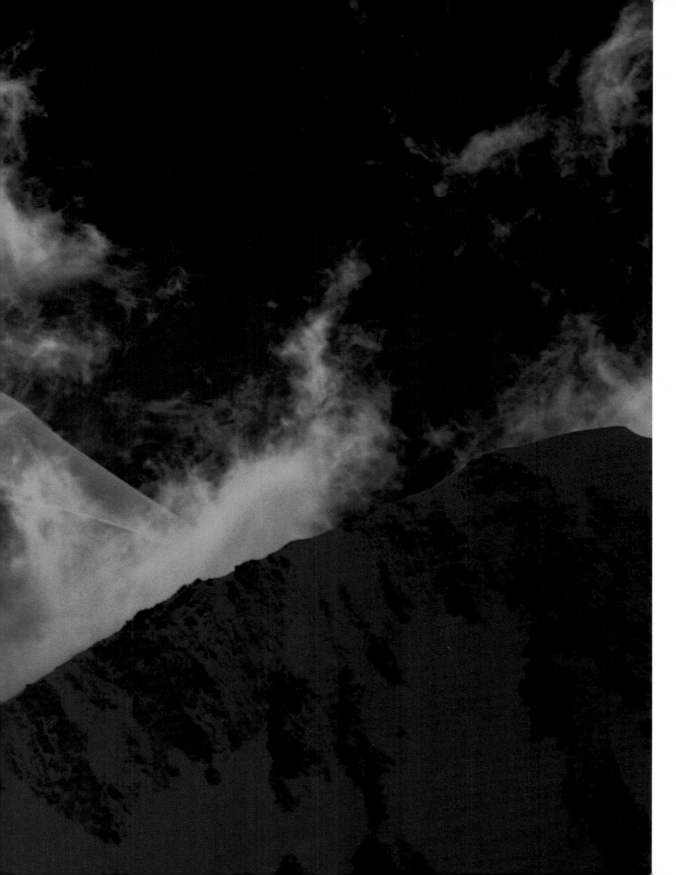

Alaska Range, Denali National Park and Preserve

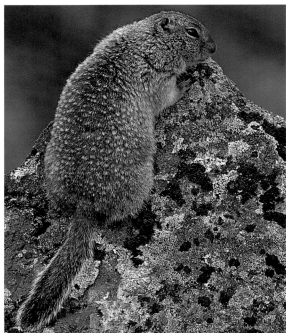

Left: Arctic ground squirrel (*Spermophilus parryii*), Denali National Park and Preserve

Below: Wrangell-Saint Elias National Park and Preserve

Right: Arctic National Wildlife Refuge

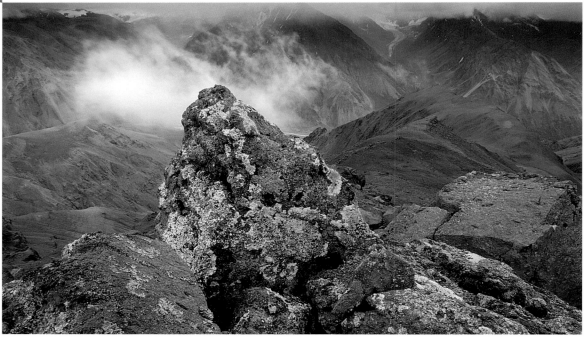

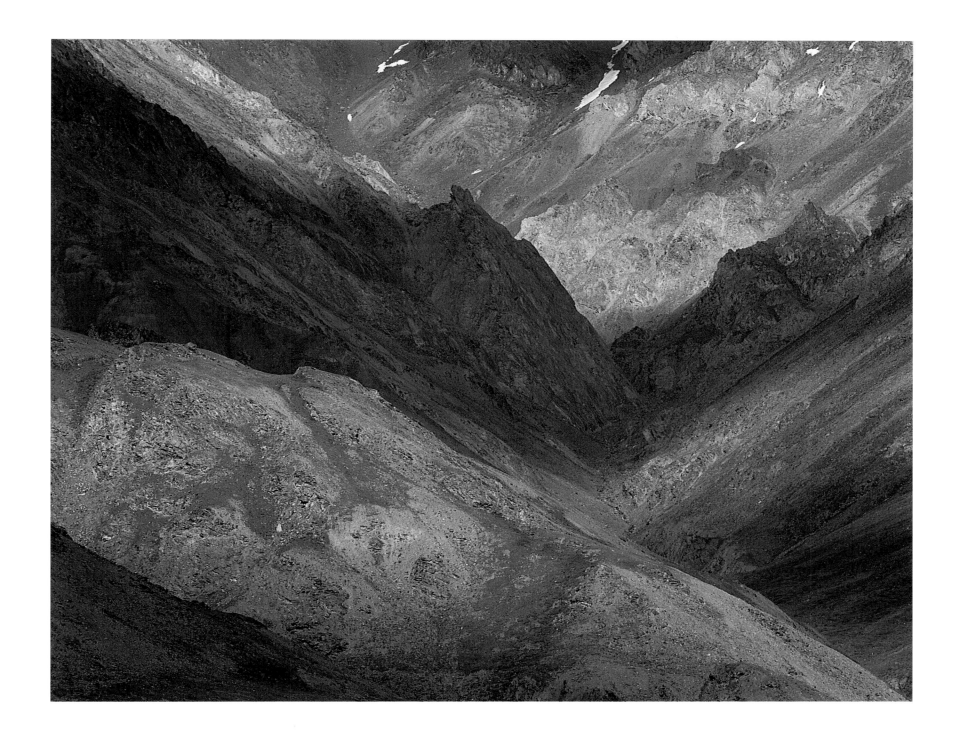

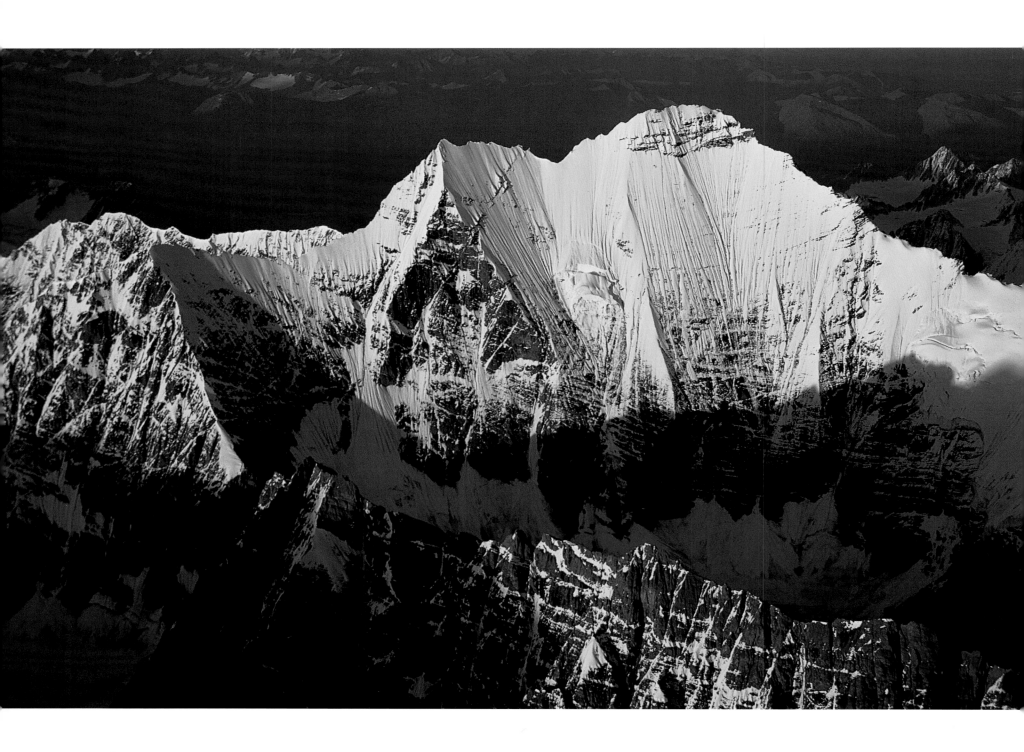

ALASKA

Alaska Range, Denali National Park and Preserve

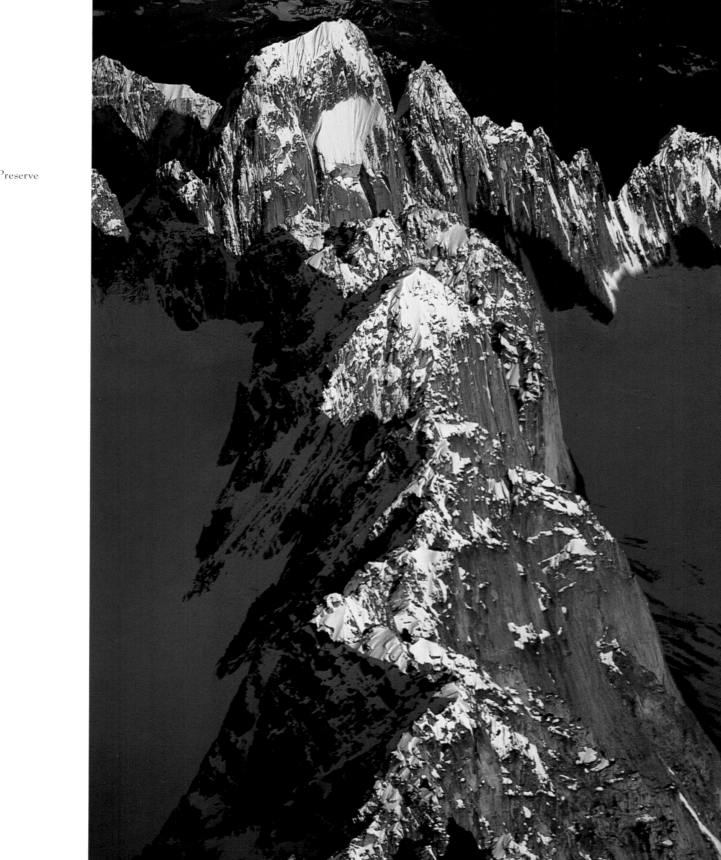

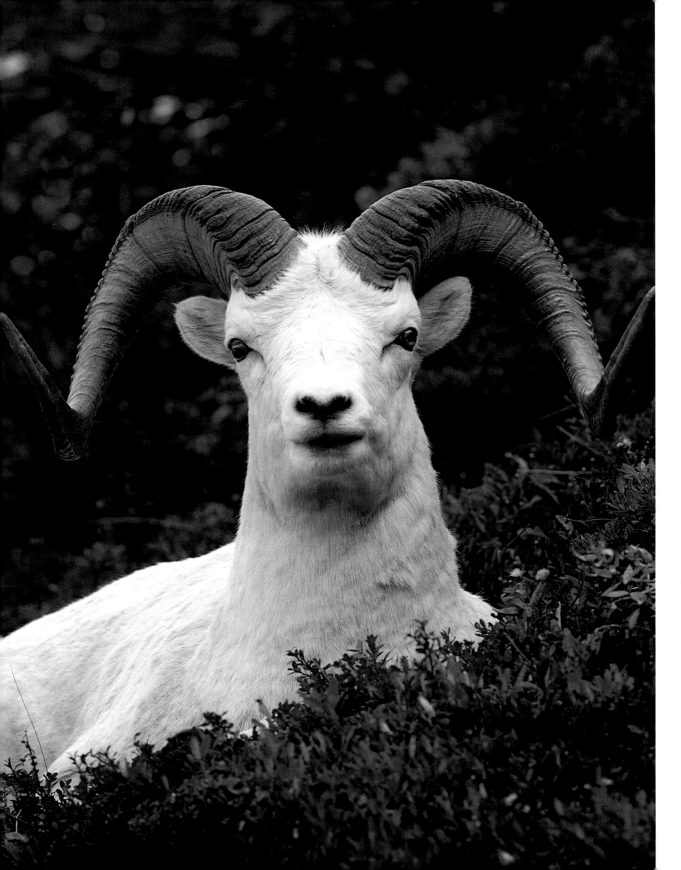

Left: Dall sheep (*Ovis dalli*) ram, Denali National Park and Preserve

Right: Dall sheep (*Ovis dalli*), Wrangell-Saint Elias National Park and Preserve

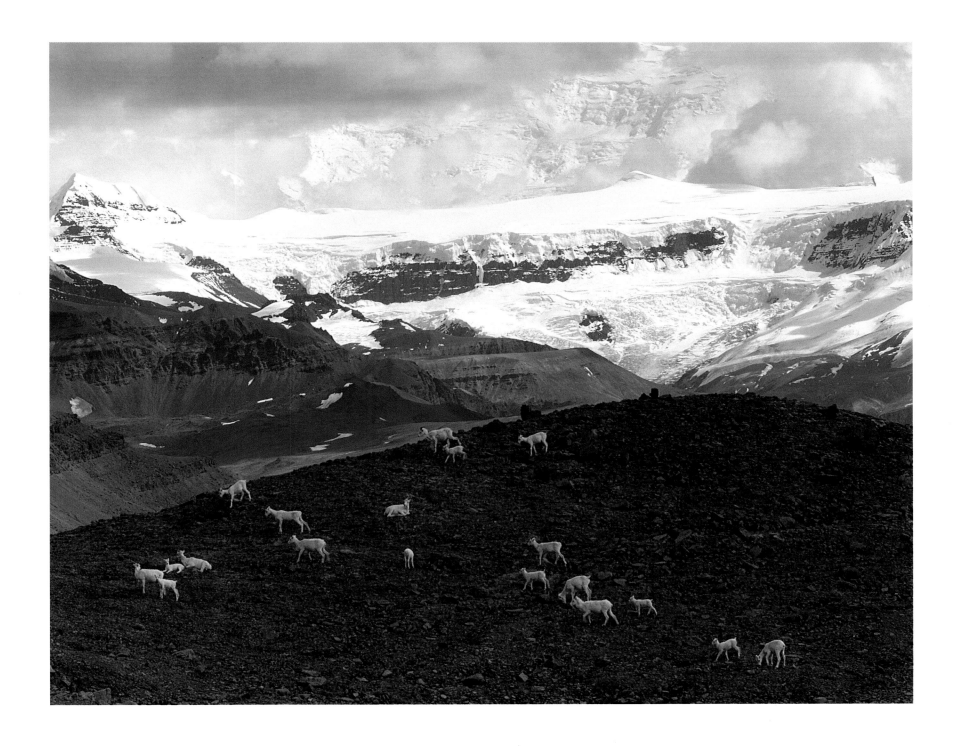

Far left: Iron deposits in stones, Wrangell–Saint Elias
National Park and Preserve

Left and below: Marine fossils, Canning River, Arctic
National Wildlife Refuge

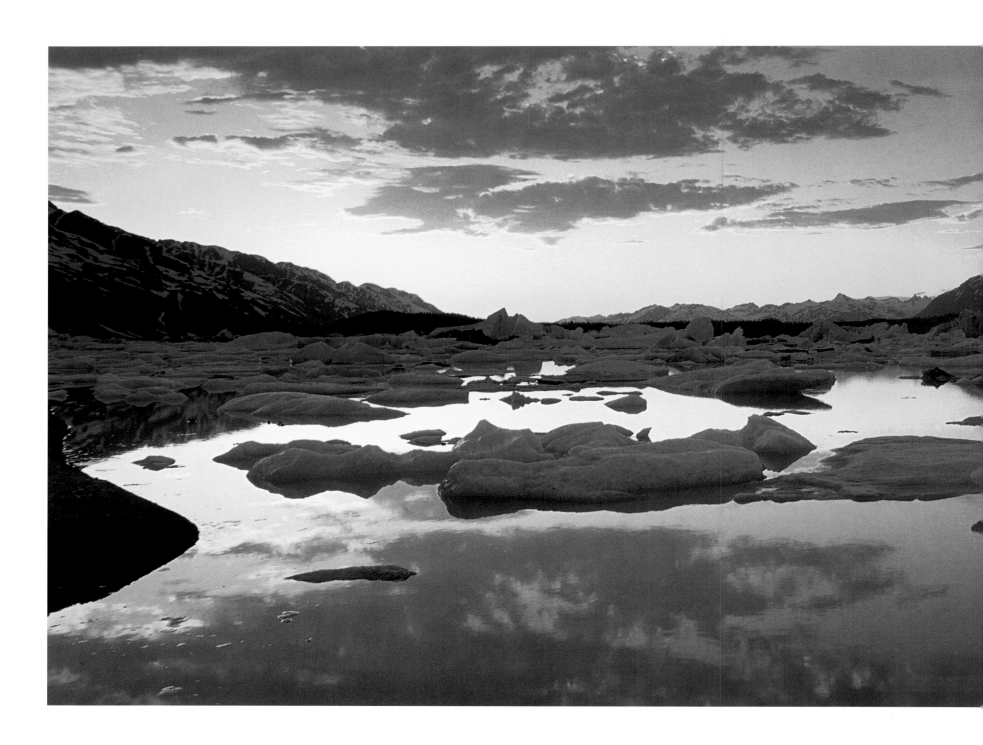

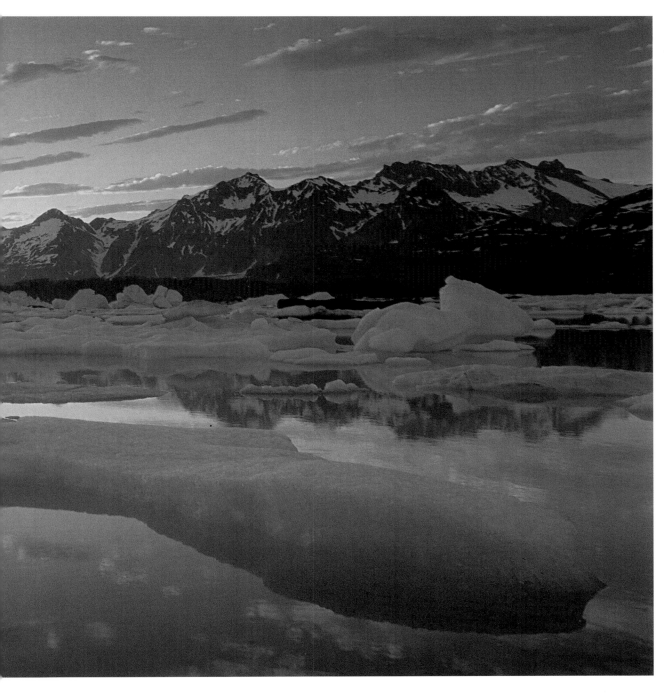

Sunrise, Alsek Glacier, Saint Elias Mountains

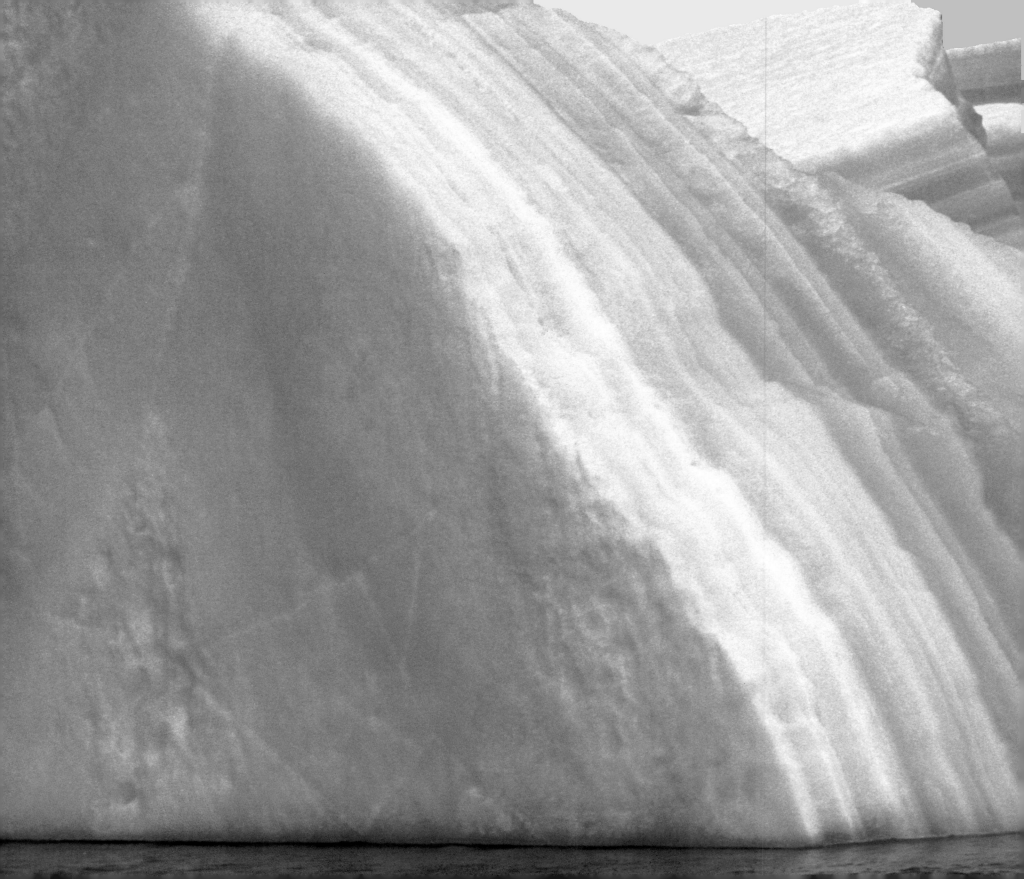

RIVER & LAKE

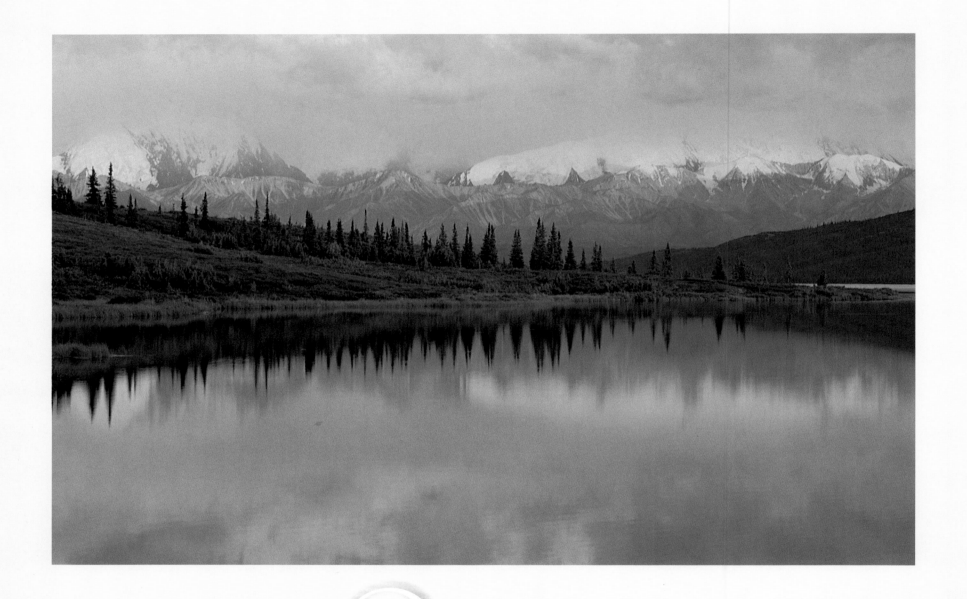

One June day twenty years ago, my friend Peter and I stood on the shores of Walker Lake in Alaska's upper left-hand corner, listening as the floatplane's roar faded into the sky. Mounds of gear lay scattered around us, along with the canoe that would take us seven hundred miles in

the next two months: down the Kobuk from the headwaters, up the Ambler and over Natmaktugiaq Pass into the Noatak, and downstream, southwest to Kotzebue on the Chukchi Sea. For me, ten days new to Alaska, it seemed the trip of a lifetime.

I suppose thirty or forty years from now I'll look back and figure the same thing. Though I've traveled uncounted thousands of river miles since, the feel of that first summer has never been equaled. Everything about that journey seems too vivid to have been real. I can recall tiny moments, even whole sequences, in cinematic detail—every cast I made to a certain grayling; the way stones looked at the bottom of that deep green pool above the Nimiuktuk; the noise the canoe thwart made as it splintered on a rock in the Lower Kobuk Canyon. I can even look back and see myself, younger and leaner, scanning the banks, the mountains, the water ahead, so wired by everything that I was about to jump out of my own skin. Some part of me must have known, even then, that I'd found home.

My experience in Alaska began with water, and the tie remains. As I write, I look out over the river that brought me into this country, and feel a surge of emotion: quiet familiarity, gratitude, passion, a sense of shared time and history. Love would be another name for it. After living along a river, as so many thousands of Alaskans do, it's almost impossible for me to imagine a life not connected intimately with its clear, cold substance. The valley this river has carved defines my home ground, both actual and spiritual; its channels and many tributaries are, summer and winter, my pathways. From it and along its banks I draw much of my food. In a real sense, part of the river flows inside me.

For many Alaskans, the tie to water remains a constant. Archaeologists can only guess at exactly who they were, but one fact remains clear: The first people in Alaska, hunter-gatherers all, made their homes by water. On the shores of lakes, along rivers and coastal beaches, they left their house pits, their tools, their bones—dated back ten thousand years and more.

Overleaf: River ice, Hulahula River

Left: Alaska Range, Denali National Park and Preserve

Right: Dead spruce, Turnagain Arm

Those who came later—from the first European explorers to the missionaries and miners, all the way to the present-day settlers—chose to live in similar places. They built their homes where hunting and fishing was good, shelter and fuel were available, and travel was easy. If the early ancestors could see the spots we've settled, they would understand why.

Water. From the far northern shores of the Beaufort Sea to the rainforests of the southeast, the landscape shimmers with it—countless melt-water ponds, streams, and sloughs; over three million lakes, some of them enormous; and a dozen major river systems. Huge, boggy flats and deltas seem more water than earth. Even in winter's cold, the water remains, locked in snow and ice. In fact, it's the six to eight months of freezing temperatures and low evaporation rate, coupled with poor drainage due to underlying permafrost, that keep much of interior and northern Alaska from being a cold Sahara. According to precipitation charts, these areas receive less moisture than southern Arizona.

As things are, the state is rich in water, and water means life. Any river, stream, pond, or lake is a magnet for living things. All you have to do is fly over patches of the Arctic, along the treeline, to see the way spruce and willows cling to the fringes of lakes and rivers, the way even a rivulet's path is marked by a curving line of alder. And in those waterside thickets, ptarmigan roost and insects find respite from the wind. Moose browse. Waterfowl nest. Meanwhile, the open flats and dry uplands seem silent by comparison.

Farther downstream, there are times when the water seems to boil with life. Millions of salmon—sockeyes, pinks, silvers, kings, chums—thrash up hundreds of rivers across the state. At bottlenecks caused by rapids or falls the fish pile up, milling by the thousands. Here gulls, eagles, foxes, and bears congregate, to take their share of the staggering bounty. Two of the richest spots are at Brooks Falls and McNeil River, in southwest Alaska, where dozens of hulking coastal brown bears gather each summer. Normally solitary and territorial, they establish an elaborate pecking order that allows them to feed, at times, almost shoulder to shoulder.

Without question, the greatest of Alaska's rivers—and one of the world's—is the Yukon, which drains the central interior. Pouring east to west from its headwaters in Canada, it's a river to match the scale of the land, draining over a third of the state's bulk. Flowing with

Right: Bald eagle (*Haliaeetus leucocephalus*)

fish, glacial silt, and ancient melted ice, a relentless, swirling current, the Yukon gathers hundreds of sloughs, streams, and tributaries over its 1,400 miles; some, like the Tanana, Koyukuk, and Porcupine, are big, powerful rivers in their own right. The Yukon valley's wide landscape encompasses most of Alaska's variety, from barren limestone peaks to lush wetlands, dense northern forest to rolling tundra. Its enormous lake-speckled delta in the far west, shared with the nearby Kuskokwim, is an important waterfowl nesting area.

Other glacial rivers of south-central and western Alaska include the Kuskokwim, Copper, and Susitna Rivers, each one fed by ice fields high in the Chugach and Alaska Ranges. Though supporting great runs of salmon, these and many other Alaska rivers never run clear; their braided, icy channels are so silt laden that a hand plunged beneath the surface disappears. Canoe and skiff bottoms are polished smooth by the constant hiss of grit.

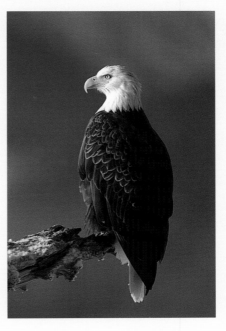

While Alaska's glacial rivers continue to shape the land, moving millions of tons of soil and billions of gallons of water each day, their impact is slight compared to that of the great Pleistocene ice sheets. For each receded valley glacier, there is a watercourse that, by force of gravity, found its way to an outlet. Some rivers, including the Yukon, were dammed by glaciers and deflected far from their original paths. Some deep-carved valleys filled with meltwater, forming what geologists call end moraine lakes. Typical of these is Walker Lake, headwaters of the Kobuk, where my first journey began. A dozen miles long and less than one wide, Walker bottoms out at over eight hundred feet. Inupiat elders still warn of an enormous fish, large enough to swallow a kayak.

A two-hundred-square-mile area at the base of the Alaska Peninsula contains the state's largest lakes, including the Tikchik Lakes, Lake Clark, and Iliamna—the latter more than seventy miles long. The entire region (which includes McNeil River and Brooks Camp,

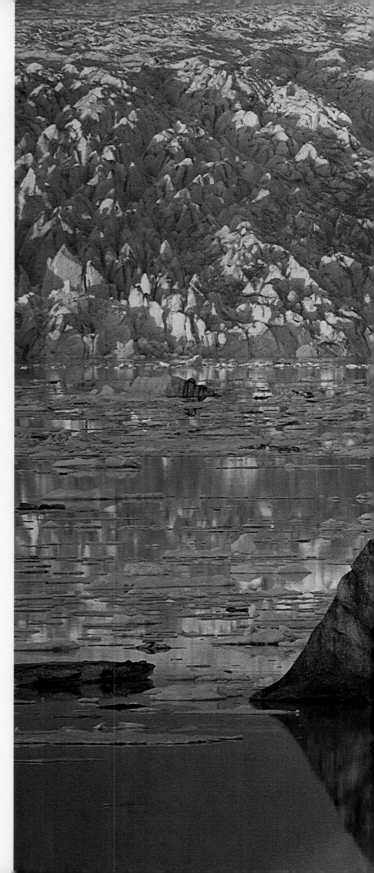

where those bears wait) is also home to one of the richest salmon runs in the world. Which leads us back, as the land always does, to rivers.

The state's nonglacial rivers come in two basic sorts: those stained brown by tannins leached from tundra and spruce, and others whose beds lie in rock, sand, or gravel—mountain rivers cutting through tundra-lined valleys and forested flats. These are the waters we imagine when we think of Alaska—so clear we can lean over and watch char finning fifteen feet below, so pure it seems like a transparent atmosphere, something we should be able to breathe. These rivers' names—Mulchatna, Noatak, Koyukuk, Sheenjek—are as fluid as the purling of their currents.

To follow one of these streams from its headwaters is to become a traveler in the old way, connected seamlessly with the land. After a few days of quiet drifting with the river, the country seems to flow past as if it has become liquid itself; time seems to fall away, perhaps because we're moving at exactly its pace. As we rarely do, we sense the rightness of our journey, its inevitable, perfect shape. Wrapped in the arms of the river, we move together, heading home to the sea.

Right: Alsek Glacier, Saint Elias Mountains

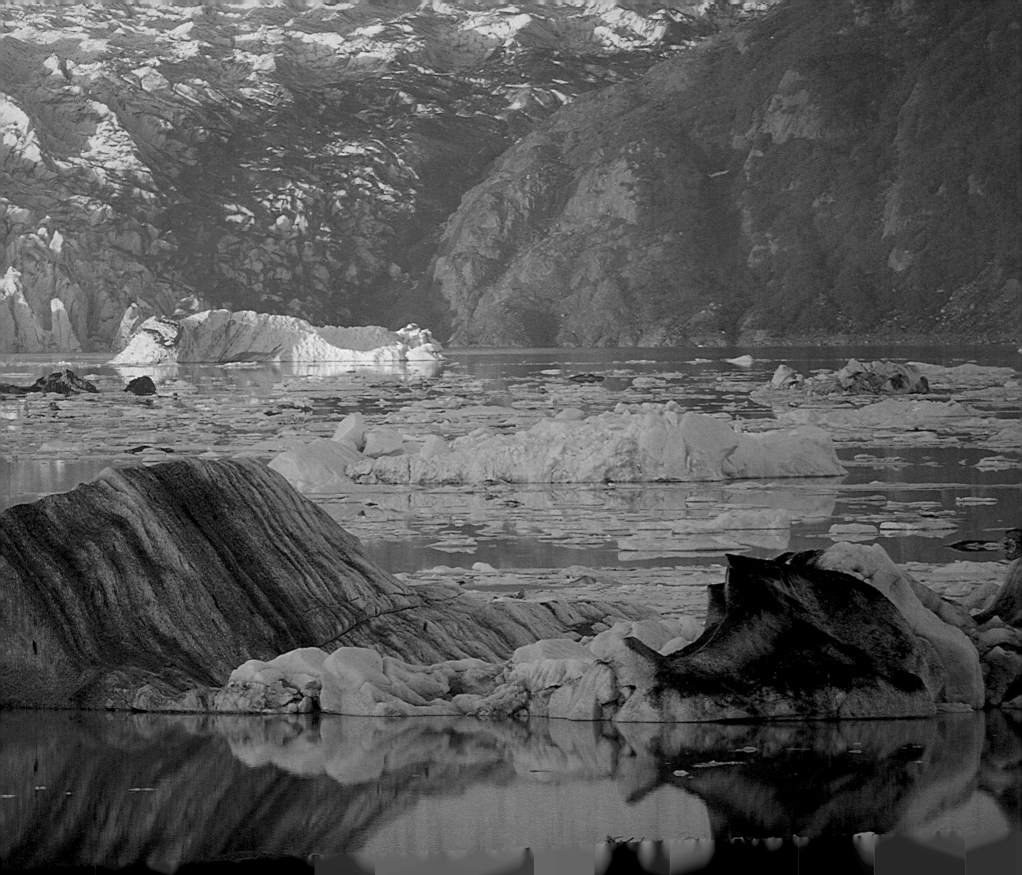

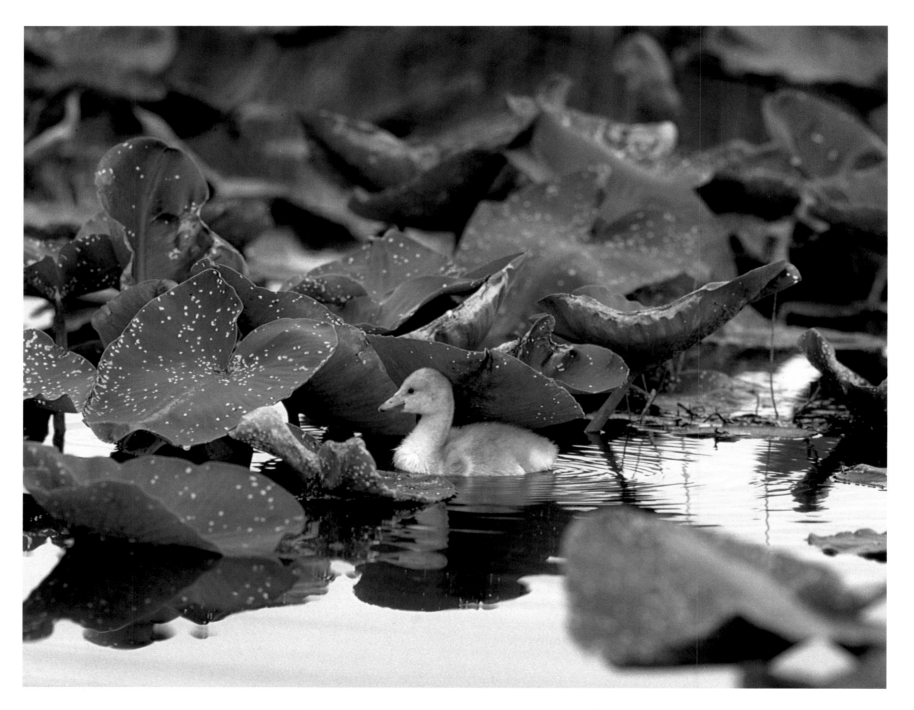

Trumpeter swan (*Cygnus buccinator*) cygnet, Kenai Peninsula

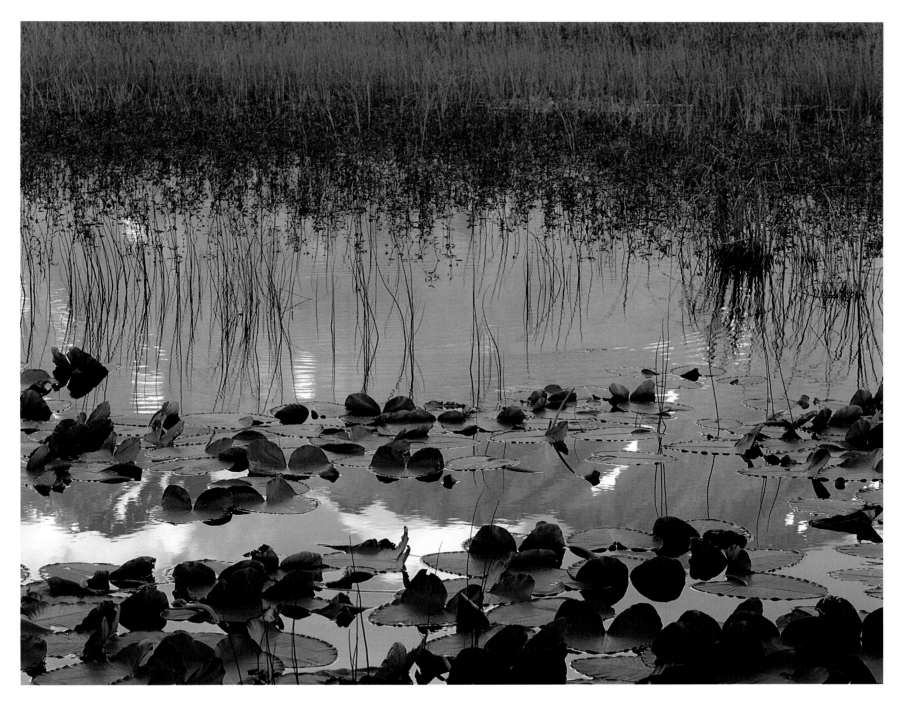

Tongass National Forest

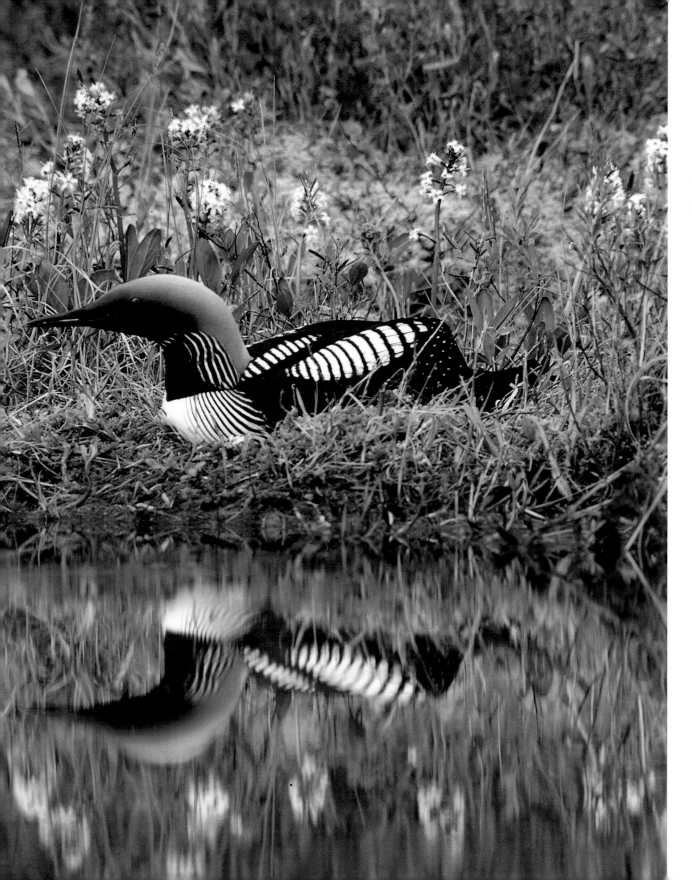

Left: Pacific loon (*Gavia pacifica*), Kenai Peninsula

Right: Bull moose (*Alces alces*), Denali National Park and Preserve

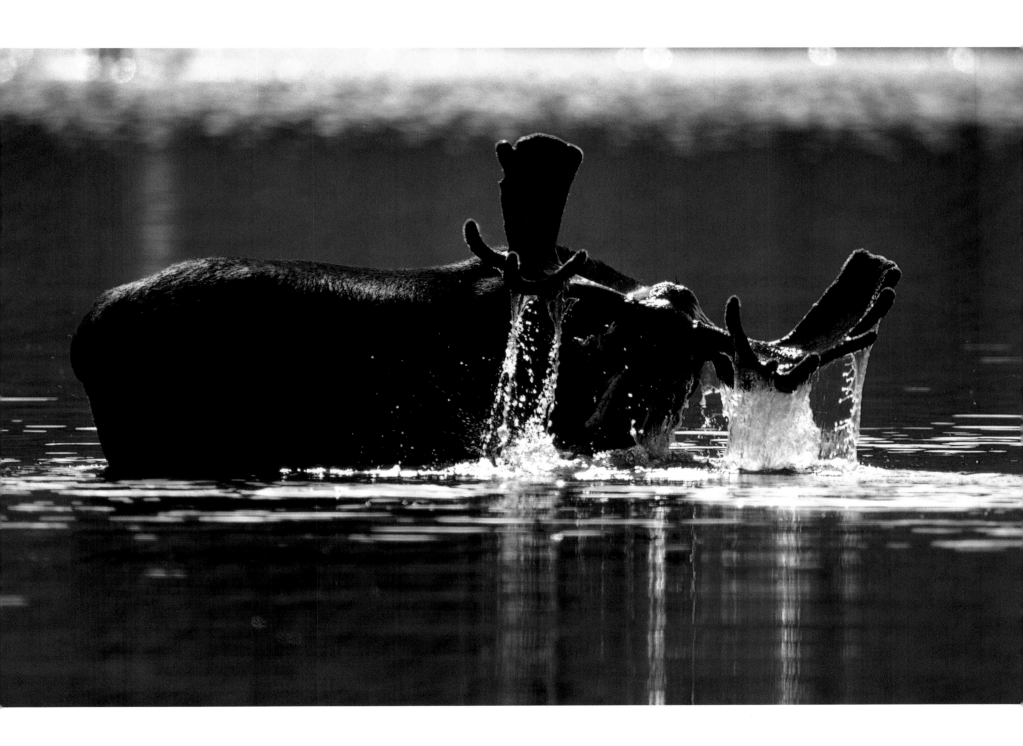

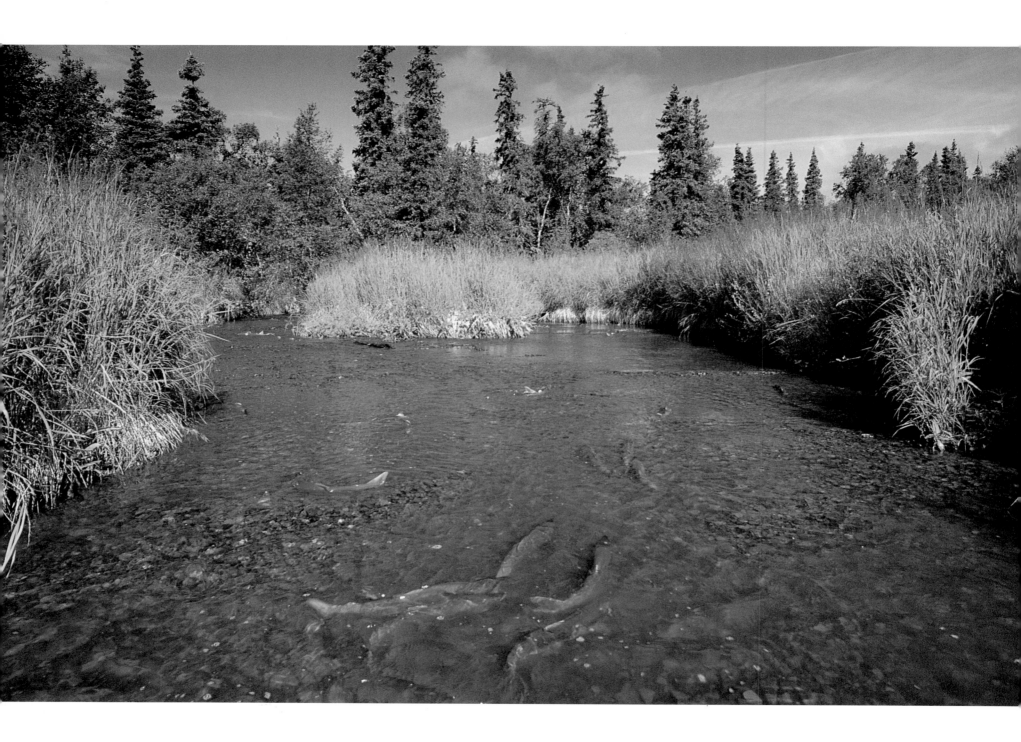

Left and right: Spawning sockeye salmon *(Oncorhynchus nerka)*, Hansen Creek, Wood River Lakes region

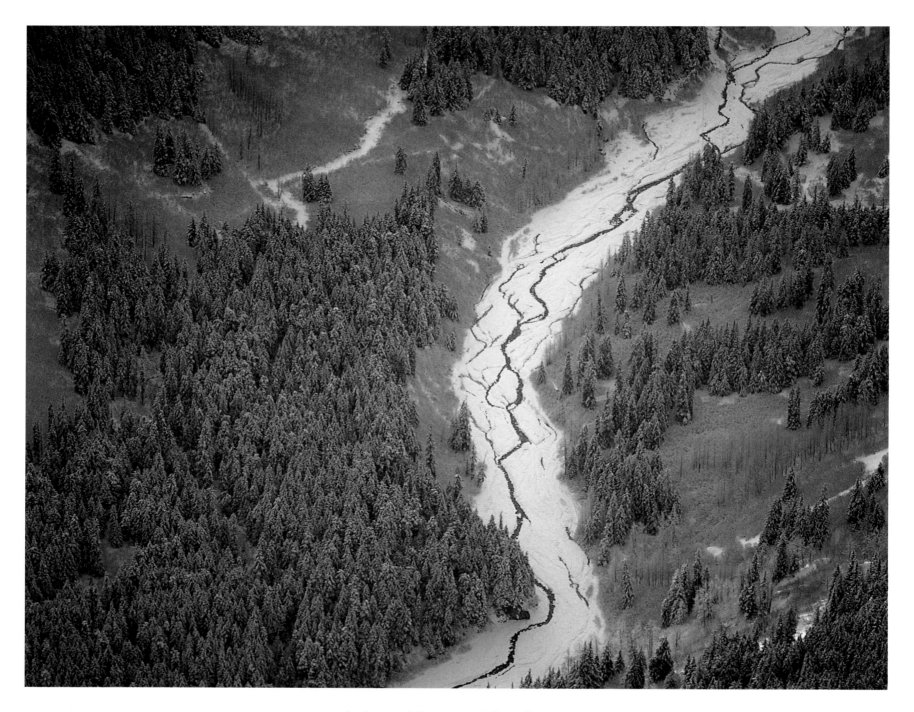

Winter landscape, Chilkat River, Chilkat Valley

ALASKA

Chum salmon (*Oncorhynchus keta*), Chilkat River

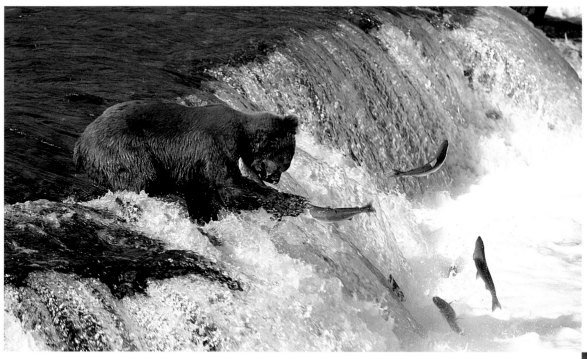

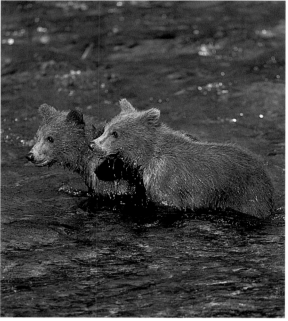

Above: Grizzly bear (*Ursus arctos*), Brooks Falls, Brooks River Bear Sanctuary, Katmai National Park and Preserve

Right: Grizzly bear (*Ursus arctos*) cubs, Katmai National Park and Preserve

Far right: Grizzly bear (*Ursus arctos*), Katmai National Park and Preserve

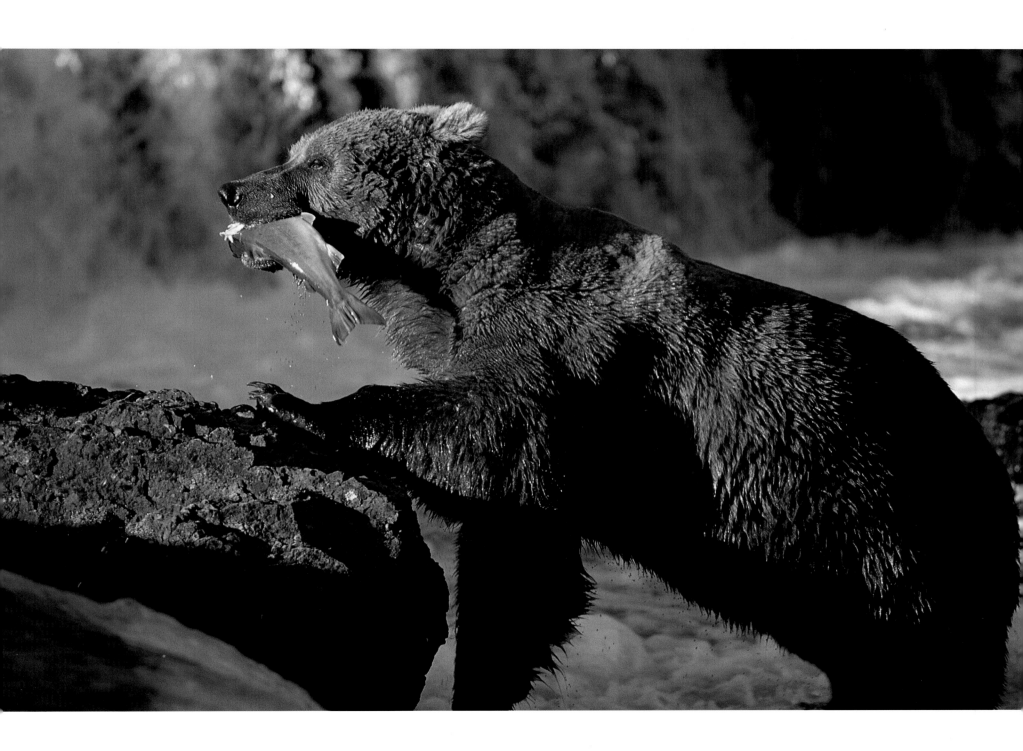

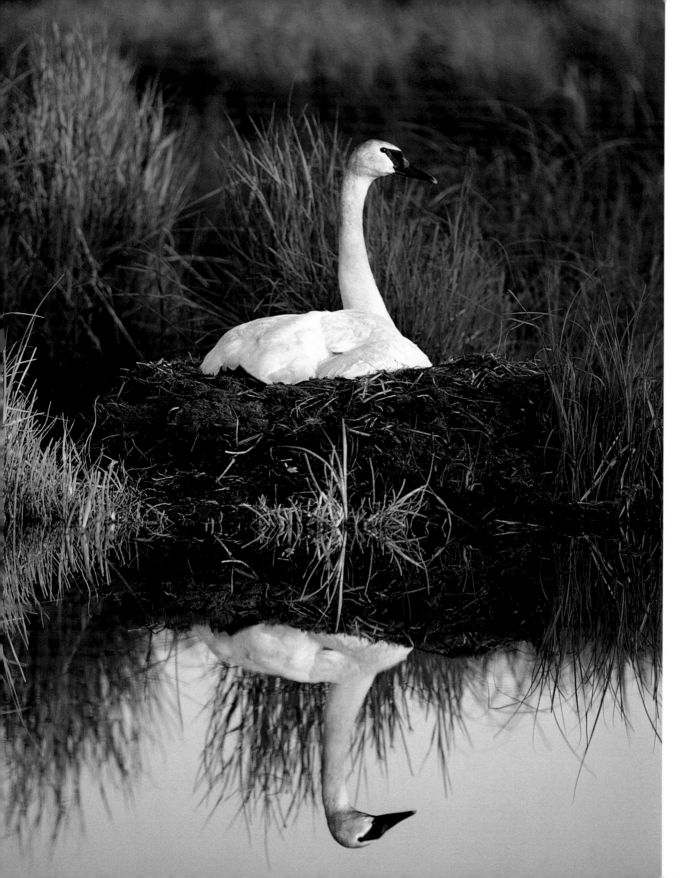

Left: Trumpeter swan (*Cygnus buccinator*) on nest, Kenai Peninsula

Right: Tongass National Forest

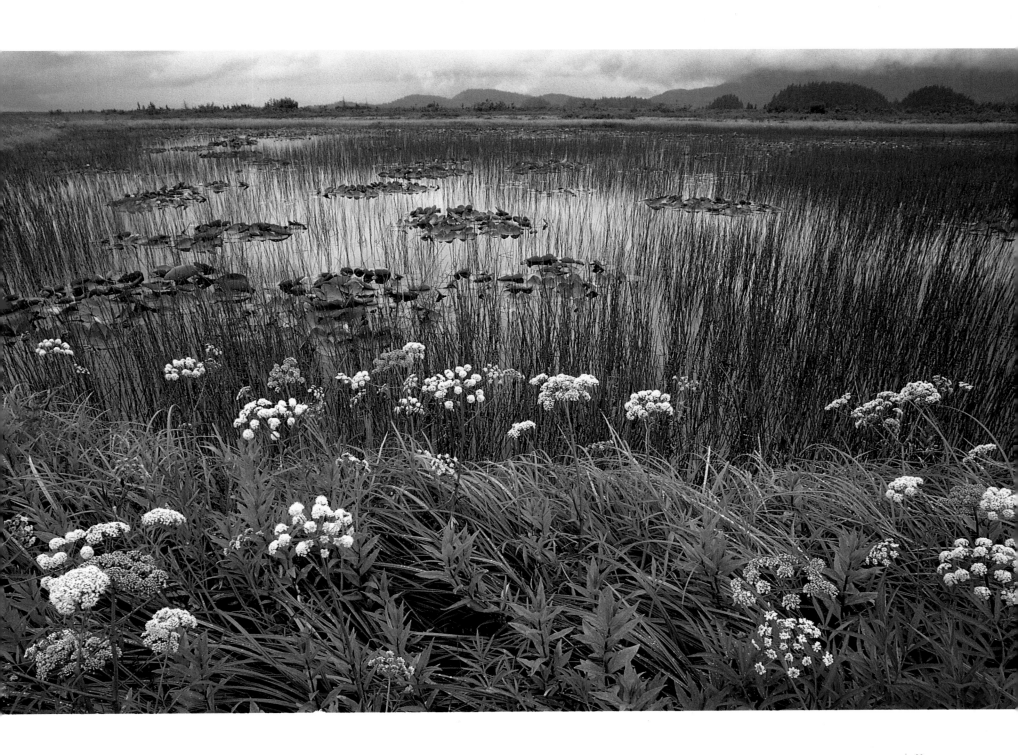

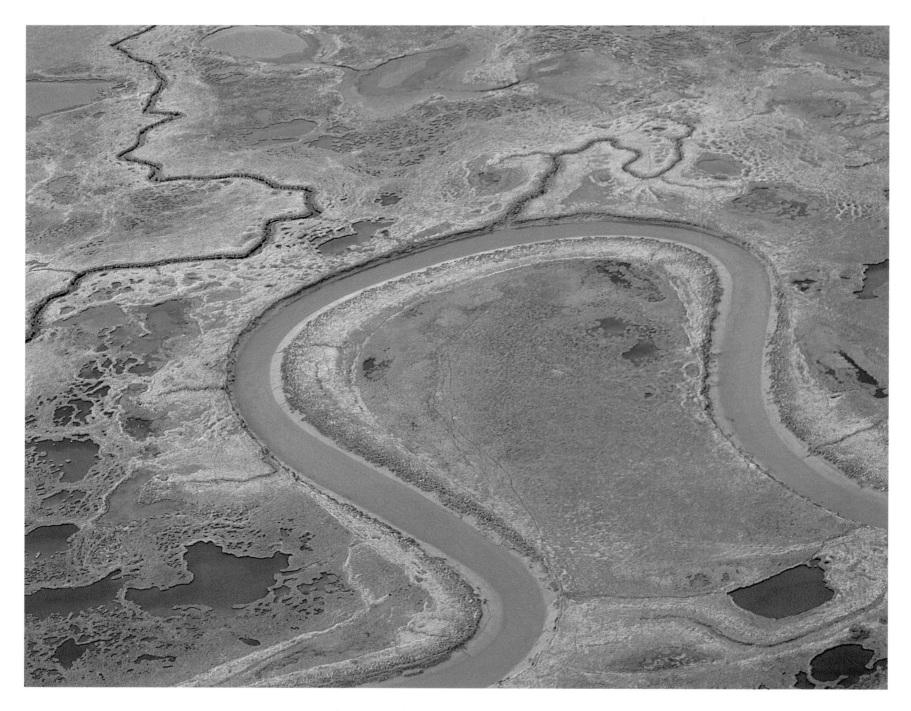

Togiak River, Togiak National Wildlife Refuge

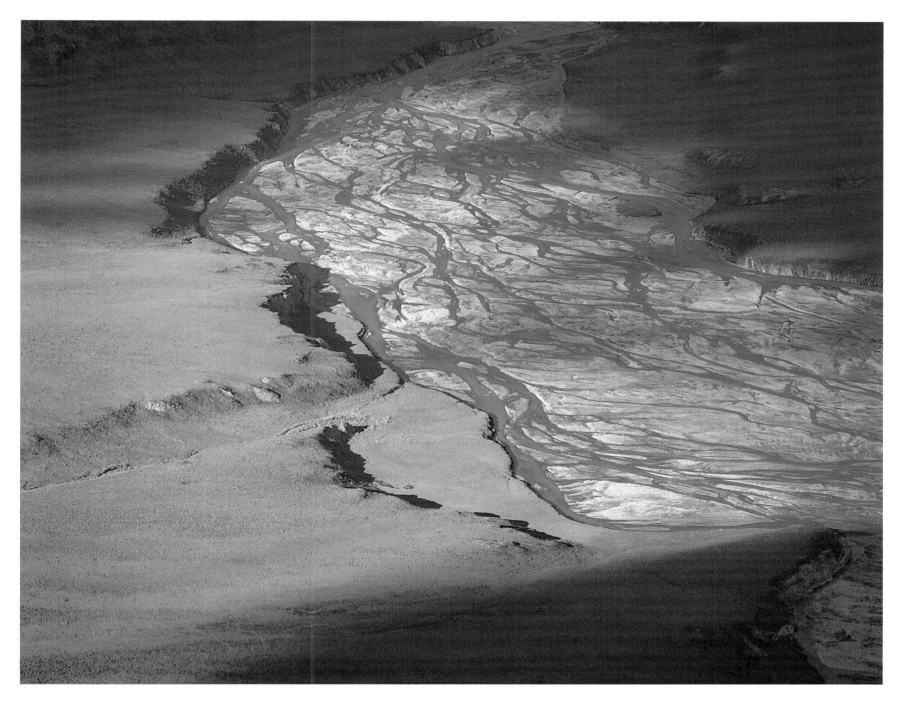

Jago River, Arctic National Wildlife Refuge

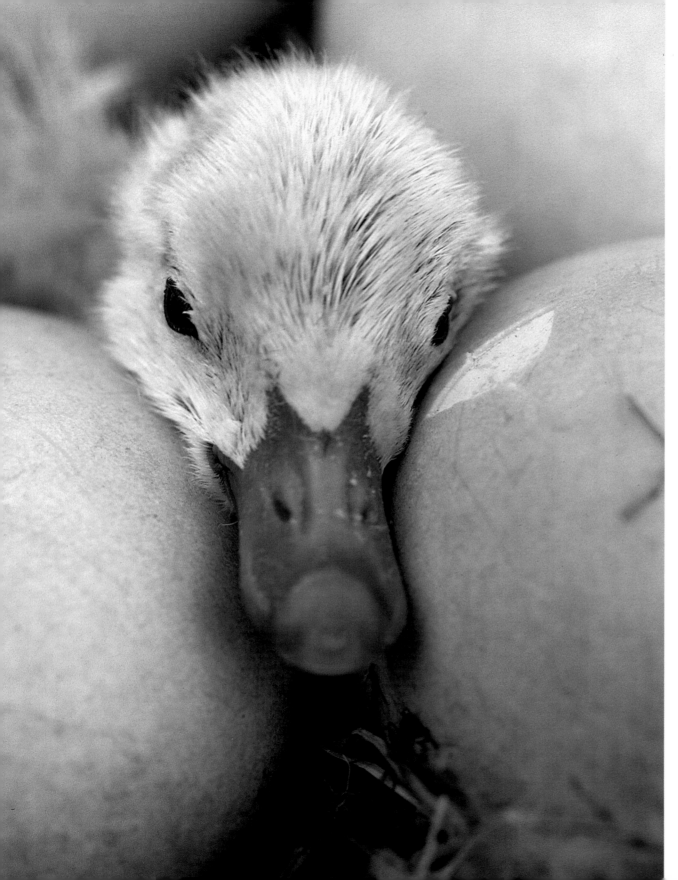

Left: Trumpeter swan (*Cygnus buccinator*) cygnet, Kenai Peninsula

Right: Trumpeter swan (*Cygnus buccinator*) cygnet hatching, Kenai Peninsula

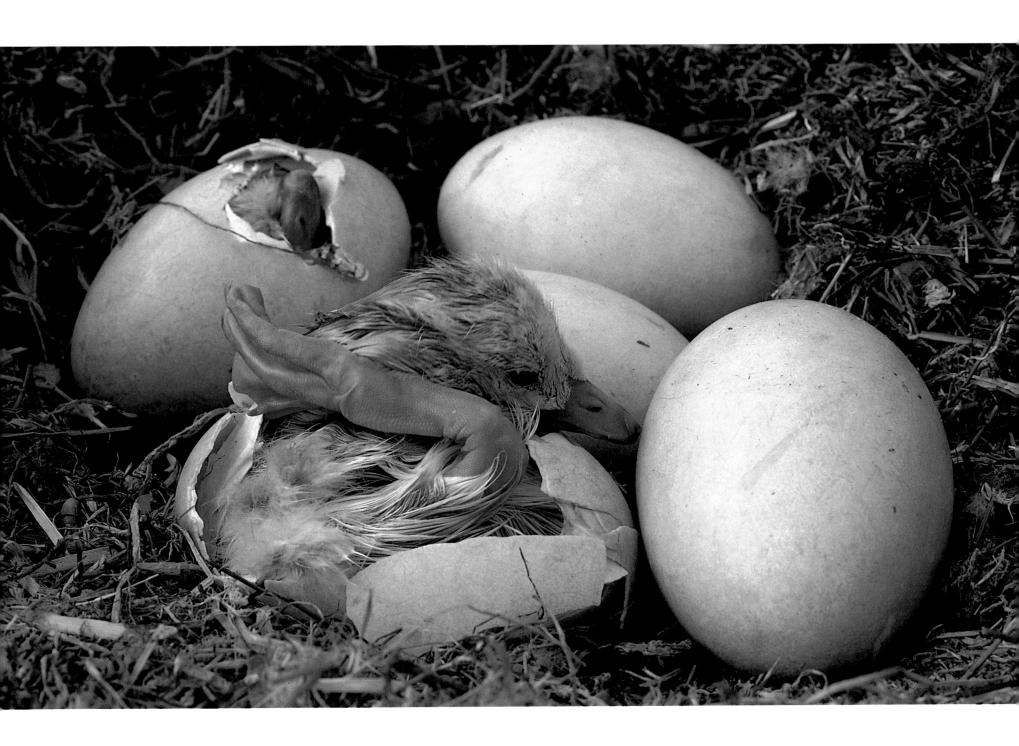

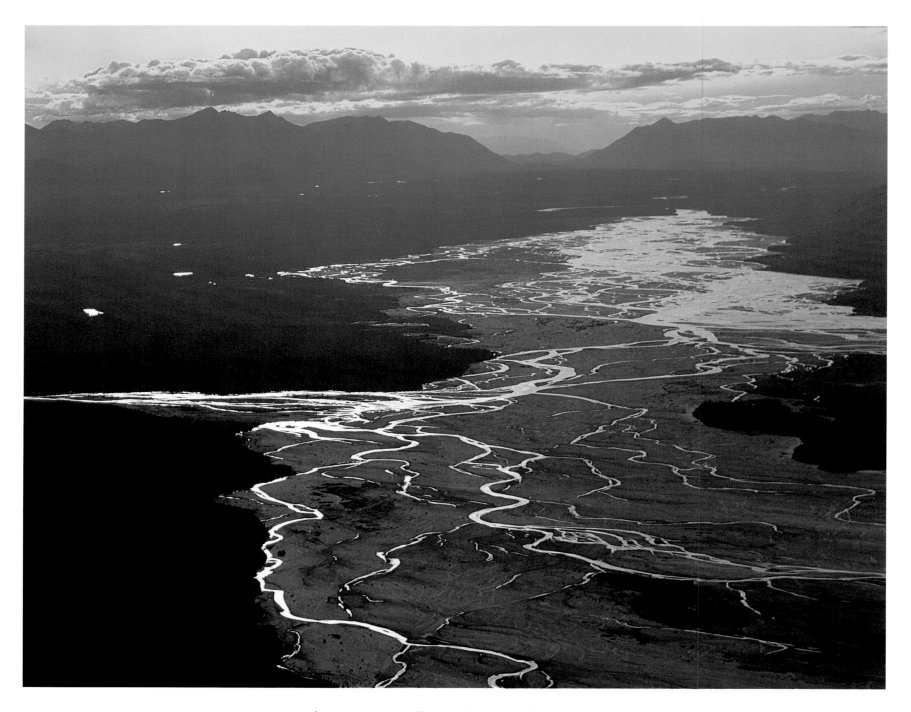

Chitina River, Wrangell–Saint Elias National Park
and Preserve

ALASKA

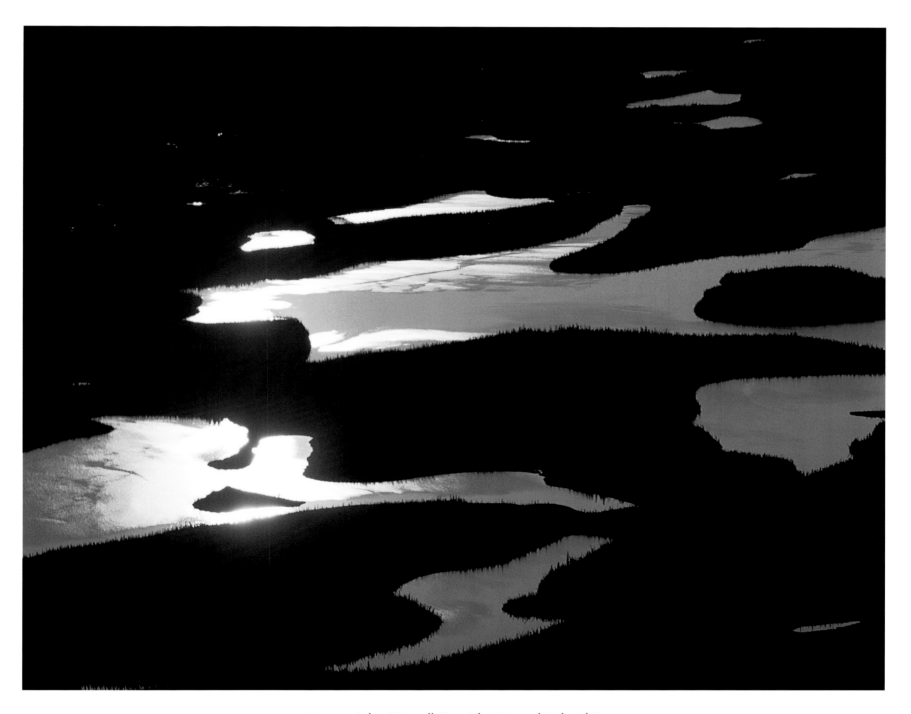

Hanagita Lakes, Wrangell–Saint Elias National Park and Preserve

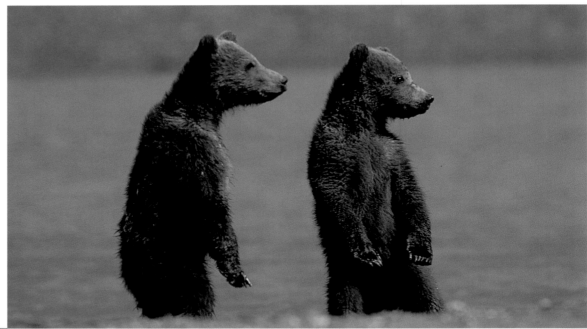

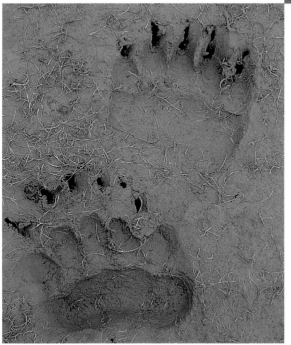

Grizzly bear (*Ursus arctos*) tracks, McNeil River State Game Sanctuary and Refuge

Grizzly bear (*Ursus arctos*) cubs, McNeil River State Game Sanctuary and Refuge

Grizzly bear (*Ursus arctos*), McNeil River State Game Sanctuary and Refuge

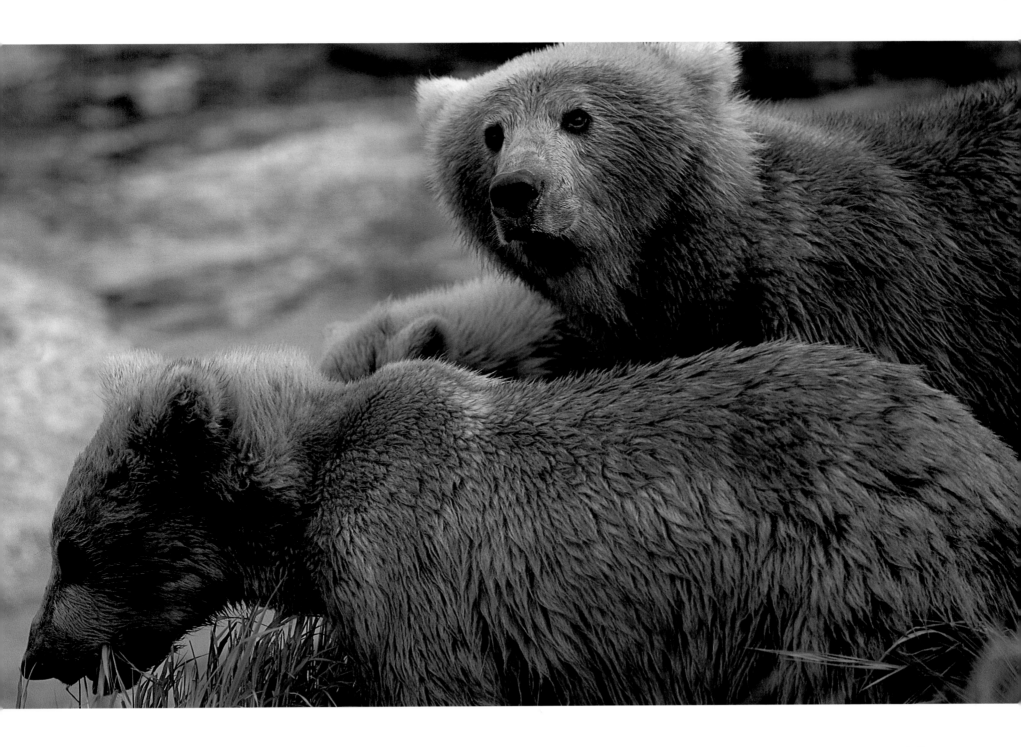

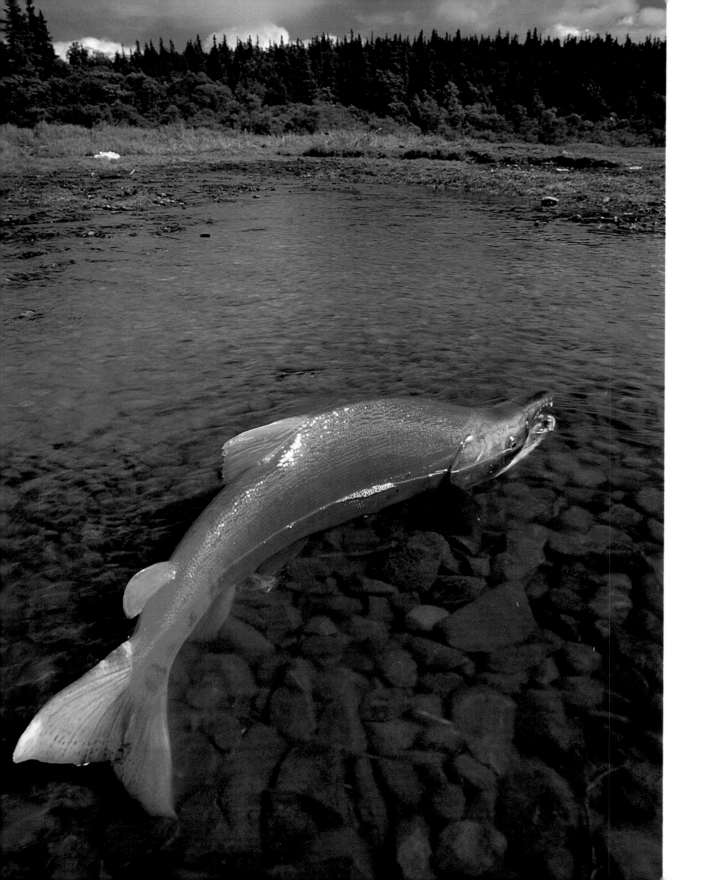

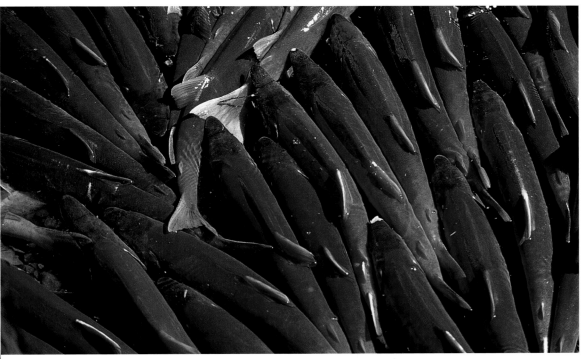

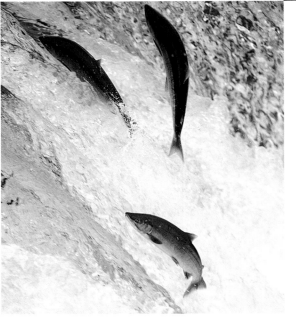

Far Left and above: Spawning sockeye salmon *(Oncorhynchus nerka)*, Hansen Creek, Wood River Lakes region

Left: Spawning salmon *(Oncorhynchus sp.)*, Brooks River

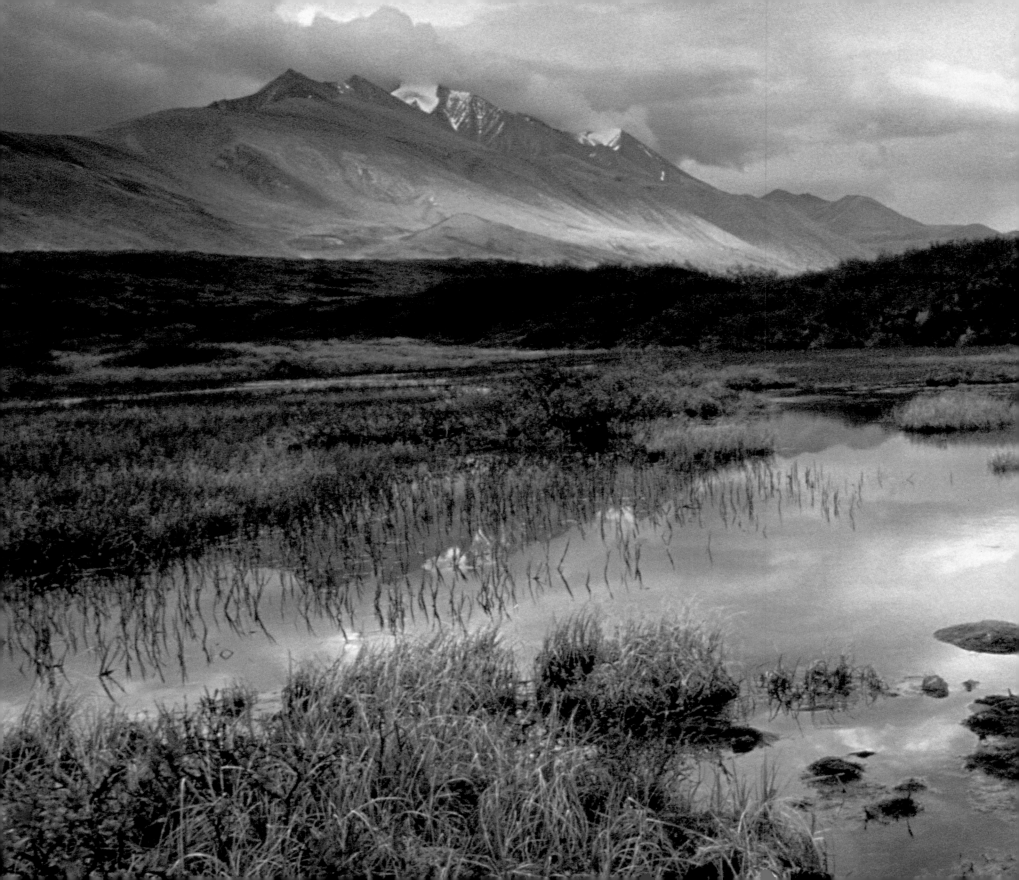

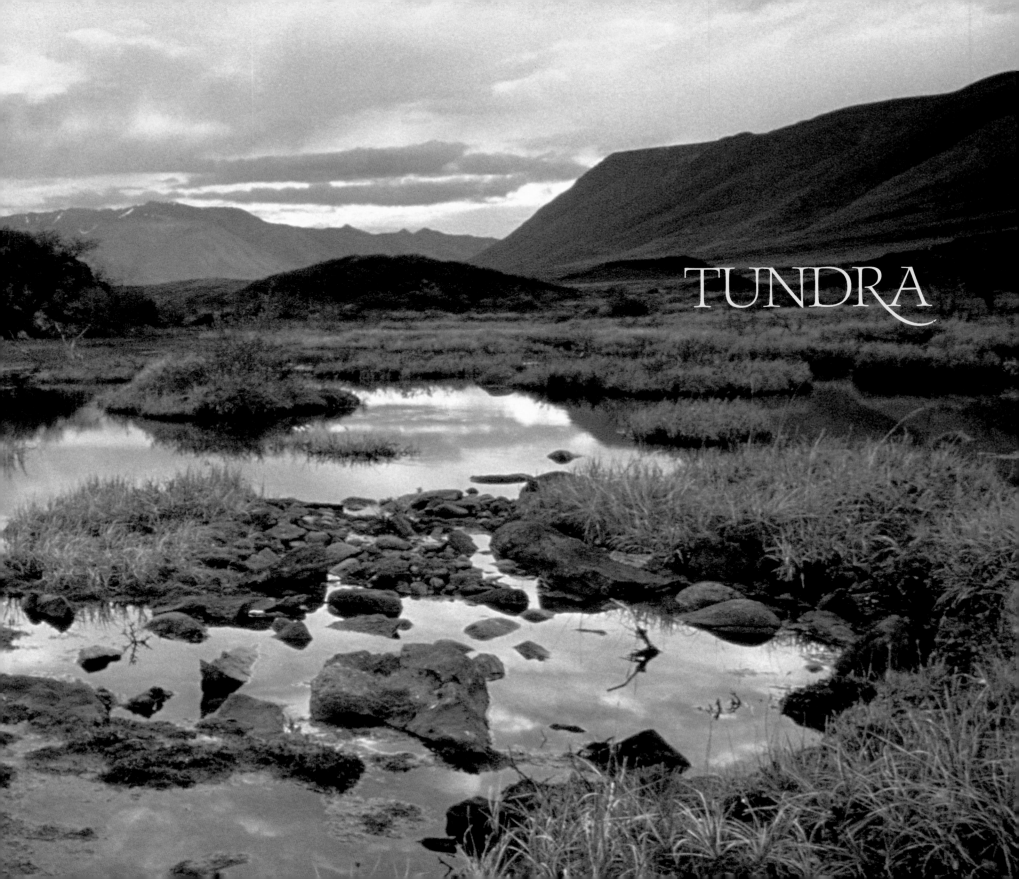

TUNDRA

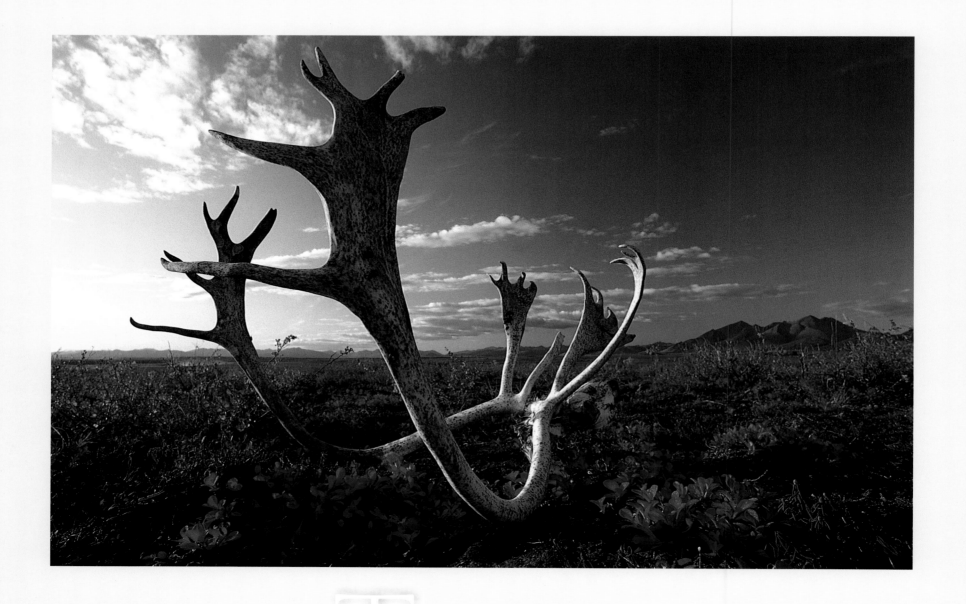

Tundra is one of those small words that spans an entire state of mind. There's a high, lonesome sound to it, something that summons longings half forgotten, a vision of limitless space, silence, wind, and cold. An austere world where life wrestles with its alternative. A world

our ancestors, Ice Age hunter-gatherers, must have known intimately.

The archetypal image that we carry is, for once, accurate. The reason trees, for example, don't grow on tundra is because they can't. Where the white spruce stop, they have reached their limit of tolerance. Anywhere you find a treeline in Alaska, you're looking at one of nature's big science projects in action. The title is an ongoing question: How much can trees stand? Where the trees stop, tundra begins.

Over half of Alaska is tundra and associated shrubland. The North Slope of the Brooks Range, most of western Alaska, the Alaska Peninsula, and the Aleutian Islands are all major regions where tundra dominates, twined by dense bands of brush, generally alder or willow. And there are thousands of other tundra areas across the state. Even the southeastern panhandle, known for its temperate rainforest, has wide stretches of alpine tundra.

Tundra, of course, signifies more than the simple absence of trees. It's an expression of biological adaptation tweaked to the maximum, existing in at least three basic, equally perfect versions: wet, or lowland; moist upland; and dry, or alpine. Exactly what plant species make up a given patch is determined by local conditions—which might change in a few yards—and where you are in Alaska. Some tundra species—grayleaf willow and dwarf Arctic birch, for example—are nearly ubiquitous. Others, like miquel wintergreen, exist only in one or two highly limited areas (in this case, Kiska Island of the Aleutian chain).

The variety of plants that can form tundra isn't as limited as one might expect. While huge areas are often dominated by one species or another, the diversity of some patches of tundra more resembles a subtropical jungle than a harsh, on-the-edge biome. A few acres of ground may contain dozens of distinct species of sedge, dwarf shrubs, lichens, and flowering plants. Across the state, there are more than twenty species of willow alone.

Wet and moist tundra generally exist wherever permanently frozen soil layers lie so close

to the earth's surface—in some cases, less than a foot down—that surface water is trapped. What doesn't evaporate in the brief Alaska summer stays put, forming a soggy layer three months of the year and a rock-hard frozen sheet in winter. The frost line is so close to the surface that the land is often fractured into odd, polygonal shapes that appear manmade, or heaved into hillocks called pingos. Even at the height of the summer thaw, the surface soil, besides being sopped with water, is so cold and thin that there is little space for root systems to grow down. Then there are periodic summer droughts, when the normally wet ground dries out. What soil does exist is acidic and nutrient-poor. These conditions should add up to a plant's worst nightmare.

But life, being what it is, finds a way—not just to exist, but to flourish. Anyone who's stood on the Selawik flats in June knows how tundra can vibrate with the energy of life: tender green shoots and leaves, dazzling miniature blossoms, fields of snow-white cotton grass stalks. The raucous, rusty-door-hinge cries of

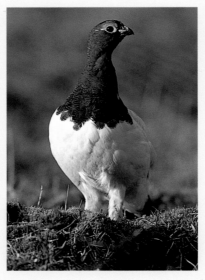

sandhill cranes, the twitter of songbirds, the cackle of nesting waterfowl, and the incessant whine of insects (notably some billions of mosquitoes, whose biomass is occasionally measured in tons) fill the air. Red-backed voles scurry underfoot. Along the edges of meltwater ponds, moose graze on succulent new growth. Black bears forage.

This explosion of life, while spectacular, is necessarily brief. Tundra plants in the interior and Arctic generally have a dozen weeks to thaw out, grow, reproduce, and slide back into eight months of winter. January temperatures hit fifty, sixty below zero; the air is as dry as that of any desert on earth. Even on a summer evening, a patch of northern or alpine tundra can be hit by frost. Any species that's managed to carve out a niche has been forced, over centuries of rough use, into a number of biologically clever adaptations.

For starters, almost every plant hugs the ground. This minimizes the drying effects of wind and sun, and maximizes protection by snow cover. Its small size—most are roots, leaves, and

flowers—also allows the plant to live on almost nothing. Precious energy and nutrients are saved for reproduction rather than being wasted on extravagant growth. Thick, leathery leaves further slow water evaporation. Building up hummocks or tussocks of dead material allows some species (like certain cotton grasses) to trap moisture, capture nutrient sediment, create microclimates insulated from permafrost, and shade out competition. Think of tundra as a miniature forest, beaten down to size. If things were a little warmer, a little richer, it would be something else entirely.

The net result is a complex, precarious, yet balanced ecosystem that's lasted, in one form or another, through repeated ice ages. In lean times, roots and seeds hunker, either buried or surviving in scattered pockets called refugia. When the opportunity to grow presents itself, as in the shadow of a retreating glacier, colonizing species take root, building soil and fixing nutrients, allowing other species to move in. The area becomes tundra—once more, or perhaps for the first time.

From there, things get more complex. Periodic floods, droughts, and natural fires sweep the land, each time setting off a distinct cycle of succession. Animals and insects inter-act with tundra plants in ways that may be direct or subtle—eating, pollinating, spreading seeds.

The barren ground caribou is, over much of Alaska, an inseparable part of the tundra landscape. In a flow driven by the seasons, the state's dozen herds (the largest, in the Western Arctic, over four hundred thousand strong) wander constantly, generally south in autumn, then north to their calving grounds in spring, forming living rivers of their own. And as with the salmon, the passage of the caribou draws a swirling eddy around it, life feeding on life: packs of wolves, Eskimo subsistence hunters, scavenging wolverines, and ravens. All congregate at passes and crossing places as the first deep frosts burn the willows gold and the snowline creeps down the mountains. The throngs of caribou flow past these predatory gauntlets, scarcely noticing those who fall. Inupiat elders say they give themselves willingly, and it seems so. The death of hundreds or even thousands is of little consequence to the single being of the herd.

These spindly-legged, huge-racked deer evolved with the tundra, were shaped by it; in turn they shape the land. If fifty thousand caribou move through a valley twice a year for decades, their impact is huge. The tundra is cropped close by grazing, grooved to bare ground

by trails. Bones, antlers, shed hair, and droppings litter the landscape, returning nutrients to the soil.

When a caribou population crashes, overgrazing is more often the cause than predation. Caribou eat year-round, each animal consuming ten to twenty pounds of sedge, lichen, and shrub per day. Favored browse becomes scarce; poorly nourished animals succumb to sickness and wolves, or simply become too weak to move. As caribou numbers fall, so do the numbers of their predators. The tundra slowly recovers. The caribou population grows once more. Such minor fluctuations occur every few decades, often set off by an especially hard winter or a dry summer; research suggests a larger cycle, spanning a century or more.

But the essence of tundra isn't contained in complex rhythms, huge space, or the sweep of time. The secret lies at your feet, caught in a cluster of white blossoms small as a fingertip, a wisp of pollen, a single blade of grass. Calling such things brave might be an anthropomorphic reach, but here they are, pushing out into a world where life holds on with both hands, where flowers are sometimes caught in tombs of ice. Look down and think of them: All these small lives shaking in the wind.

Right: Sheenjek Valley, Arctic National Wildlife Refuge

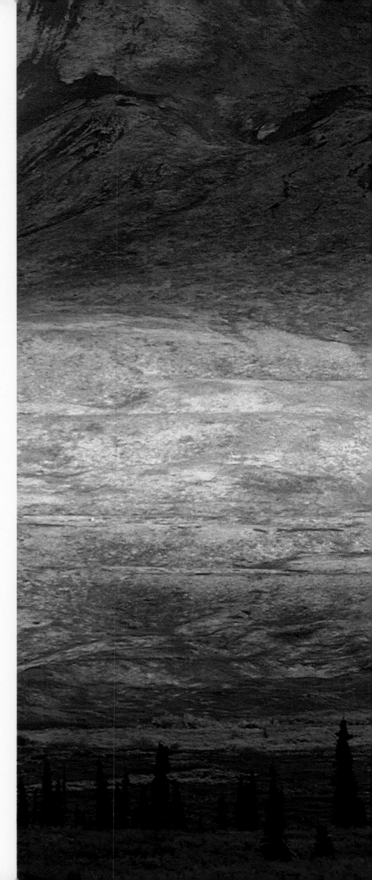

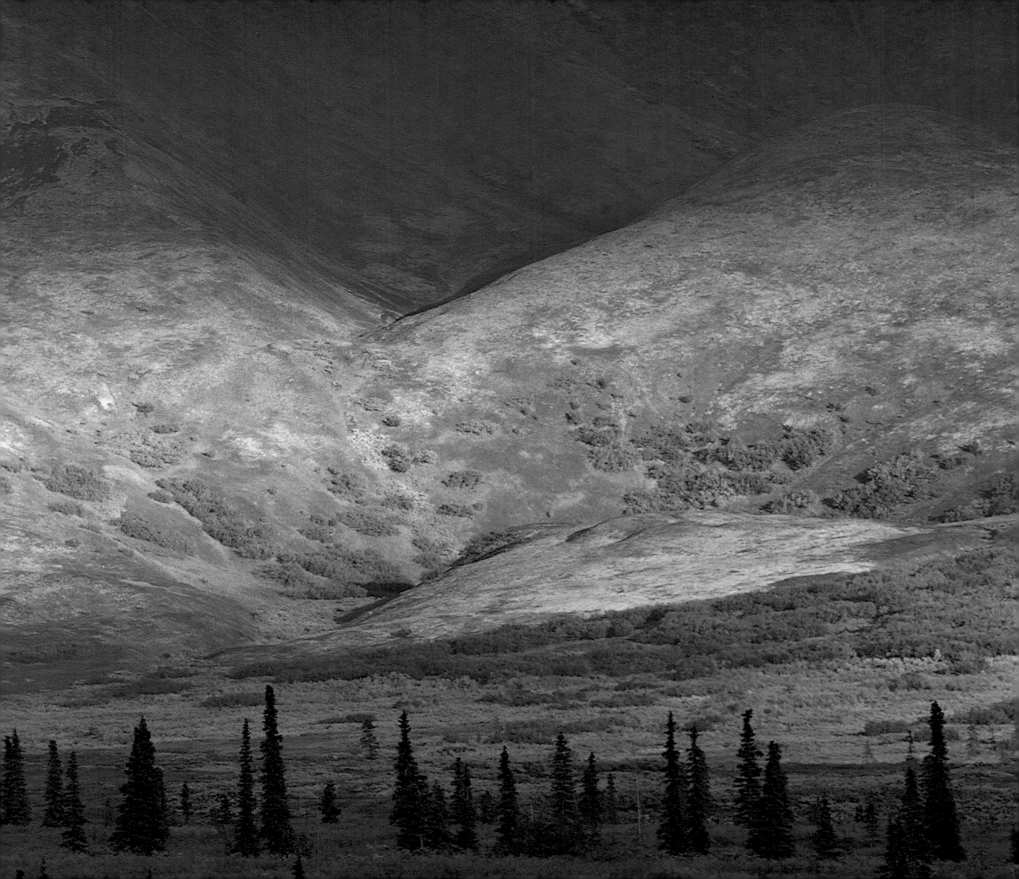

Right: Lesser golden plover (*Pluvialis dominica*), Arctic National Wildlife Refuge

Below: Whimbrel (*Numenius americanus*), Arctic National Wildlife Refuge

Far right: Arctic cottongrass (*Eriophorum callitrix*), Arctic National Wildlife Refuge

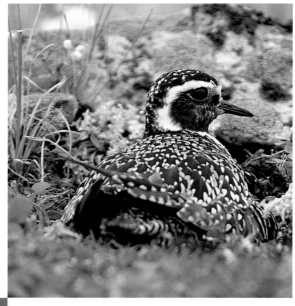

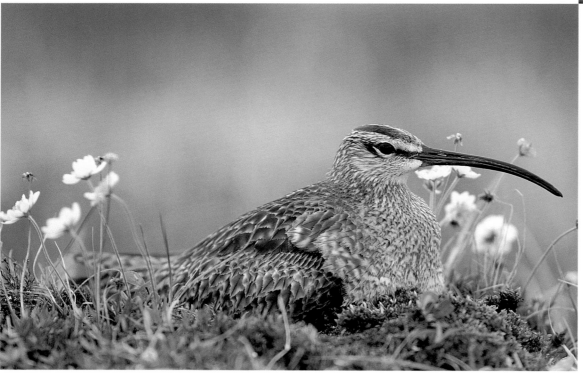

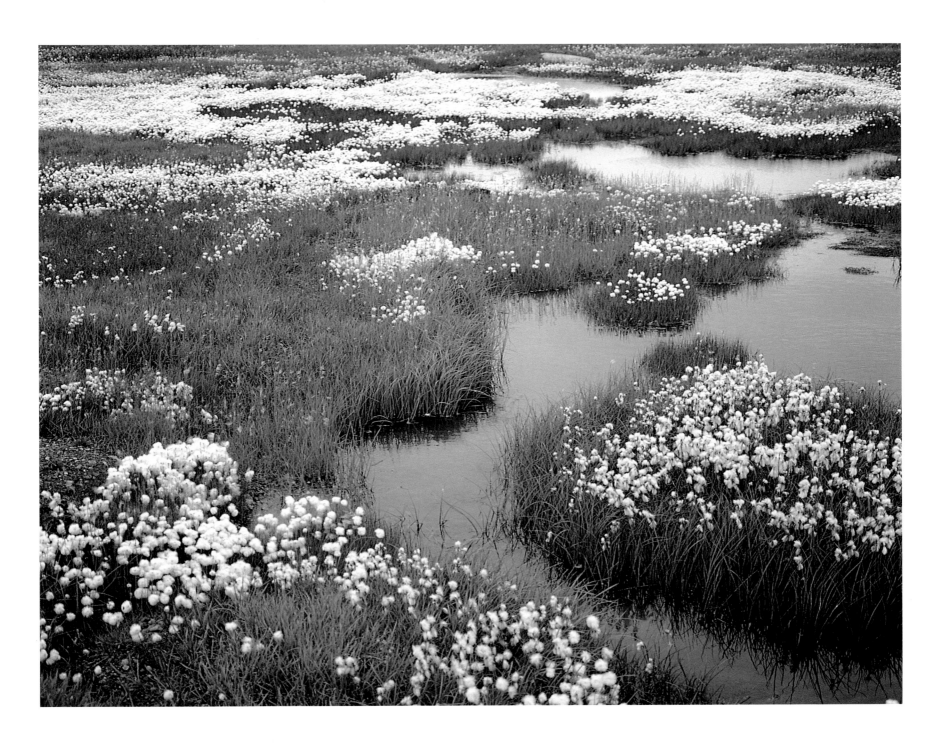

TUNDRA

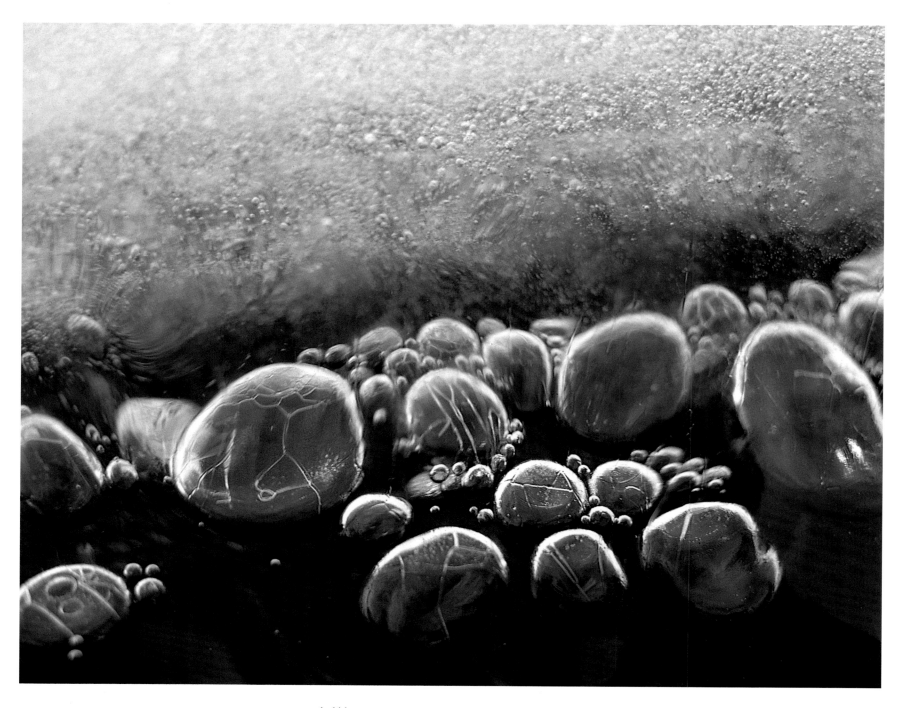

Ice bubbles, Arctic coast

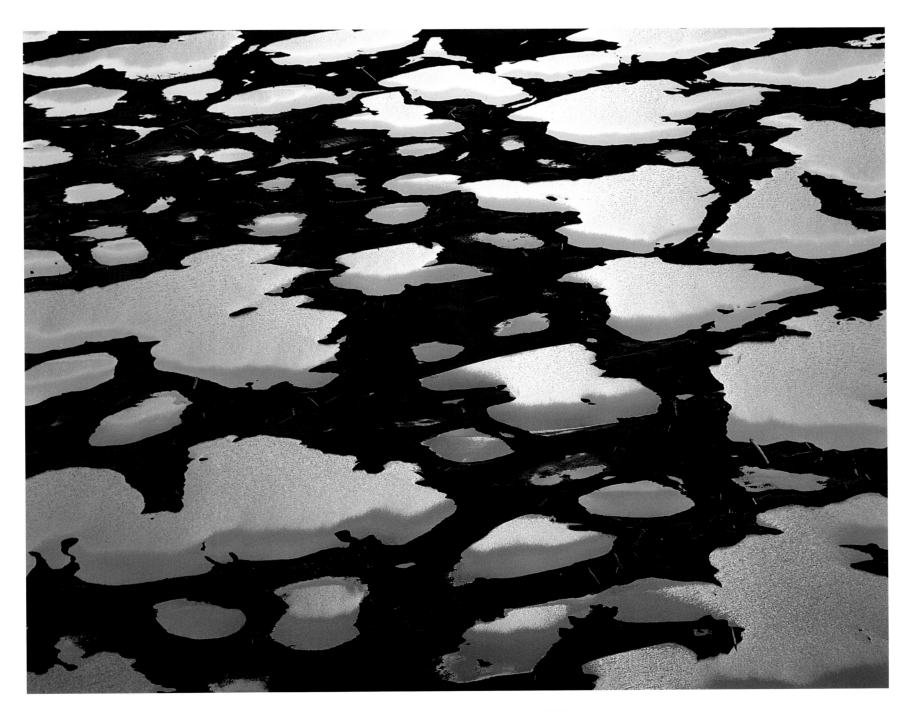

Aerial view of coastal plain, Arctic National Wildlife Refuge

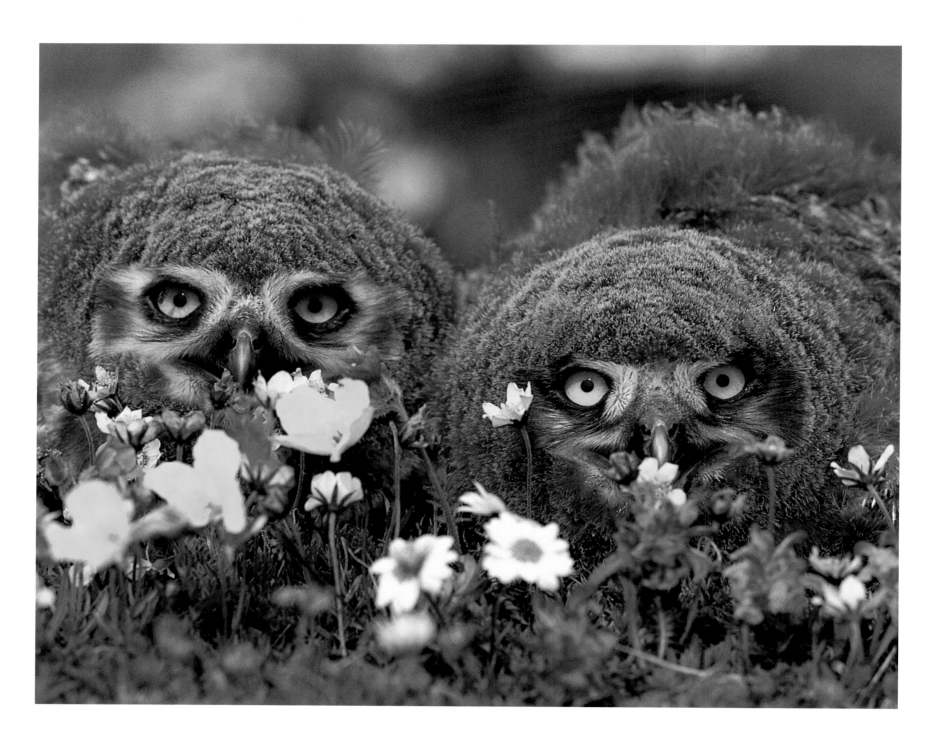

ALASKA

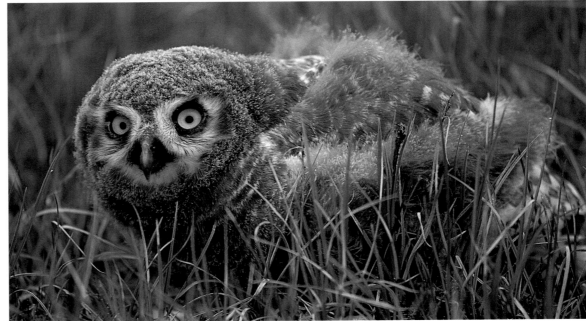

Left and below: Snowy owlets (*Nyctea scandiaca*), Arctic National Wildlife Refuge

Right: Snowy owl (*Nyctea scandiaca*), Arctic Slope

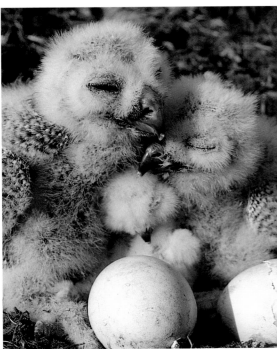

Tundra lake, Brooks Range

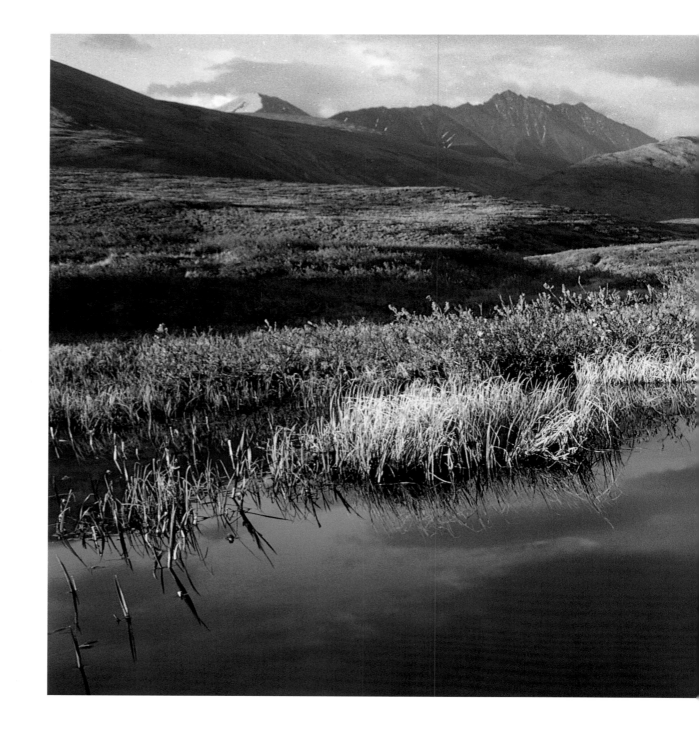

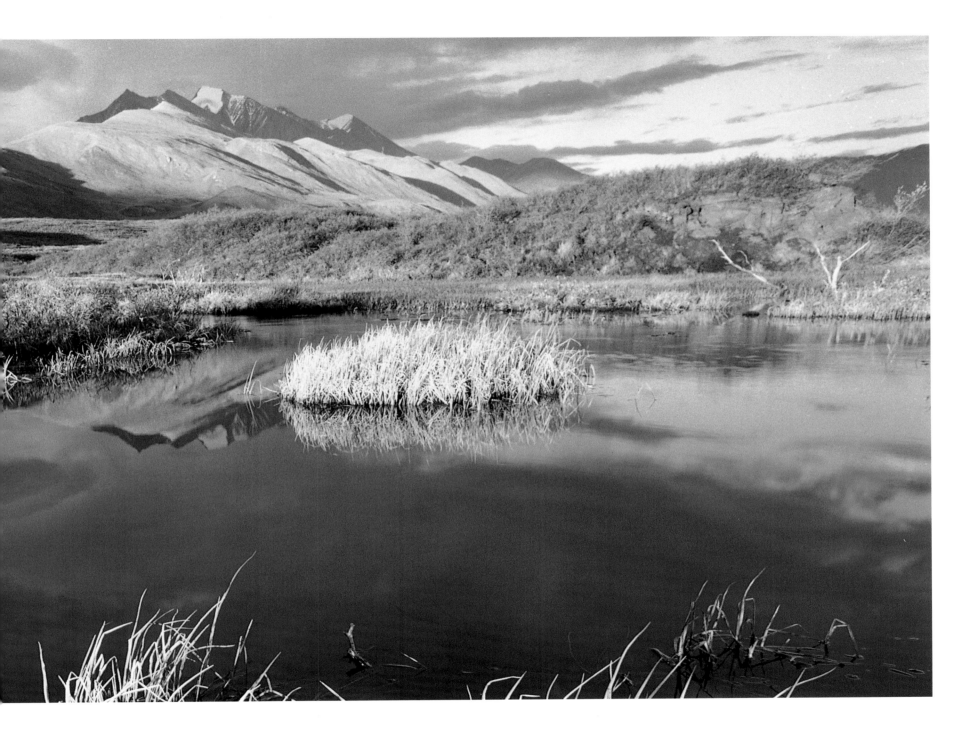

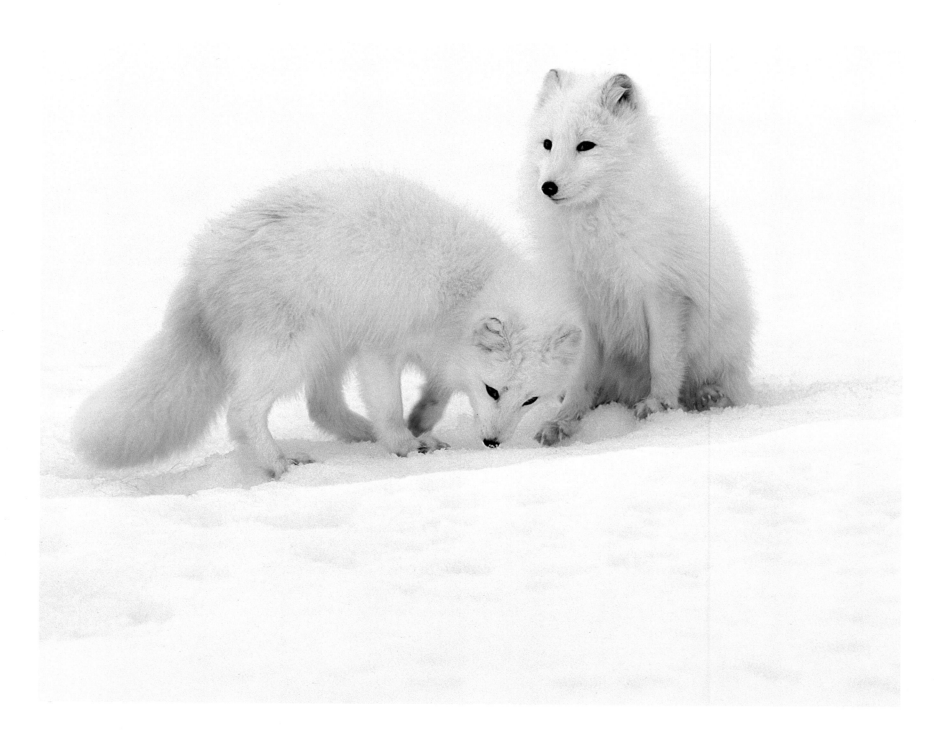

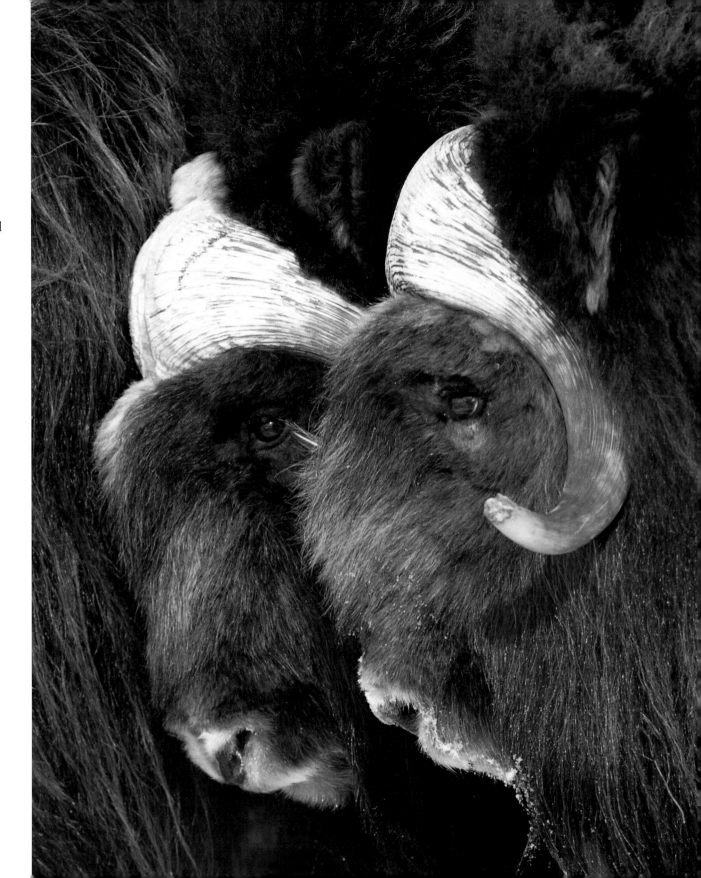

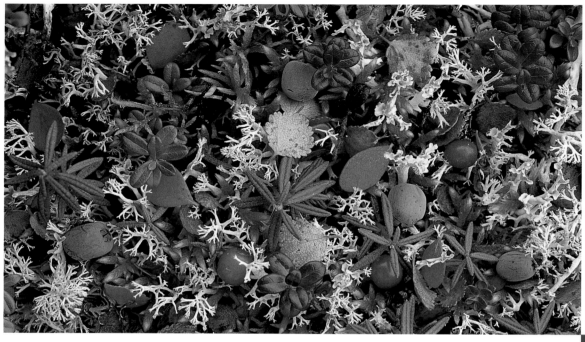

Above: Tundra foliage, Denali National Park and Preserve

Right: Arctic ground squirrel (*Spermophilus parryii*), Arctic National Wildlife Refuge

Far Right: Gray wolf (*Canis lupus*), Denali National Park and Preserve

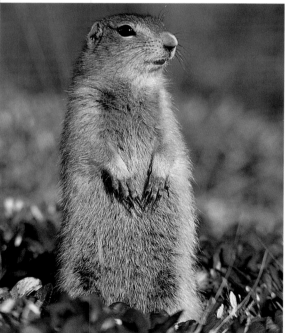

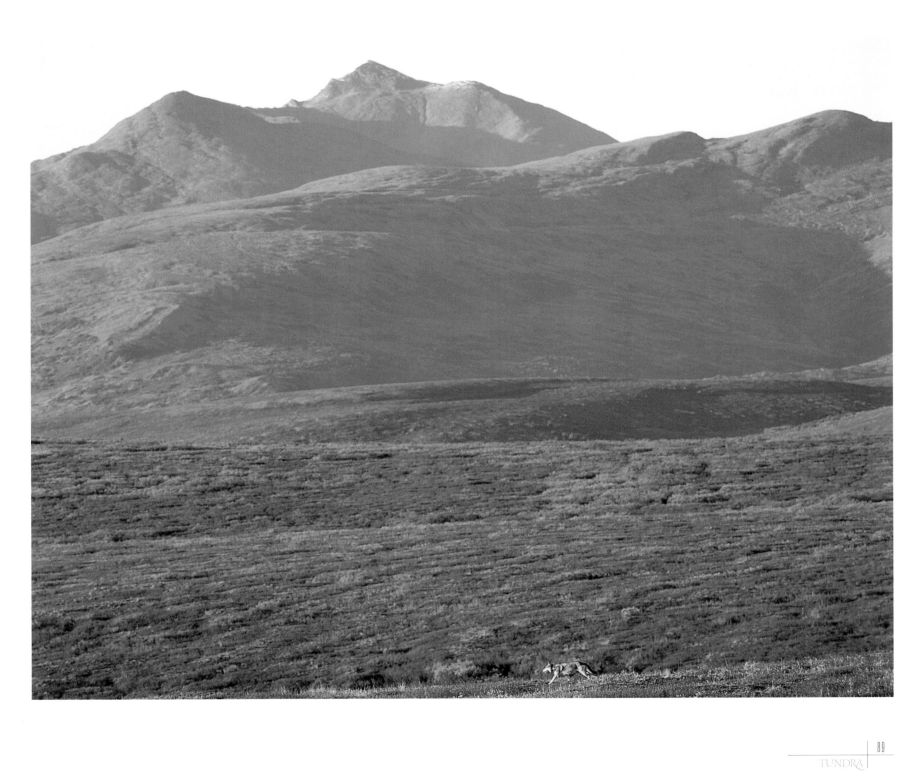

TUNDRA

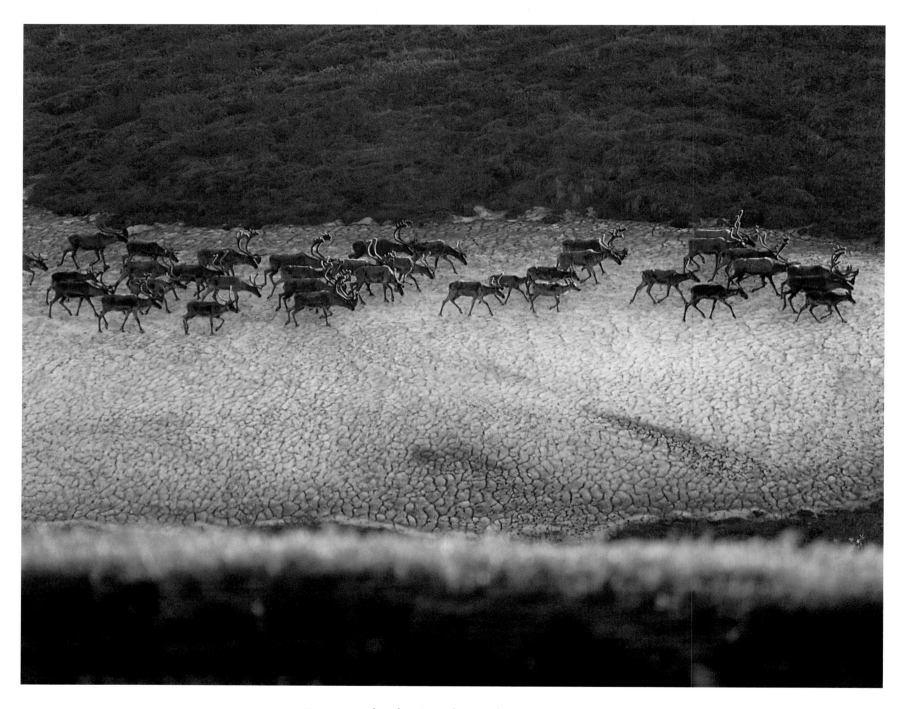

Barren ground caribou (*Rangifer tarrandus granti*), Canning River

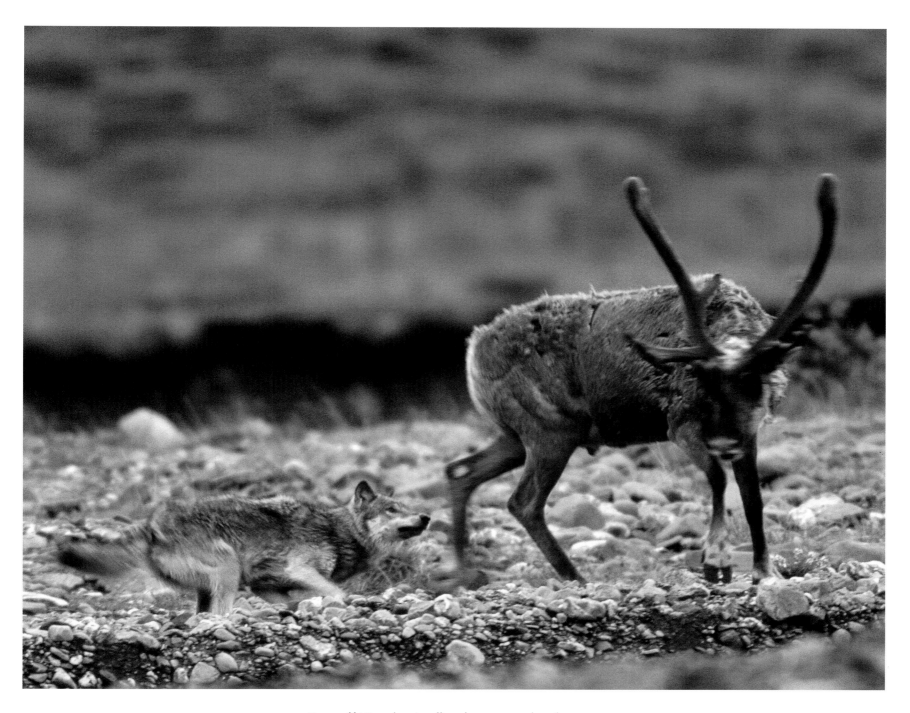

Gray wolf (*Canis lupus*) stalking barren ground caribou
(*Rangifer tarrandus granti*), Denali National Park and Preserve

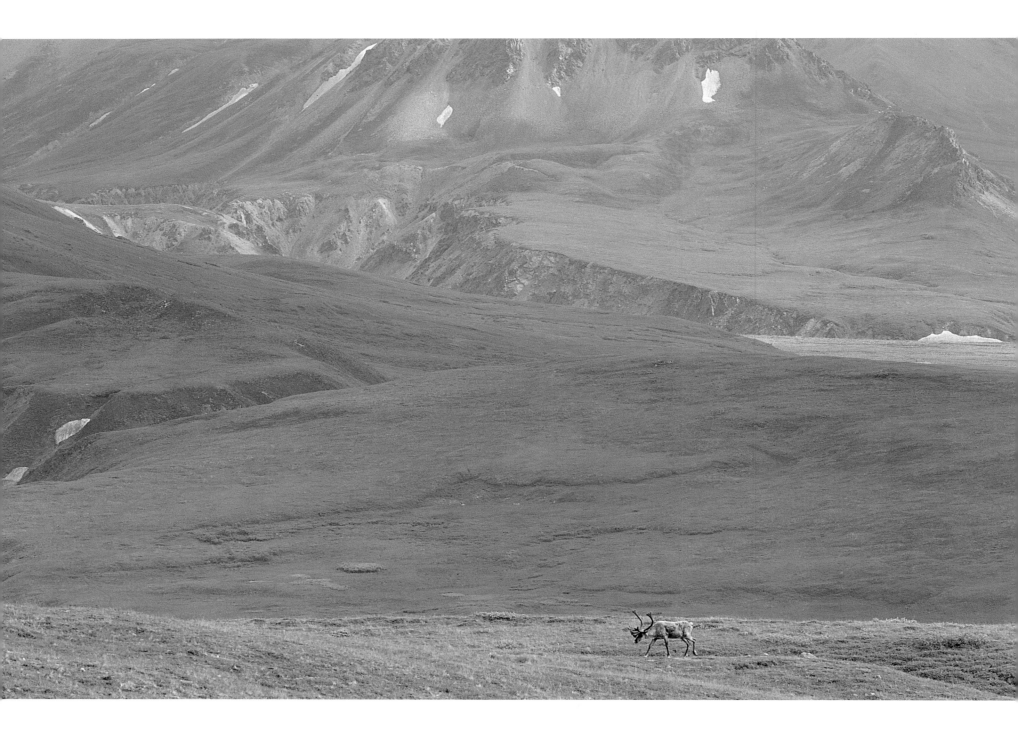

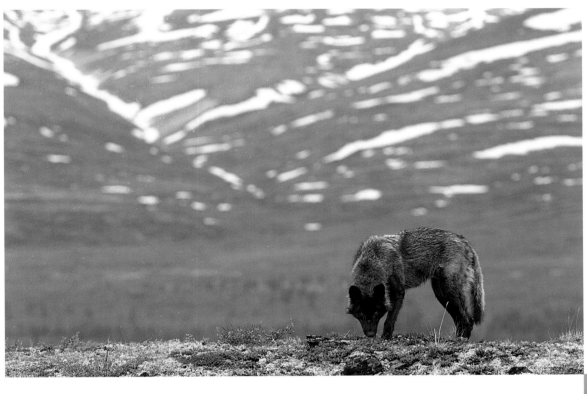

Left: Barren ground caribou (*Rangifer tarrandus granti*), Denali National Park and Preserve

Above: Gray wolf (*Canis lupus*), Alaska Range

Right: Blue fox (*Alopex lagogus*) kit, Saint George Island, Pribilof Islands

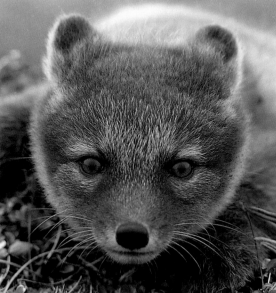

SEA & COAST

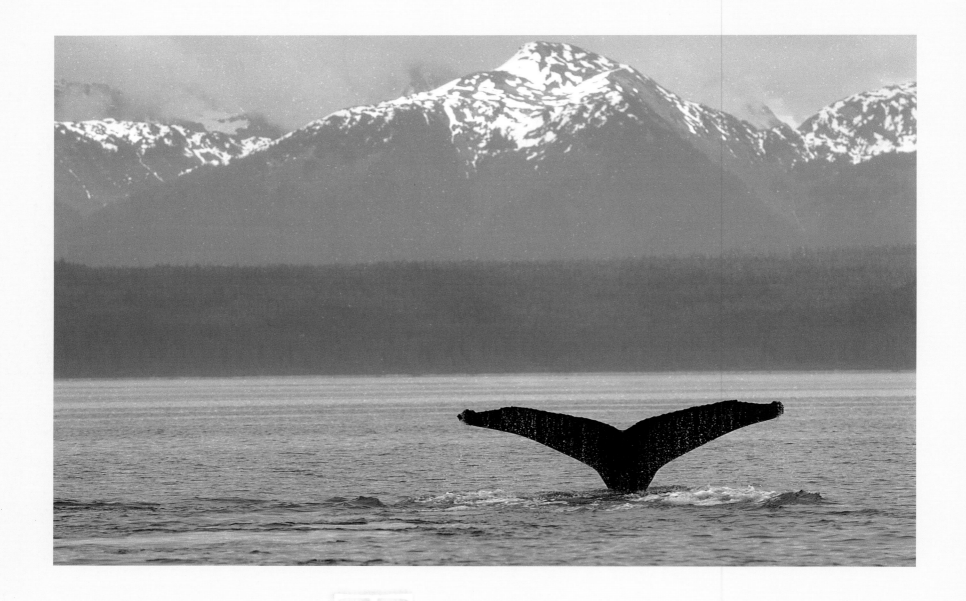

The hardest thing to understand about Alaska may be its size. I've lived here twenty years, and done my share of traveling—from Prudhoe Bay to the Alaska Peninsula, Fairbanks to Prince William Sound, the Brooks Range to Wrangell Island. I've boated,

driven, flown, walked, and snowmobiled tens of thousands of miles; studied maps and charts; read and reread stacks of books. And I still don't get this dimensional business. I try to act like I do, but intellectual grasp and genuine understanding are two separate issues. Explaining the scale of things, I end up falling back on the same stale geographic facts the tour guides are so fond of.

You know. Alaska is eighteen times the size of Iowa, twice the size of Texas. Fourteen hundred miles north to south. If all the caribou in the state were lined up head to butt, they'd reach from Kuwait to Buenos Aires. Or some similar gee-whiz nonsense. It's all a way of attempting to whittle things down somehow, and it just doesn't work.

But here's one figure that hit home, somehow pushed me a little closer to getting a handle on the near-infinite space that is Alaska: The state has 33,900 miles of oceanic coastline. Thirty-three thousand, nine hundred miles. In other words, enough to circle the earth at the equator, plus a third of a lap more. When I think of it that way, some miniature train of realization chugs through my cerebral cortex: Now that's big.

No matter where you are in Alaska, if you're traveling toward any point of the compass except east, you're headed directly toward an ocean, either the North Pacific or the Arctic. The whole state is, in fact, one enormous peninsula carved into hundreds of undulating coastal features: smaller—and still huge— peninsulas, capes, sounds, spits, arms, points, deltas, inlets, and bays. The dividing line between oceans is exact: the Bering Strait, the ribbon of current-ripped icy water separating the jutting nose of Alaska (the Seward Peninsula) from the Siberian mainland. North of that demarcation lies the Arctic Ocean; to the south, the Pacific. Within that gigantic stretch of space, there's all the variety one might expect: mountain-rimmed glacial fjords, wave-pounded beaches, silt-laden estuaries, exquisite tidal pools, and grinding pack ice.

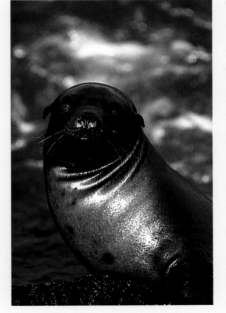

Overleaf: Iceberg, Prince William Sound

Left: Humpback whale (*Megaptera novaeangliae*), Point Adolphus

Right: Steller sea lion (*Eumetopias jubatus*), Point Adolphus

Alaska owes much of its life to the sea. Without those vast weather fronts rolling in off the North Pacific, without the warm onshore currents that warm much of Southeast, there would be no coastal rainforest. No glaciers with their nutrient-rich outwash. Fewer salmon, and, so, far fewer bears and eagles. A colder, drier, and much more silent place.

As it is, Alaska's shores roil with a volume of life that overloads the imagination. Perhaps Amazon mangrove swamps or South Pacific coral reefs harbor more species; but there's nothing there to match the majestic bulk of humpback whales that migrate here each summer to feast on great clouds of herring and shrimp-like krill. Nothing like the bears—black, polar, and brown—that patrol the edge of land and sea, growing huge on the bounty of both. Pods of feeding orcas and porpoises. Ice floes packed with walrus. Seals and sea lions. Otters. Millions upon millions of birds—murres, auklets, gulls, and puffins—who gather on rocky cliffs to breed, depending on the sea to nourish their young.

Consider the astonishing hordes of salmon. Each spring through autumn, all along the coast from the southeast panhandle to the Arctic, they swirl in schools that darken the water, catapulting into the air as if forced upward by sheer weight of numbers. There are five species in all, dozens of distinct populations pulled by a force stronger than gravity, all seeking the streams or lakes of their birth, the same places where their lives will end.

Salmon are to the water what the caribou are to the land: the great lifegivers around whose deaths so many other lives are formed. They are, too, perhaps the strongest link between land and sea, a manifestation of the two melded into one. Without the sea, salmon can't grow; without fresh water, they can't reproduce. No doubt their singular life cycle is an adaptation to the glacial world in whose shadow they evolved. Once purely freshwater fish living in cold, sterile streams, some wandered or were swept out to sea, where they found relatively warmer water and food in abundance. But their breeding cycle,

Left: Tufted puffin (*Fratercula cirrhata*), Pribilof Islands

the survival of their young, remained tied to the land. It's no coincidence that, while salmon are found along Alaska's entire coast, the largest runs are still associated with glacier-fed rivers.

Even on the moon of some distant world, it's difficult to imagine a landscape more imposing and surreal than the glacial fjord country of southern Alaska, with its blue-white rivers of ancient ice pouring into the sea, framed by the ragged heave of mountains two miles high. Centuries-old Sitka spruce, cedar, and hemlock shoulder down to the tidal zone, which is just the continuation of the mountains, sloping off into abyssal depths.

Beneath the surface, flooded glacial valleys lie, relics of a time when the land was colder, the worldwide sea level seven hundred feet lower. It wasn't so long ago—ten millennia at most—that all those billions of gallons of water were heaped above sea level in sheets of ice, and the coastline we know was a different shape entirely.

Against these slopes great tidal currents pour, funneled by the gaps between drowned mountain peaks, each ebb and flow like the pulse of some massive heart. Squadrons of humpback whales gorge within a stone's toss from shore, trapping masses of baitfish in choreographed

bursts of exhaled breath as they lunge together headfirst through the surface. Steller sea lions haul out to warm on channel buoys, while bald eagles wheel overhead. Dozens of fathoms below, schools of Pacific cod and gigantic halibut—fish over two hundred pounds are common—scour the tips of sunken sea mounts. And tight against the bouldered, sloping shore, forests of giant kelp sway in the current. Throughout the water column, billions of smaller creatures and plants thrive. All these living things move and breathe within the cold, unceasing rhythm of tides.

Glacier Bay, sixty-five miles long, inlaid with thirteen active tidewater glaciers and dozens of smaller hanging glaciers, is arguably the world's most spectacular fjord system. Johns Hopkins Inlet alone holds no fewer than nine glaciers in a mere ten miles. These bodies of ice seem to have their own tidal pulse; while many here and across Alaska are in rapid retreat, others—including the Johns Hopkins glacier—are actively thickening and advancing. Typical daily flow is measured in inches; surging glaciers may travel over a thousand feet in a single day, sliding on a warm layer of water resulting from volcanic activity, or skidding over a smooth patch of bedrock after being shaken

loose by an earthquake. Wherever glaciers—advancing or retreating—meet the sea, huge shards of ice calve off, falling in wet roars.

Yakutat Bay, farther north on the Gulf of Alaska, also hosts massive tidewater glaciers, including the Malaspina, as large as Rhode Island. The coastal ice fields continue, dominating the landscape for nearly a thousand linear miles, from Petersburg in the southeastern panhandle as far north as Prince William Sound. Meanwhile, far to the northwest, around the Bering Strait, is another world: still Alaska, but otherwise distinct. While the coast is still formidable, the land is more austere—rolling tundra sweeps interspersed with shrubland and what biologists call gallery forest: narrow bands of trees hugging watercourses and well-drained slopes. The margins of life here are obviously thinner. But, though somewhat reduced compared to the southeast, the sea remains incredibly rich. The whales, fewer in number, are most commonly bowhead and gray, with occasional pods of orcas. Walrus, localized or absent farther south, become commonplace, and polar bears, true marine mammals who wander the pack ice, range north from here. Coastal rivers still host solid runs of salmon, as well as Dolly Varden char and sheefish (giant members of the whitefish clan).

At the far rim of Alaska, the north-facing Beaufort Sea coast, the country is true cold desert—treeless, flat, wind-scoured, frozen up to nine months a year. But still there are bowhead whales offshore, moving through leads in the summer ice. Bearded, harbor, and ringed seals all provide food for the polar bears, arctic fox, and Inupiat hunters, who for centuries have looked away from the land for survival. As if to echo the bond, most of that rich marine life holds within a few dozen miles of shore, seals and whales seeming to recall the hand-shaped bones upon which they once walked. And so it is along all of Alaska's great coastline. Life remembers its way home: here, the narrow space where the ocean meets the land.

Right: Humpback whale (*Megaptera novaeangliae*), Point Adolphus

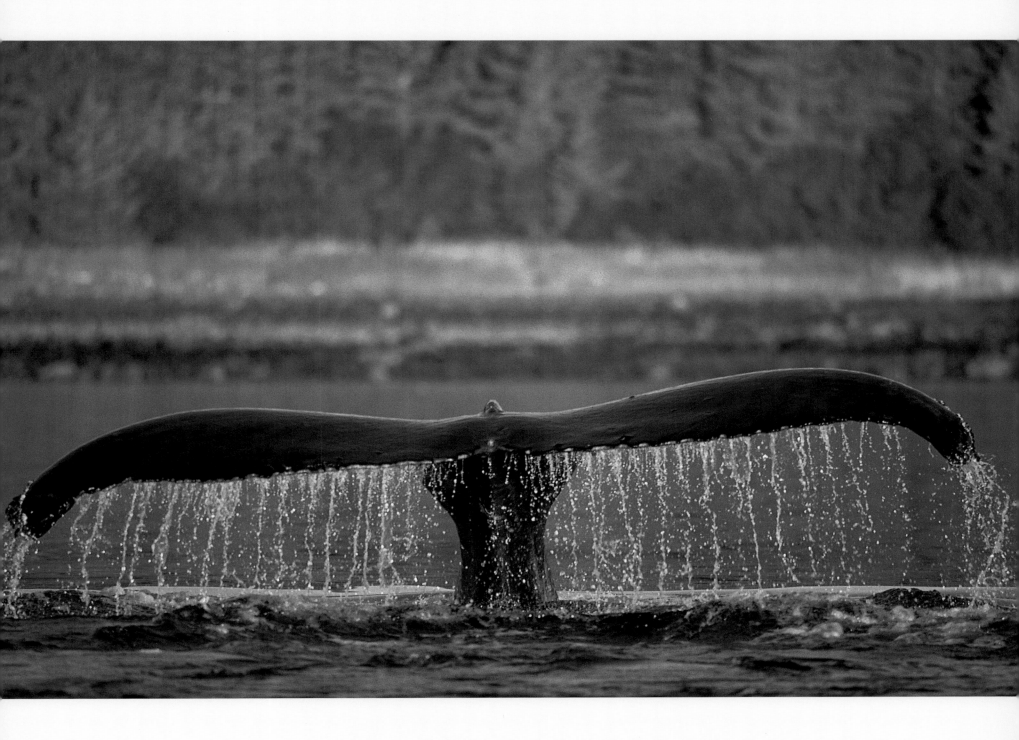

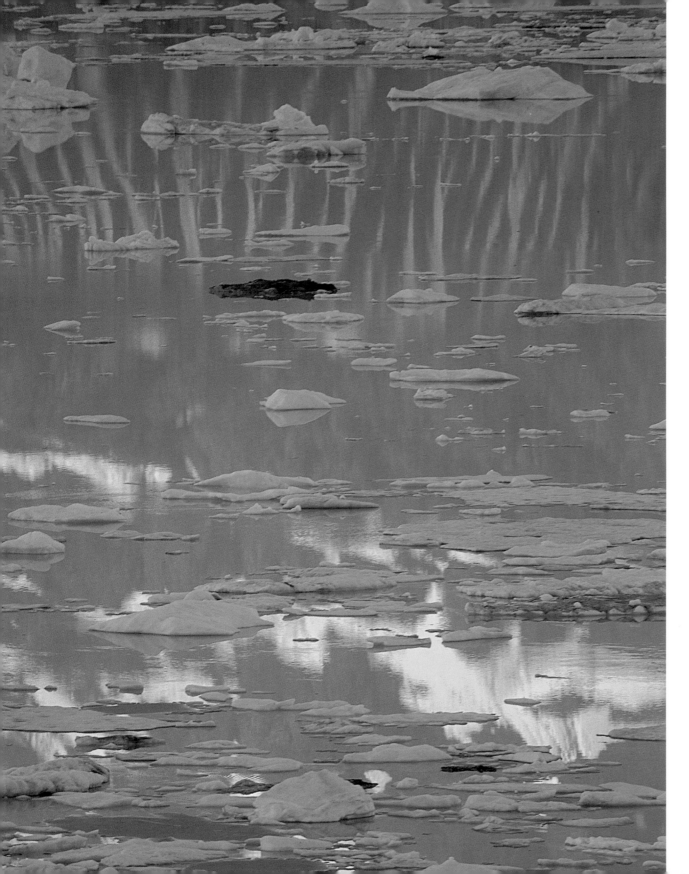

Left: Icebergs, Alsek River

Right: Alsek Glacier, Saint Elias Mountains

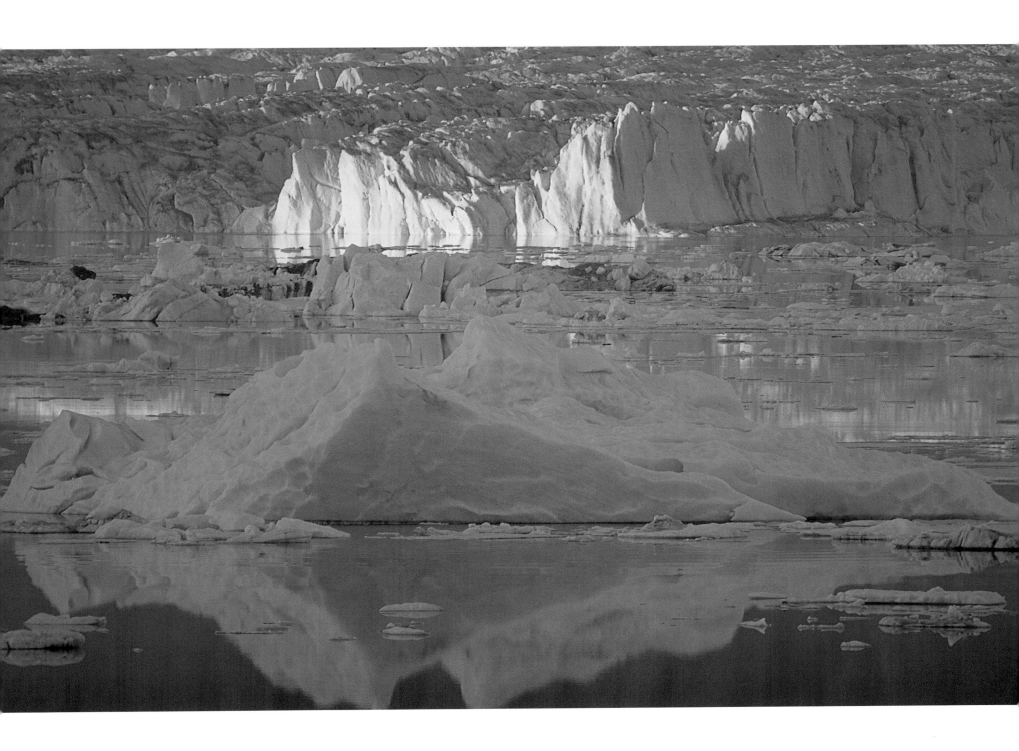

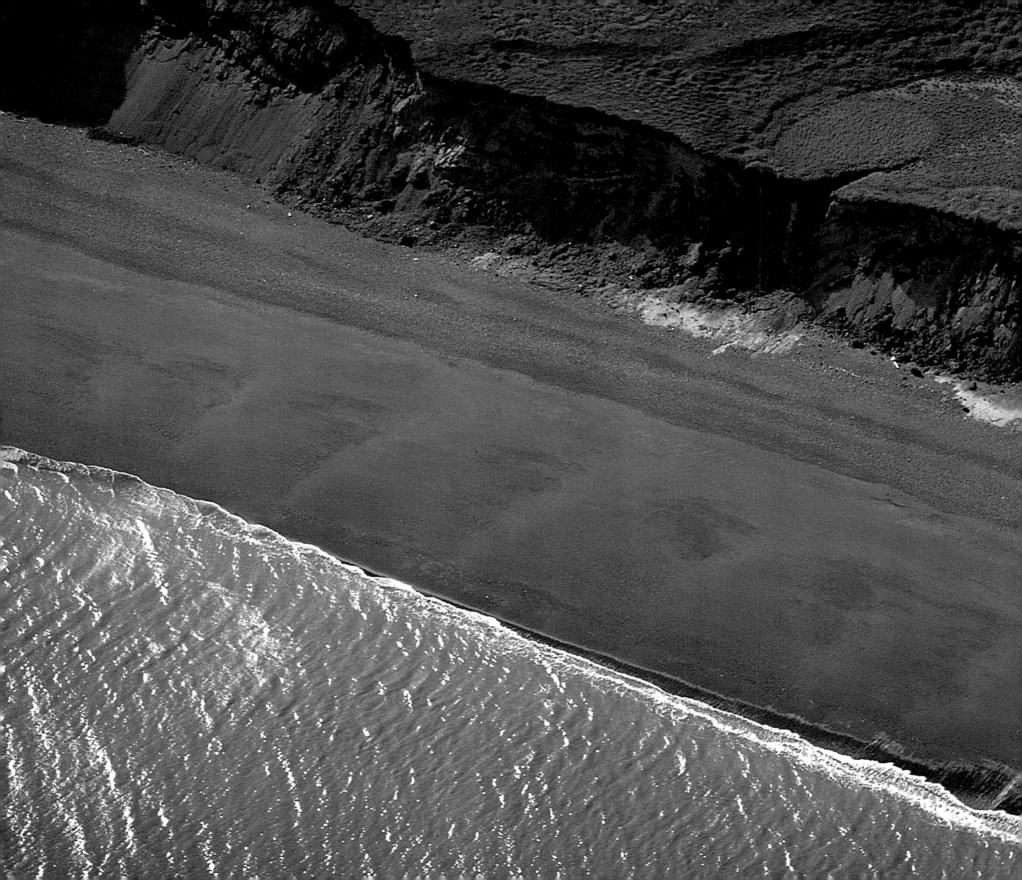

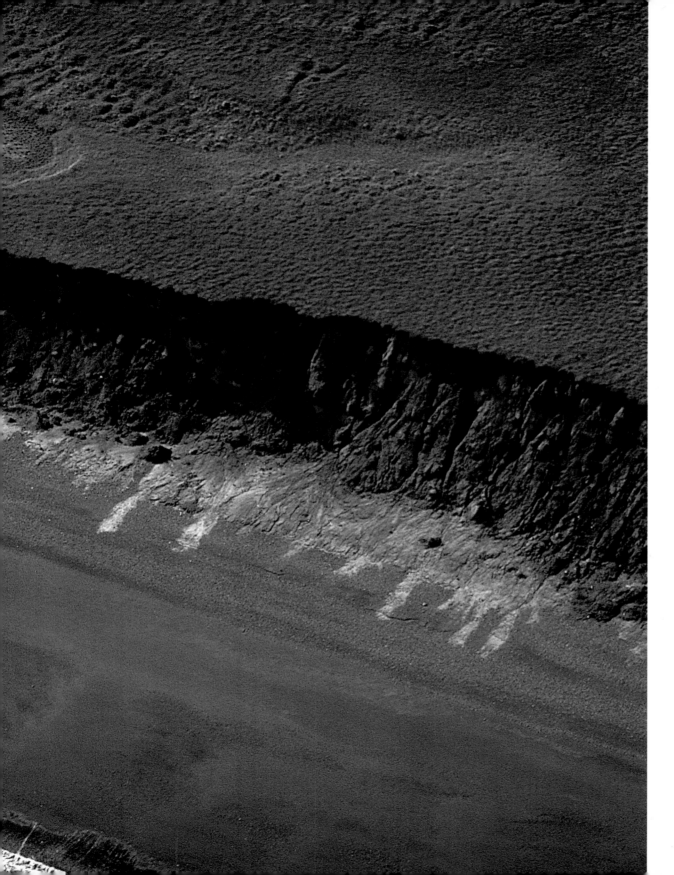

Aerial of shoreline, Togiak National Wildlife Refuge

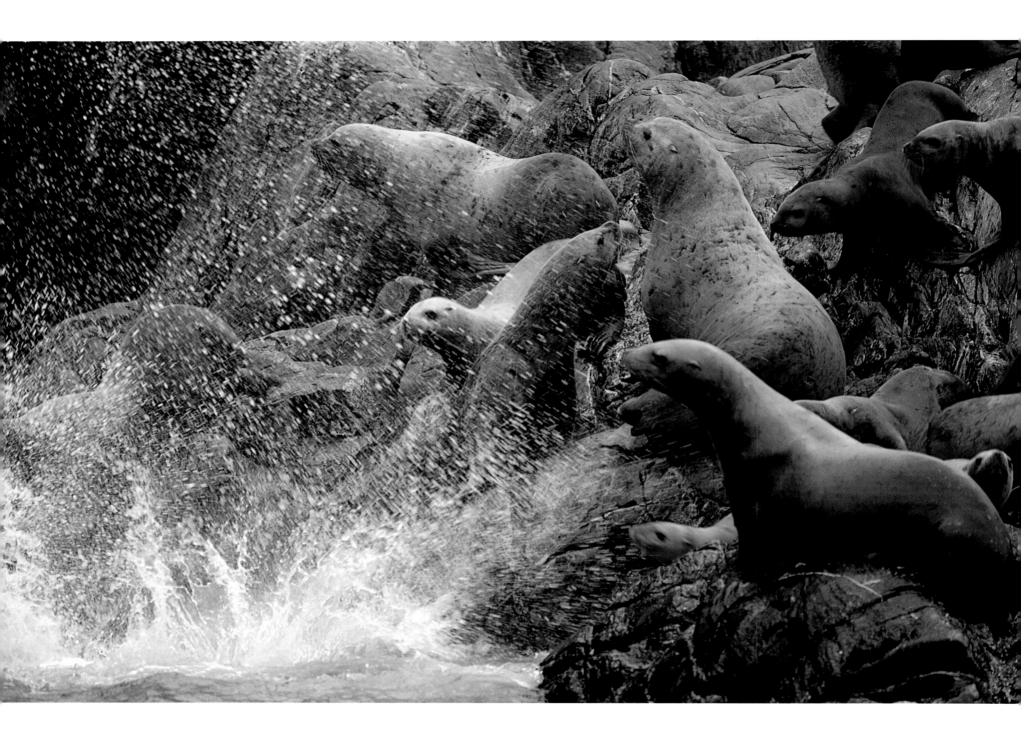

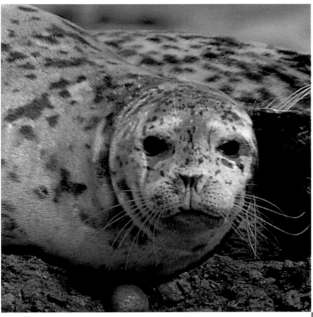

Far left and below: Steller sea lions (*Eumetopias jubatus*), Point Adolphus

Left: Harbor seal (*Phoca vitulina*), Kenai Fjords National Park

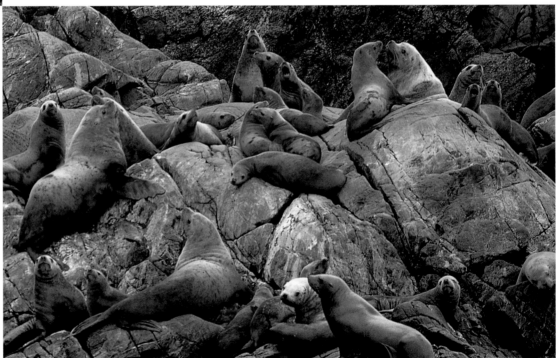

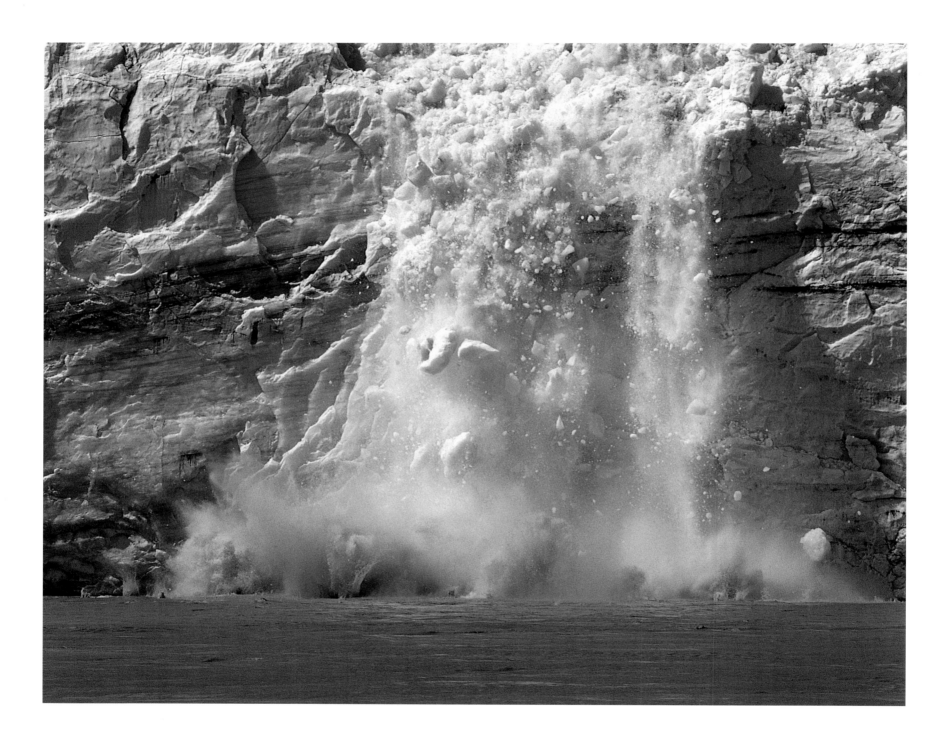

ALASKA

Left: Calving, Miles Glacier, Copper River

Right: Prince William Sound

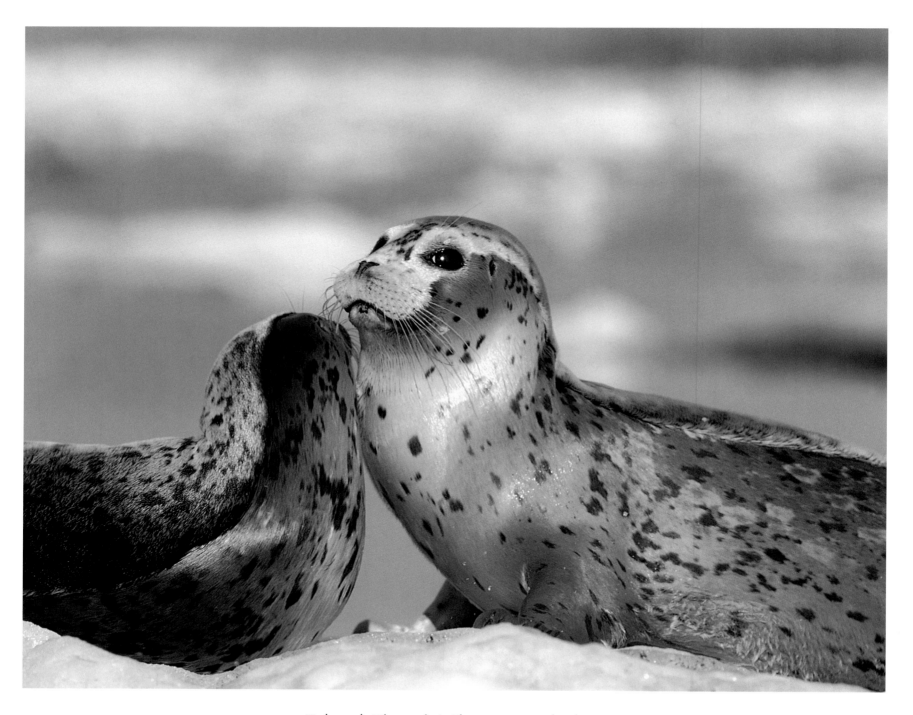

Harbor seals (*Phoca vitulina*), Glacier Bay National Park and Preserve

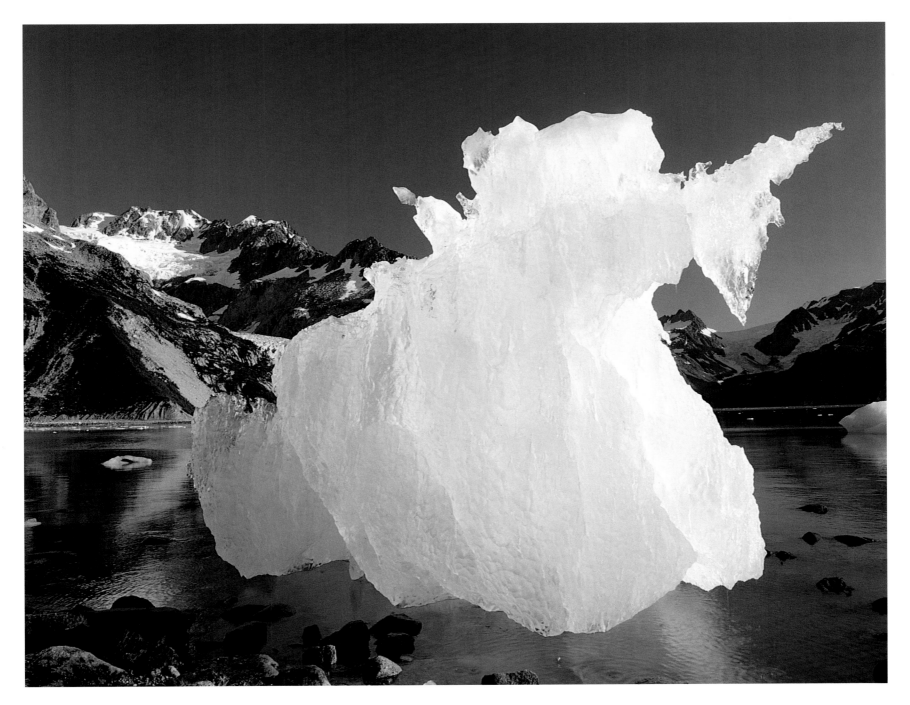

Iceberg, Kenai Fjords National Park

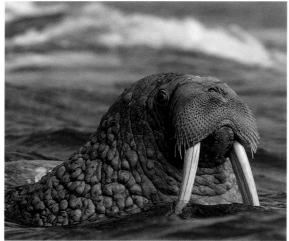

Left and below: Bull walrus (*Odobenus rosmarus*), Cape Pierce, Togiak National Wildlife Refuge

Right: Bull walrus (*Odobenus rosmarus*), Round Island

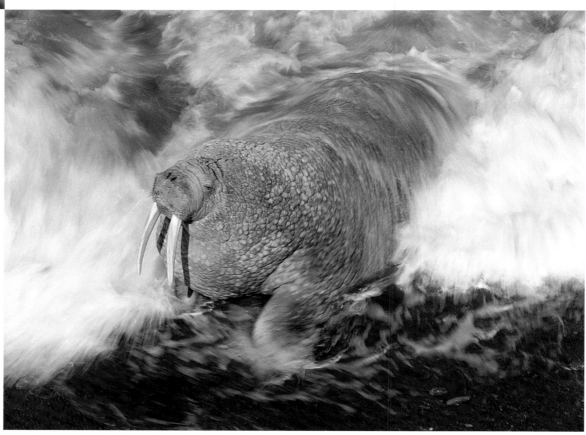

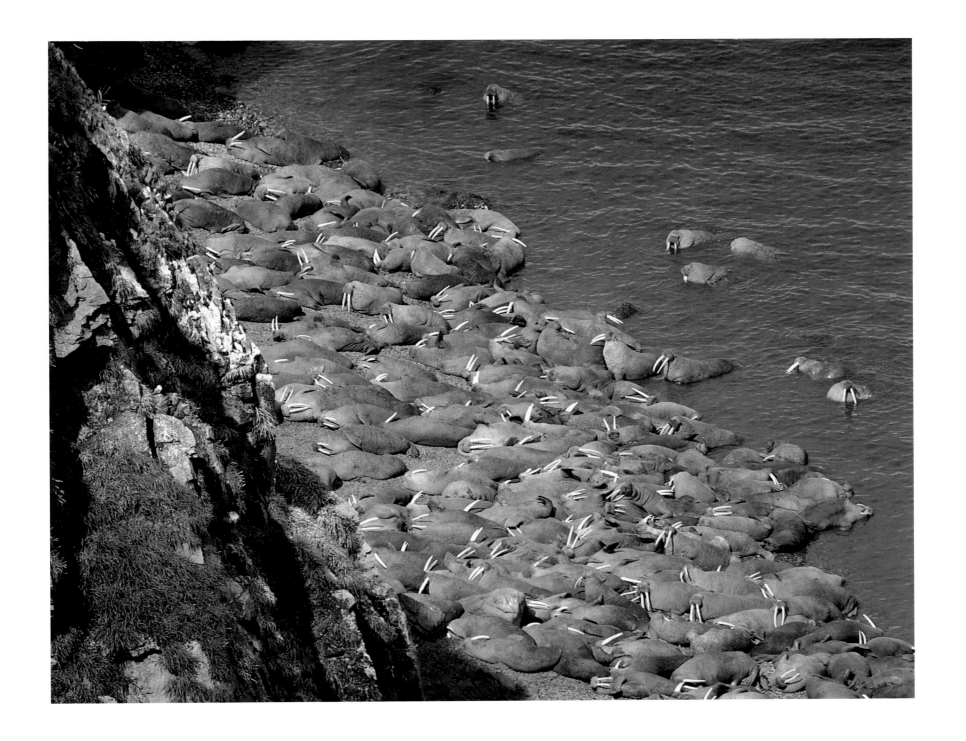

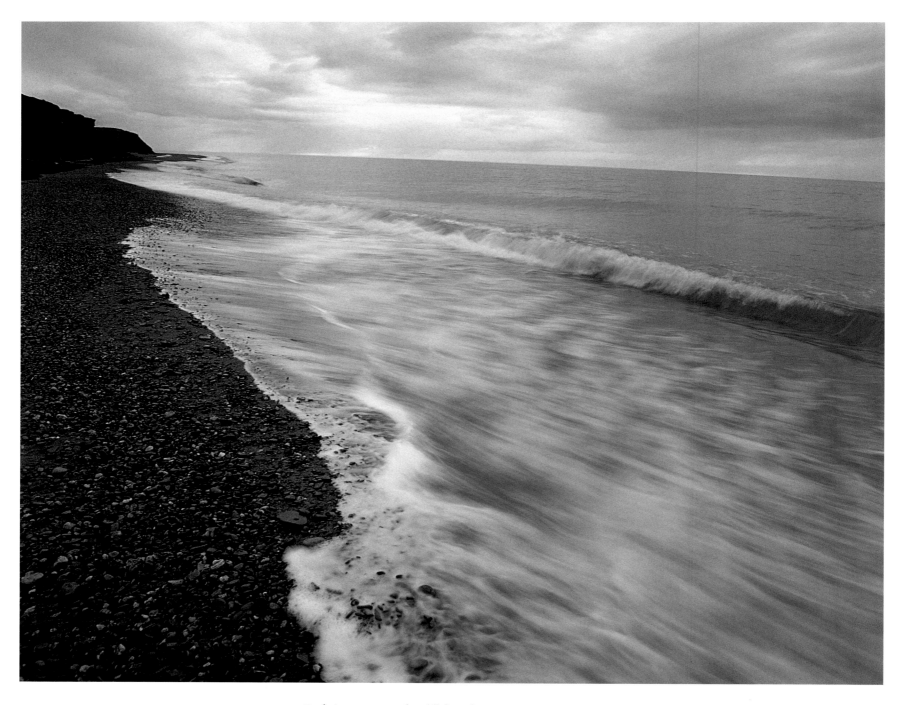

Surf, Arctic National Wildlife Refuge

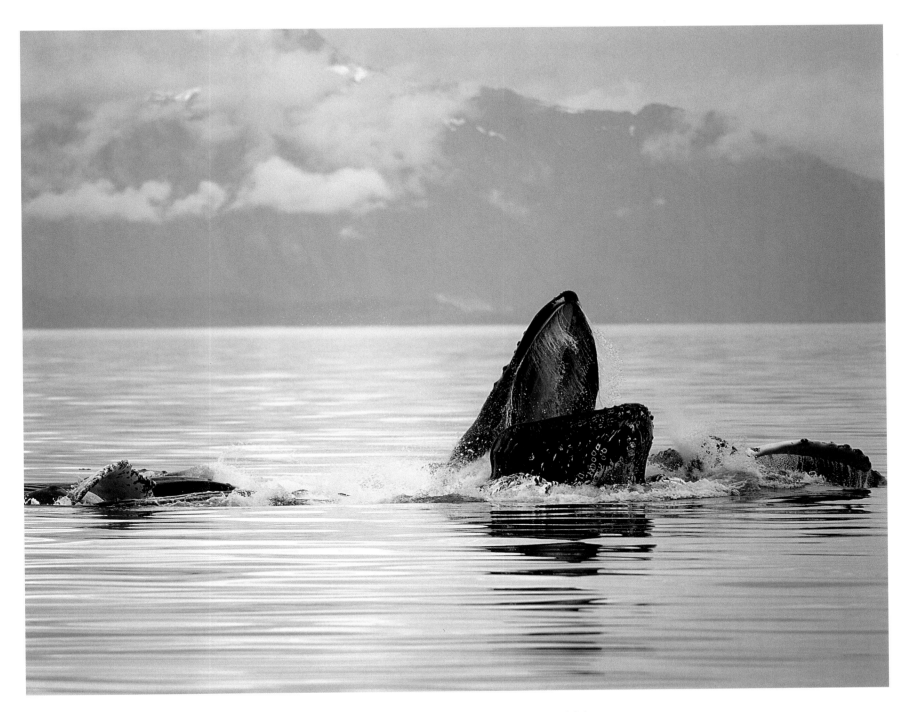

Humpback whales (*Megaptera novaeangliae*), Point Adolphus

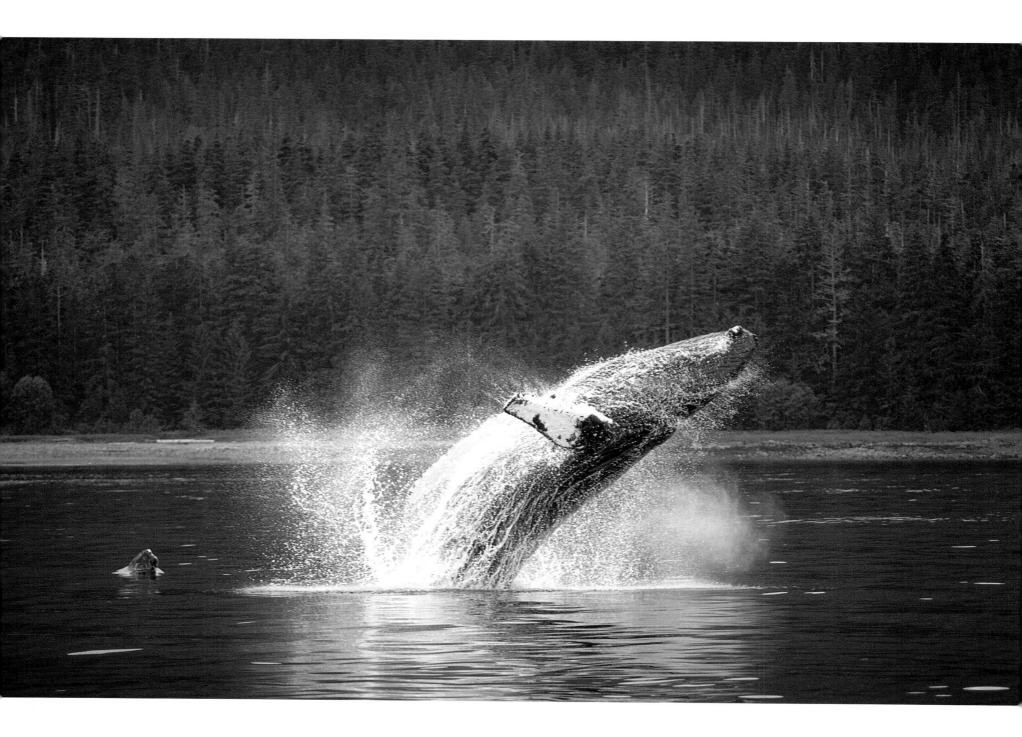

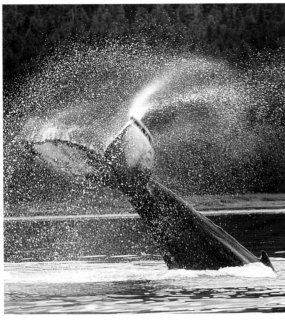

Far left and left: Humpback whale (*Megaptera novaeangliae*), Point Adolphus

Below: Orca (*Orcinus orca*), Prince William Sound

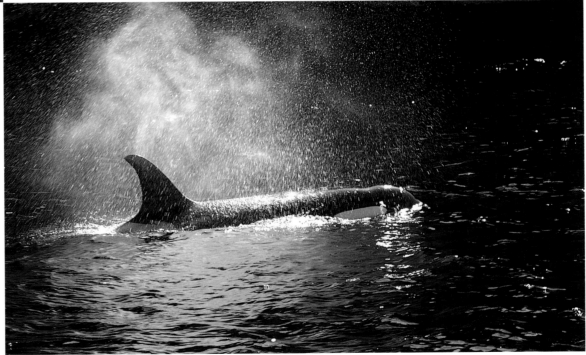

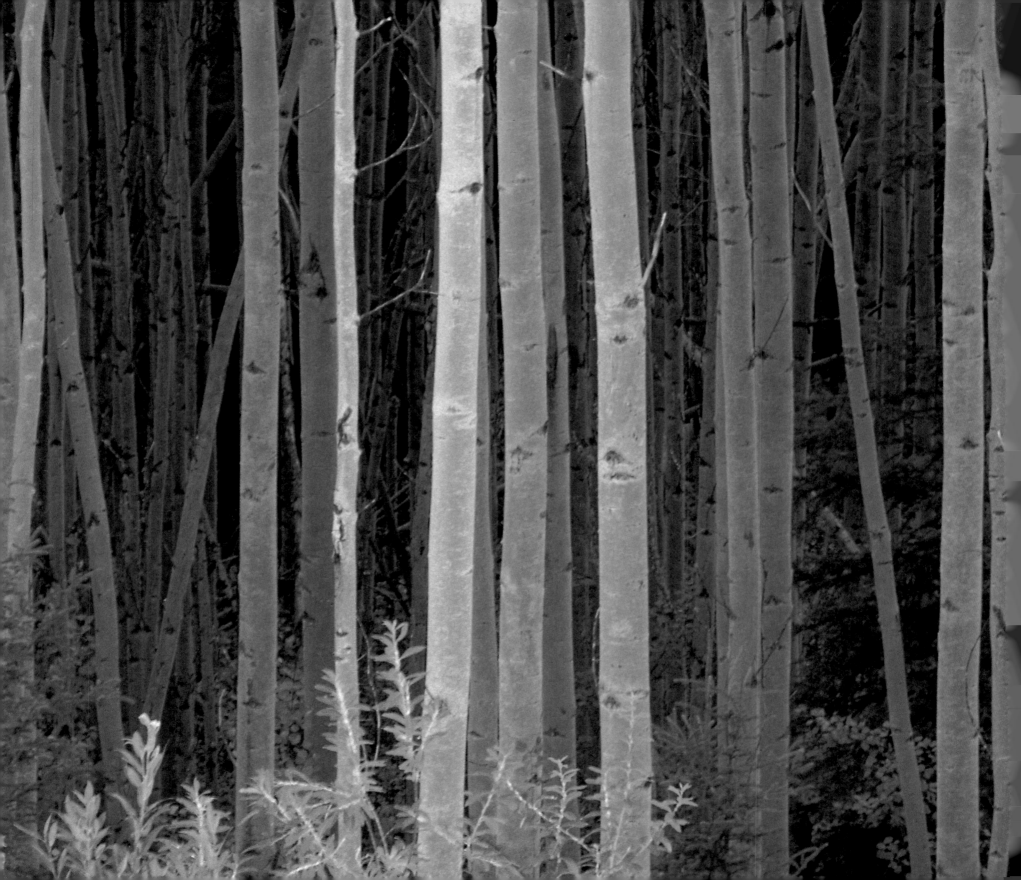

FOREST

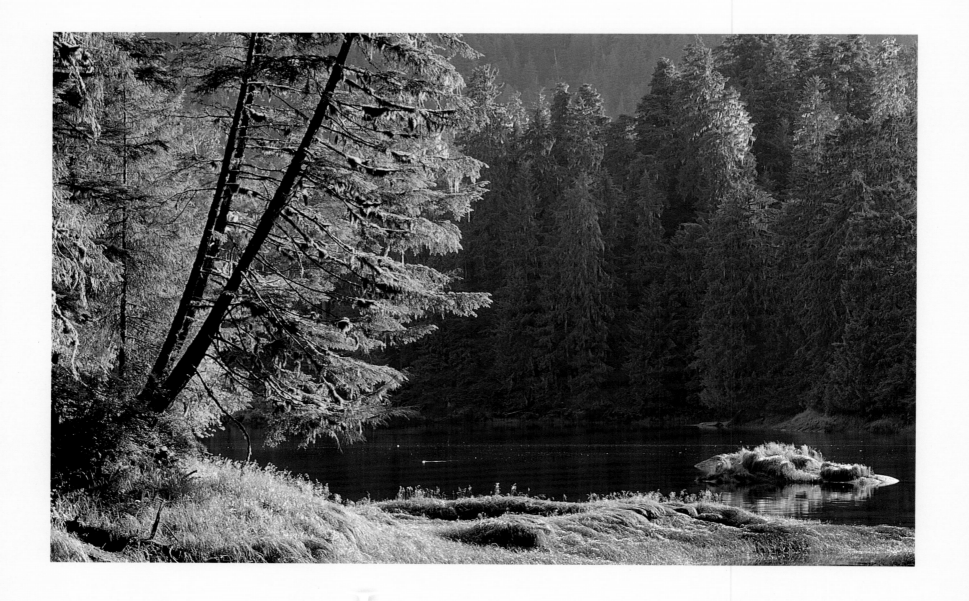

Inside the trees, the light itself becomes green, the air alive with the scent of growing things. Thick-bodied Sitka spruce and western hemlock thrust upward, their intertwined limbs bearded with moss, slicing sunlight into diffused, shifting prisms. In damp hollows,

bat-eared leaves of skunk cabbage cluster, some broader than a man's chest, luminous and improbable as anything in Rousseau's painted jungles. Wickedly thorned, bright-berried clumps of devil's club hem in narrow game paths, beaten to bare earth by centuries of passage: bear, deer, and man. And beneath it all runs a dripping, burbling undercurrent.

The air steams with water. It whispers through the soil. Without doubt, this is rainforest—part of the great belt of trees that spills down the southern coast of Alaska. Caught between moisture-laden waves of weather curling off the North Pacific and the abrupt, glacier-strewn crags of the Coast Range, some mist-shrouded valleys receive rain measured in hundreds of inches per year. The soil is thin and acidic, but the constant cycling of water drives a huge green engine, one of Earth's richest ecosystems. There are trees here that were huge when Shakespeare held his pen, and many are older than the nation that now claims them.

It's almost impossible to stand in this forest and not think of it as permanent, to imagine these giant living things away, see the landscape as something else entirely. And yet, within recent geologic memory, this forest didn't exist. Neither is it unique in that regard. Alaska's trees, from the thick stands in the southern rainforest to the last straggling white spruce in some far Brooks Range valley, are constantly on the march, flowing north and south over the land, sure as any caribou herd—though it's hardly as if they lift up their skirts and tiptoe around when our backs are turned. Their wanderings are often imperceptible, but this reflects more our own temporal limitations than anything else. Simply put, trees live one hell of a lot longer than we do. Their lives are outside our frame of reference. Still, trees and man have something in common, especially at the northern fringe of the planet. Though it's hard to imagine the landscape without either of our kind, we are fellow travelers, newcomers living in the shadow of recently receding glaciers, our fortunes tied to the inexorable movement of ice. Both of us inhabit only where it allows our existence.

Overleaf: Quaking aspen (*Populus tremuloides*), Tanana River Valley

Left: Tongass National Forest

Right: Bunchberry (*Cornus canadensis*), Tongass National Forest

From there, our destinies overlap, brush past, and become separate. The rhythm of trees becomes their own. They are, despite our protestations to the contrary, their own nation, quietly fighting their own wars, dealing with separate famines, disasters, and pestilence. Though at times that pestilence may include our own indiscriminate use and influence, by and large Alaska's forests are still driven by forces that existed long before our coming. At the closing of this millennium, about one-third of the state is forested. Twenty thousand years ago, this figure was far smaller. Some scientists who study fossil pollens argue that back then there were few, if any, trees at all. Certainly minor pockets at best: dwarf forms clinging to nunatak (mountain peaks rising above the great ice fields) or hugging streambeds in the dry, unglaciated valleys of the interior.

In nature, we often equate pristine with unchanging. But the natural world is constantly shifting, moving, and reinventing itself—sometimes by cataclysmic, apparently chaotic methods. And nowhere is that more apparent than in Alaska. The forces that move trees—or

allow them to move—are manifold and wide as the landscape. Glaciers. Wildfires. Earthquakes and volcanoes. Water. Perhaps the cycles of the sun itself, which may in the first place affect the coming and going of those first-mentioned glaciers, after which everything else follows. Concentric, overlapping spirals of cause and effect—what the poet Yeats called gyres—are surely at work.

One of the most memorable of recent large-scale shifts was the 1912 eruption of the volcano Novarupta, which obliterated an entire forest—forty square miles of white spruce, birch, and balsam poplar—at the base of the Alaska Peninsula. Dubbed the Valley of Ten Thousand Smokes, the area is buried under six hundred feet of volcanic ash, a landscape as strange as that of some distant planet. The ghosts of trees are still standing there, far beneath our feet. And though, after more than eighty years, the area is as barren a place as exists on earth, it's only a matter of time before the land becomes something else again. Tundra. Forest. The floor of a shallow sea.

Left: Steller's jay (*Cyanocitta stelleri*), Tongass National Forest

Right: Lichens and mosses, Tongass National Forest

Change is taking place also two hundred miles east, on the Kenai Peninsula. Tens of thousands of old-growth acres of spruce stand dead or failing, destroyed by a plague of bark beetles. A dry summer, a chance spark provided by a thunderstorm, and fire will explode across the land, setting off a new wave of succession. Accounts from a century ago describe an almost treeless landscape in this same area, hinting more of a perpetual cycle than some overwhelming disaster.

Beyond the openly destructive lies the constant pulse of water, a force that gives life as quickly as it takes it. Each of Alaska's rivers and streams is constantly shifting its course, undercutting trees along one bank while on the opposite side a growing sandbar becomes a nursery for plant life. Water-loving grasses and willow shrubs spring up first, then balsam poplar or black cottonwood, and finally (sometimes after a century or more) large conifers. Each species overtakes and shades out the previous one, creating a pattern as obvious as it is predictable.

When the river or stream shifts course, maybe due to an ice jam at breakup or a sudden summer flood, mature trees on one bank are toppled into the current and swept away, often to lodge on a gravel bar downstream, where they catch silt and create a haven for seedlings, which in turn build more ground, attract more trees, and deflect the river's path once more. The process is constant and dynamic, so interconnected it's impossible to find the seam between creation and destruction.

We tend to see trees—rooted in one spot, dependent on outside forces for seed movement, unable to lift a branch in self-defense—as passive victims of their environment. Perhaps the most remarkable Alaska forest cycle of all is one initiated and seemingly controlled by the trees themselves. A climax white spruce forest shades out the shrubs and broadleaf species that precede it; after a century or two the ground becomes so shaded that permafrost creeps upward, cooling the surface soil and squelching seedlings. Colder, boggier ground conditions

develop, which lead to the rise of mossy-floored black spruce woodlands. The carpet of mosses and lichens insulate the soil, bringing the permafrost layer still higher. Eventually the black spruce, too, may fade out, to be replaced by boggy tundra. Ironically, or perhaps by plan, each species's success is part of its own inevitable decline.

But things seldom progress this far. In the game of succession, the wild card is fire. Set off by lightning strikes in dry summer conditions, natural fires consume millions of acres of Alaska each year: tundra, broadleaf, or climax spruce. Only the coastal rainforests, perennially soaked, are immune. In particularly dry years, smoke dims the sun for weeks at a time. When I think of the state's interior forests, I find it difficult not to visualize areas of burn as part of the landscape. The frequency of natural wildfire is borne out by the fact it's almost impossible to find a black spruce forest older than two hundred years, though certainly the species can live to twice that age.

Once again, death circles back into life; fire is less destruction than a reshuffling of the deck. Black spruce cones, in fact, depend on fire to open them. The ash-enriched soil provides bedding; competing shrubs have been stripped away,

allowing the seedlings a chance to grow. The forest returns, nourished in part by the slowly decaying and falling snags left by the fire.

Within these overlapping waves of change, Alaska's trees stand silent, immobile, and stoic as any living things can be. If only we could slow ourselves down, we might glimpse, if not comprehend, the true nature of their lives: certain, purposeful, and, in at least some genetic sense, intelligent as any life form. If someone offered me the chance to live for several hundred years, have a few thousand children, and bend when the wind blows, I just might take him up on it.

Right: Fog bow, Alaska Range, Denali National Park and Preserve

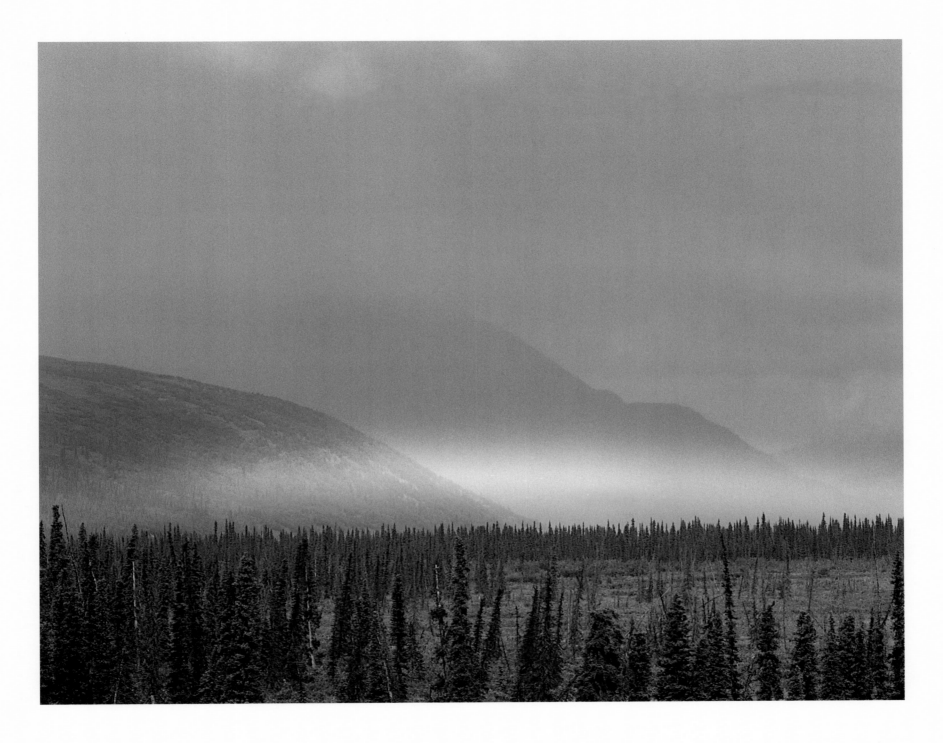

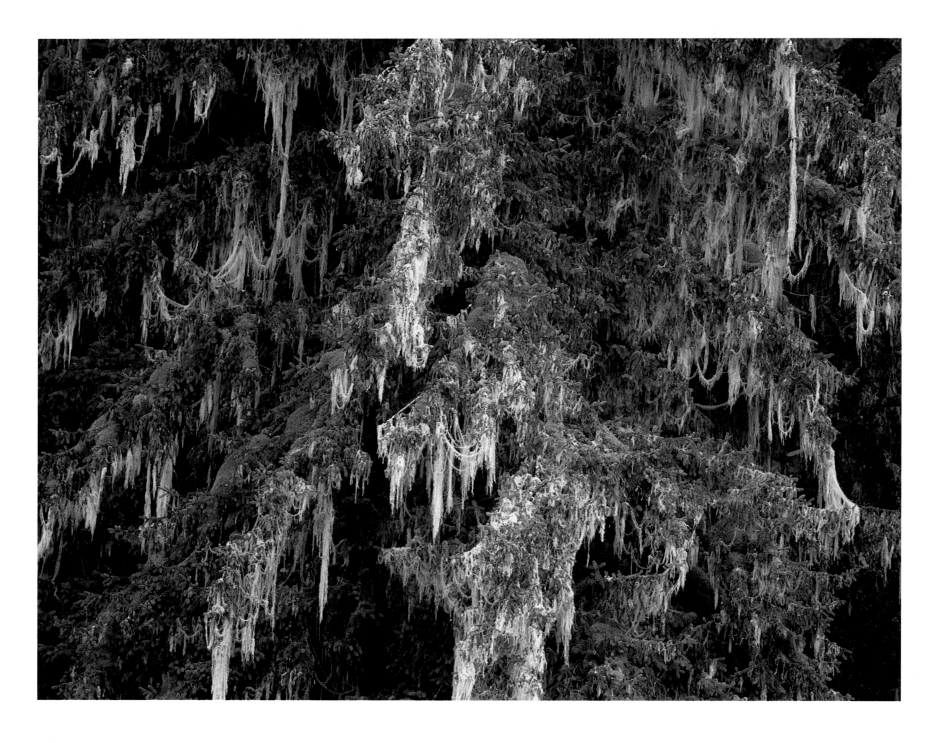

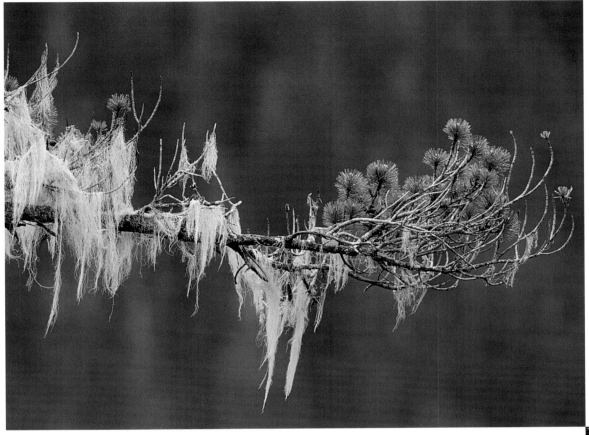

Far left and left: Lichens, Tongass National Forest

Below: Willow (*Salix* sp.), Tongass National Forest

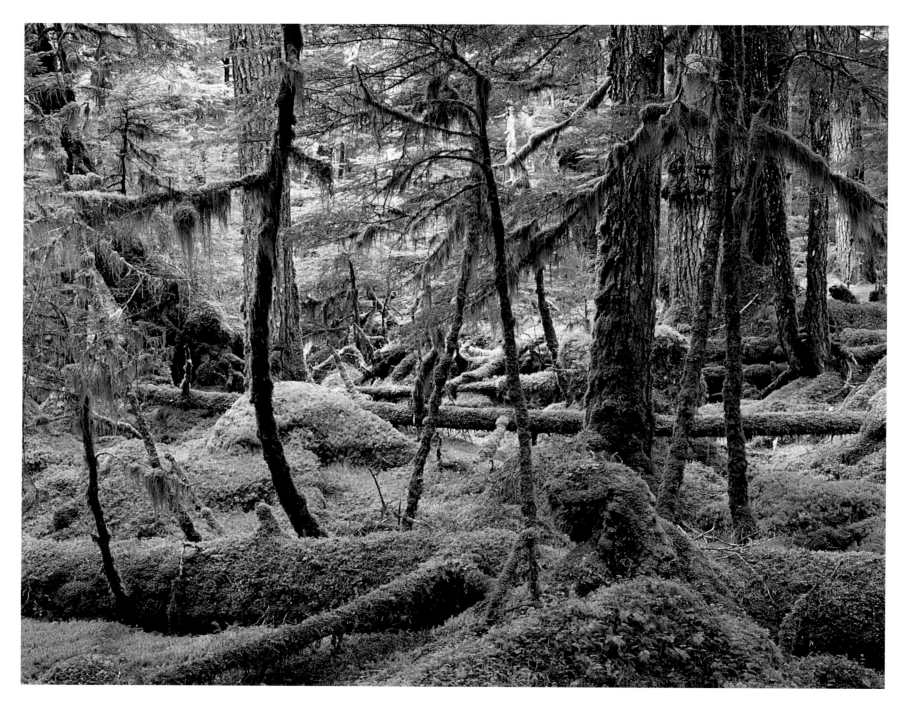

Rainforest, The Brothers Islands, Southeast Alaska

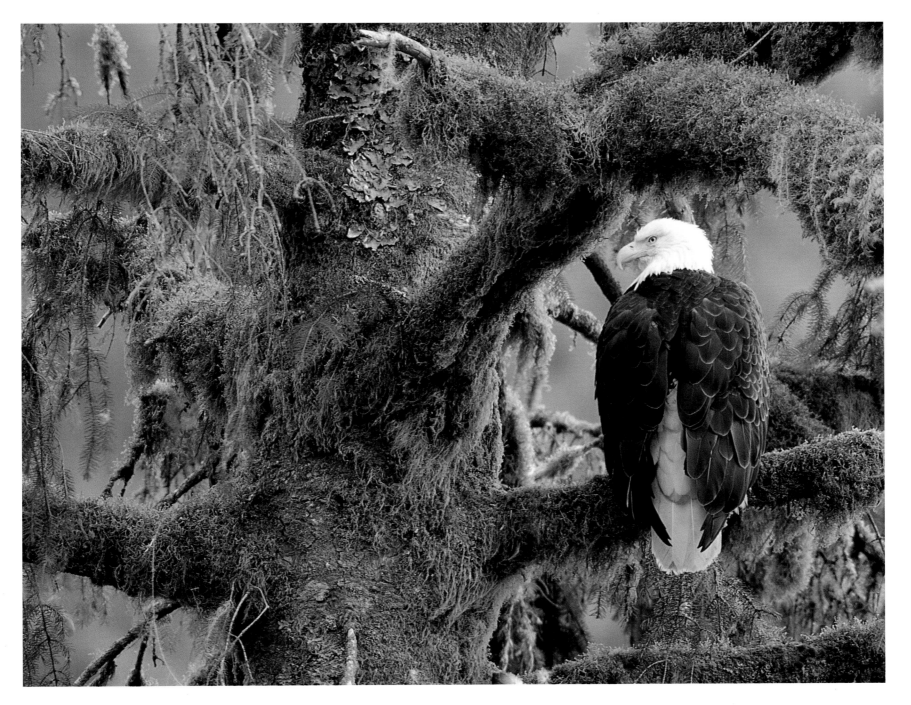

Bald eagle (*Haliaeetus leucocephalus*), Tongass National Forest

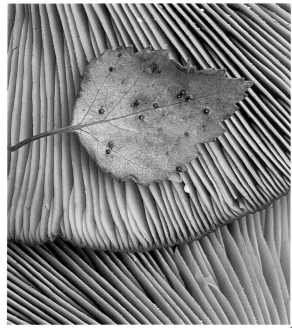

Left: Paper birch (*Betula papyrifera*) leaf, on mushroom gills, Alaska Peninsula

Below: Moose (*Alces alces*) calves, Wonder Lake, Denali National Park and Preserve

Far right: Bull moose (*Alces alces*), Denali National Park and Preserve

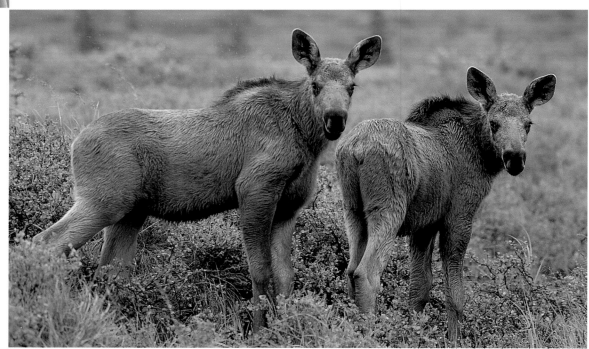

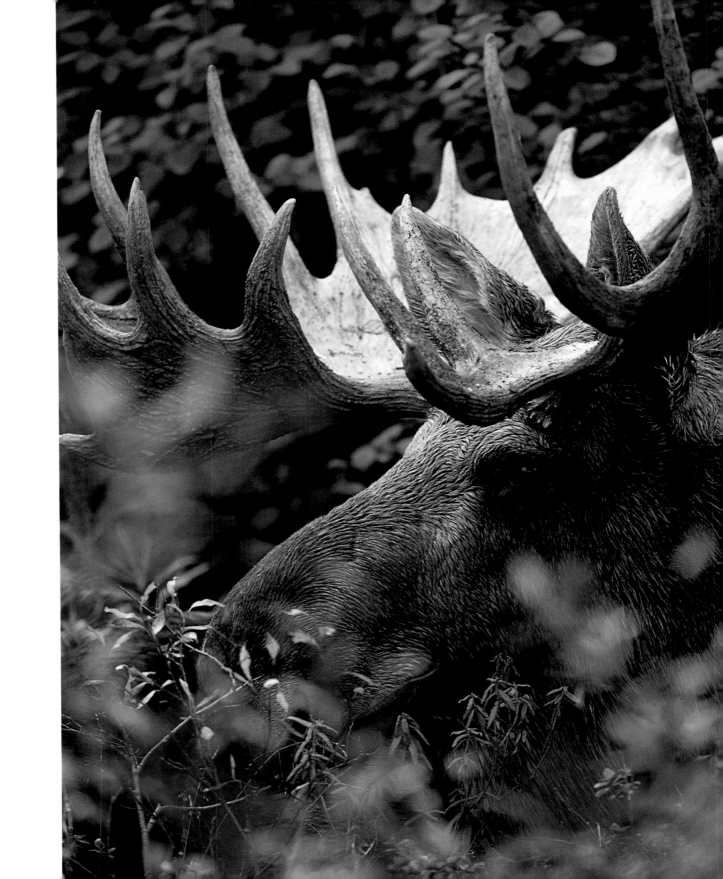

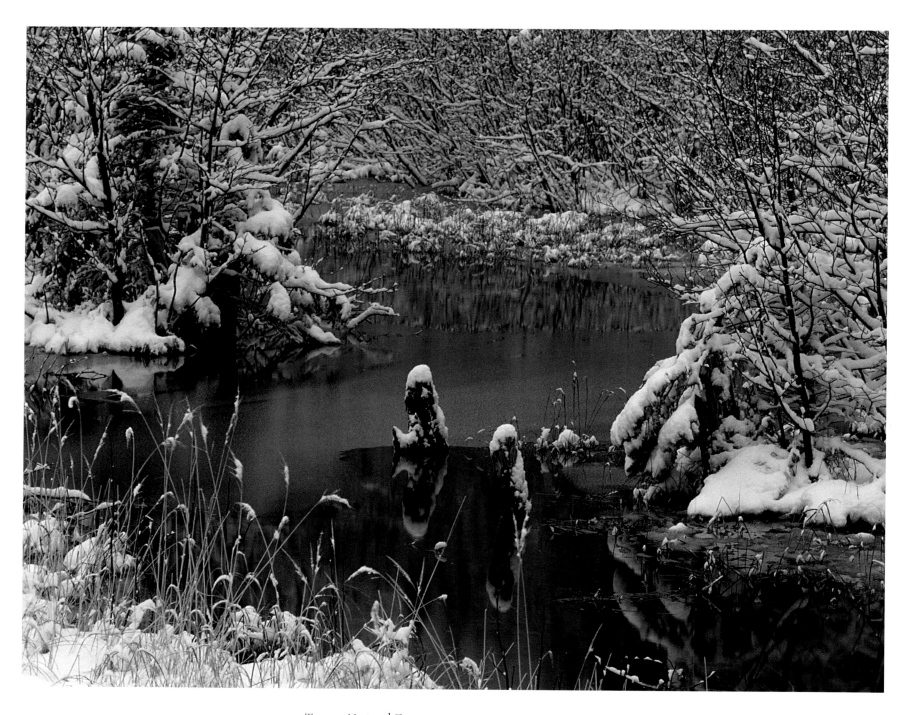

Tongass National Forest

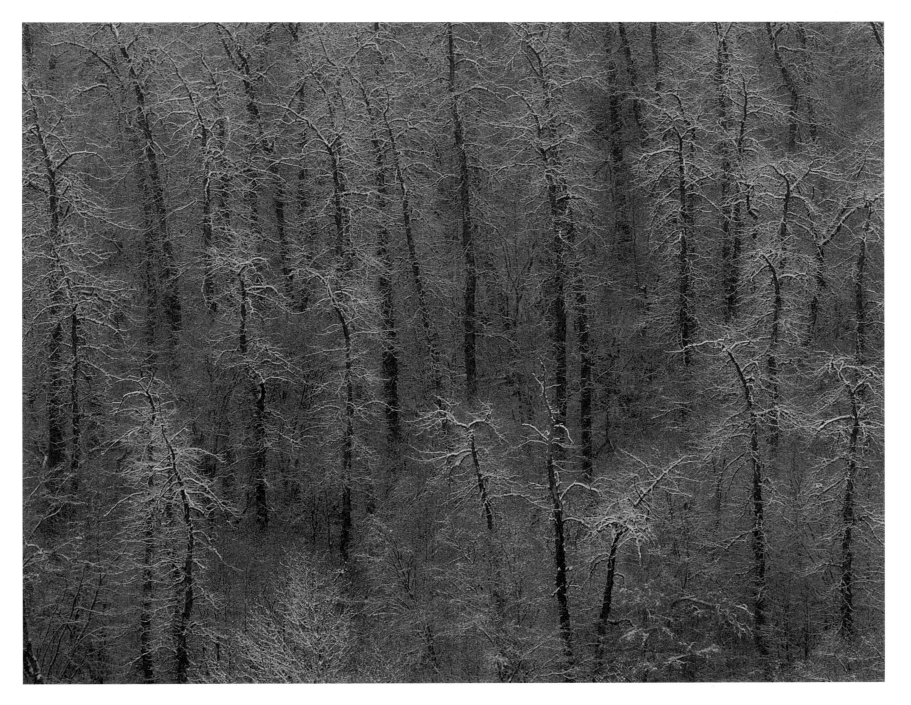

Quaking aspen *(Populus tremuloides)*, Haines

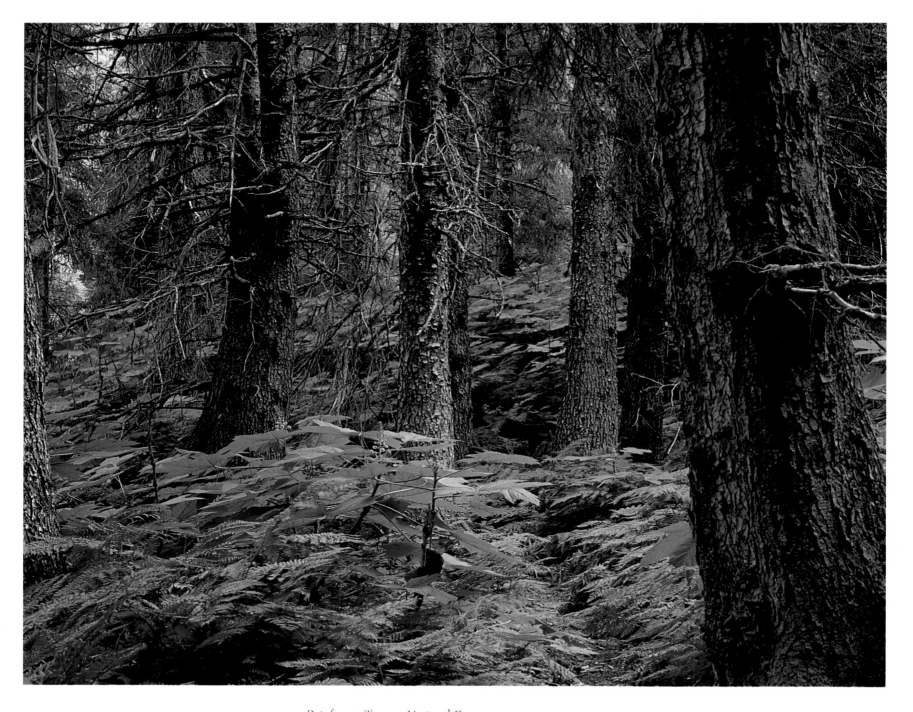

Rainforest, Tongass National Forest

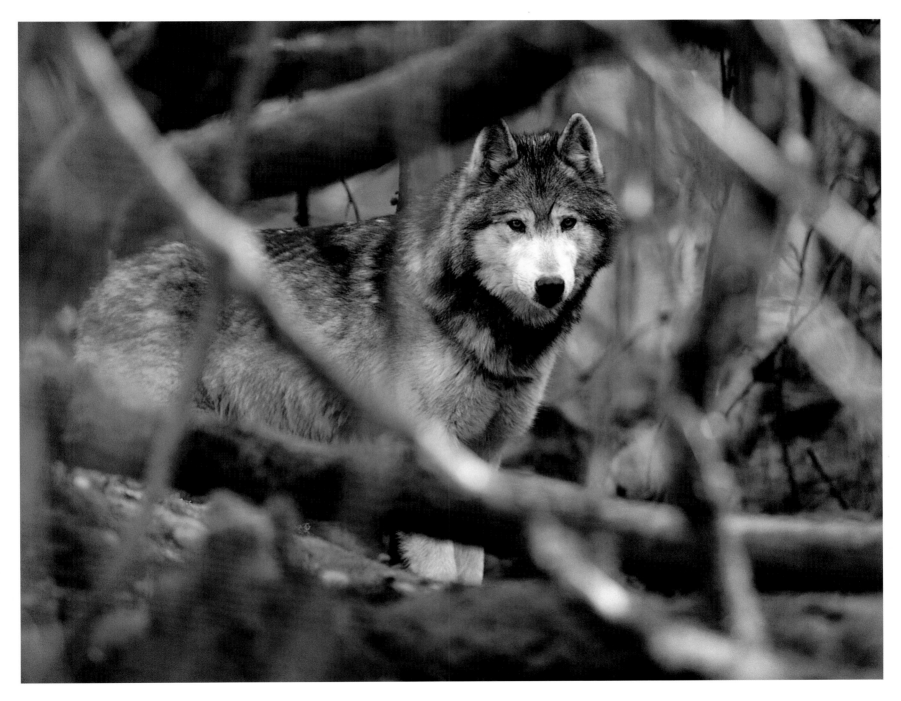

Gray wolf (*Canis lupus*), Tok Junction

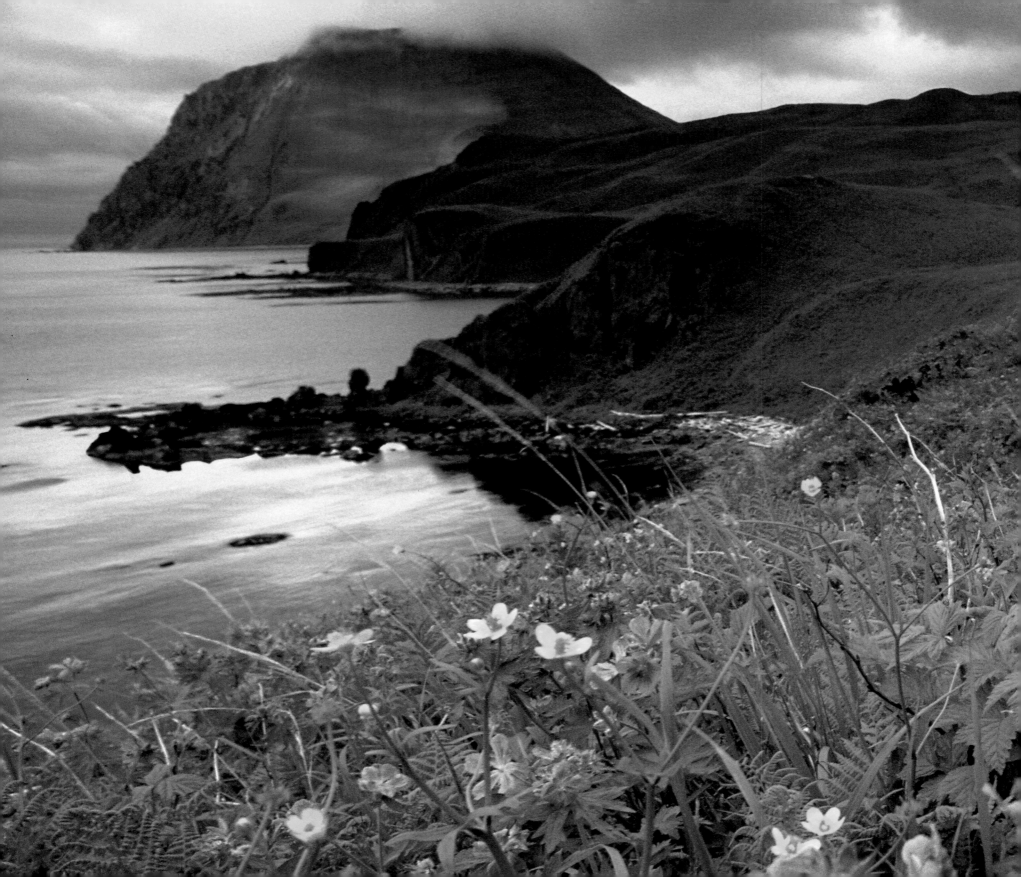

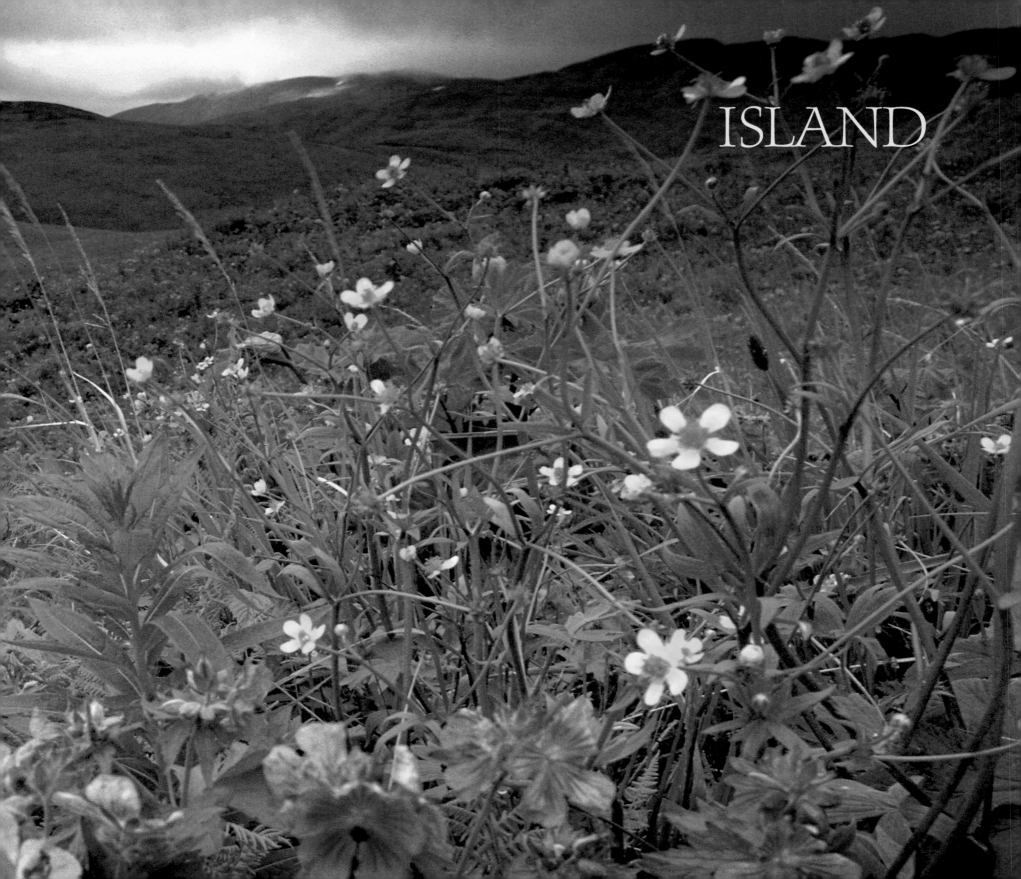

ISLAND

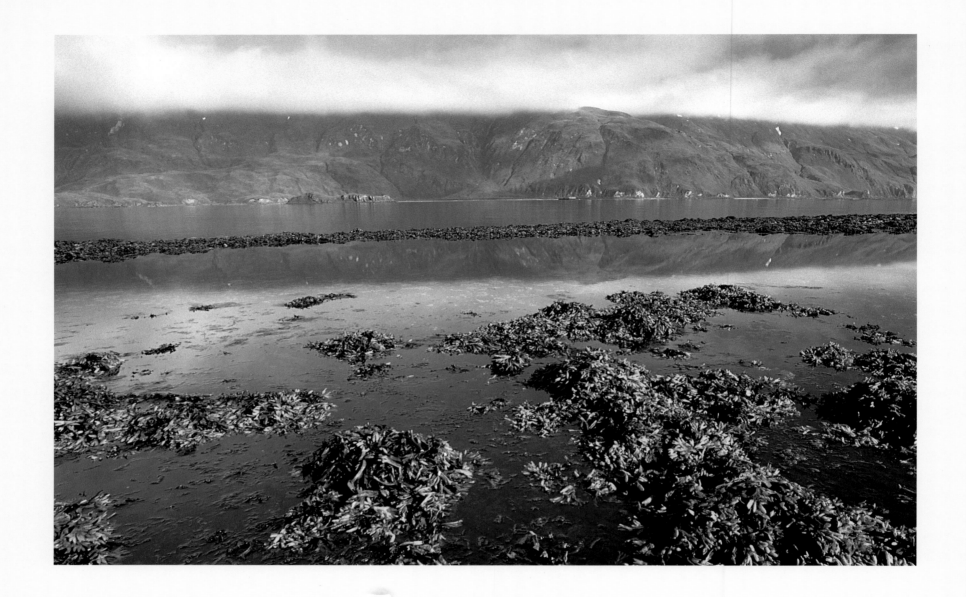

Alaska's islands are as many and varied as its convoluted, thirty-odd thousand miles of coast-line suggests. Huge-trunked coastal rainforests. Bleak, wind-scraped tundra inches high. Glaciated volcanoes. Mist-washed, rolling hills, and clear streams filled with fish.

Some of these are about as remote as it gets on this close-shouldered planet. Others are dotted with settlements whose roots are long forgotten. And it's all so big, as usual, that it's almost impossible to keep track. There are fair-sized islands, even entire archipelagoes whose names or locations draw a blank with longtime Alaskans. Most know where Kodiak and the Aleutians are, but what about the Semidis, the Shumagins, or Stuart Island?

I'm ashamed to say I pinned all these down exactly for the first time the other day. It's not that I'm uninterested. But given a map of the state, my eyes move inland, for one simple reason.

The ocean scares me. The more time I spend on it, the more I realize why I feel afraid, and why I should. The land may be rough, but it's home. That constantly shifting, cold-pouring world out beyond the breakers is distinctly not. The real wilderness is there, in those walls of fog, green water, and freezing spray, where there are few landmarks and little refuge, where human life becomes a tenuous thing.

And on the edge of this expanse—or in its midst, far offshore in some cases—Alaska's

islands lie. Each shares similarities with its neighbors, and with the mainland. But every island is its own world, its own distinct version of Alaska. Some hold species of plants that are found nowhere else in the state, or are visited by birds usually found in Asia. Separation allows each island to express its own evolutionary destiny. The unique dynamics and excesses of island biogeography are set free.

Without competition, a single species, rare or absent elsewhere, may become absurdly abundant. For example, all but a handful of the world's fur seal population breeds on the two main Pribilof Islands, and the beaches are seasonally clogged with them. The red-legged kittiwake, a rare and graceful gull, is a common sight here as well, along with millions of other seabirds. Admiralty Island, 1,600 miles almost directly east, has the greatest known concentration of brown bears—exceeding one per square mile.

Even human prehistory reaches some sort of summit in the islands of Alaska. The area around the tiny Aleut village of Nikolski, on

Overleaf: Wild geraniums (*Geranium* sp.) and buttercups (*Ranunculus* sp.), Unalaska Island

Left: Unalaska Island

Right: Arctic forget-me-nots (*Eritrichium* sp.), Pribilof Islands

Unmak Island, halfway down the Aleutian chain, has been, according to archaeologists, continuously inhabited longer than any other place on earth: at least ten thousand years. The civilizations of the Nile delta and the Fertile Crescent are a third younger.

While there are hundreds of Alaska islands, their distribution is uneven. Two great southern archipelagoes, the Alexander and the Aleutian, hold most of the state's offshore land. Then there are the odd chunks of Alaska that truly stand by themselves. Places like the Pribilofs and Saint Matthew Island—the former four hundred, the latter two hundred miles offshore.

The Aleutian chain is a sweeping parabola of islands 1,400 miles long, jutting so far out into the North Pacific that the westernmost tip deflects the International Date Line. Follow lines of longitude due south from the western tip of the chain, and you wind up in New Zealand. Tokyo is closer than Anchorage. A rough dozen of larger islands and many smaller describe the archipelago's curve. So far from the mainland's influence, trees and larger land mammals are absent (except where introduced by human hand). What lives here was carried by wind, water, or wondrous chance.

The Aleutians are part of the North Pacific's ring of fire, where vast tectonic pressures come to bear. Some volcanoes climb almost six miles from their bases on the ocean floor. Eruptions here are, geologically speaking, unavoidable—not a matter of if, but when and where. As new crust flows from these vents, oceanic plates subside in seismic shudders.

The Alexander Archipelago, part of the area commonly known as the southeast panhandle, is another story. Admiralty, with all its bears, is one of these islands. These coast-hugging islands are part of that rich southeastern rainforest, where everything grows in large profusion. A mainland species may be absent or present from one island to the next, but the sum of all things is more similar than different.

And there are others: Kodiak, the largest Alaska island, a stair step between the Aleutians and Alexanders; Nunivak, with its musk oxen; Saint Lawrence, north near the Bering Strait; nearby King Island and Little Diomede, fortresses of rock.

Left: Feather with morning dew, Pribilof Islands

North of the Arctic Circle, islands become conspicuously rare. Even counting offshore boulder piles, there are only a few. Best known and farthest north of these is Barter Island, an ancient Inupiat trading place on the icebound Beaufort Sea coast.

Besides being worlds unto themselves, Alaska's islands are, finally, vantage points, actual and metaphorical. To the east looms the mainland, itself almost as much an island, for all its vastness, as it is the northern arm of a continent, cradled like a child in a far larger sea. Standing on a smaller part of this whole, we're afforded some perspective: Barter Island is Alaska shrunk down to a size we can comprehend, a model of the infinite. The trees or tundra here, the streams, the bears or seals, the mountains, the fish and birds—all are part of a single breathing thing, so closely intertwined that no true separation is possible. A thick cloud is pushed inland from the ocean, up a slope that makes rain; on its way downhill, the water nourishes green things, strains through the soil, and forms a river. In that river salmon spawn, and they in turn feed the larger creatures who, when they die, turn back to the land and sea. In every creature, every stone, the whole is contained: hardly an original concept, but one that seems to require constant reminding.

What is true for one island is true of all Alaska, though the spirals and webs are far larger and more complex. Perhaps we are too small and near, too brief-lived ever to grasp the eternal sweep of this land, the comings and goings of mountain ranges, rivers, forests, and animals. But moments of illumination will forever surprise us, like a wolf glimpsed as he glides silently across a clearing, or a sudden shaft of light on a tundra ridge—the truth of everything caught in an instant of clarity and focus. All we can hope is to be there, and to be looking in the right direction.

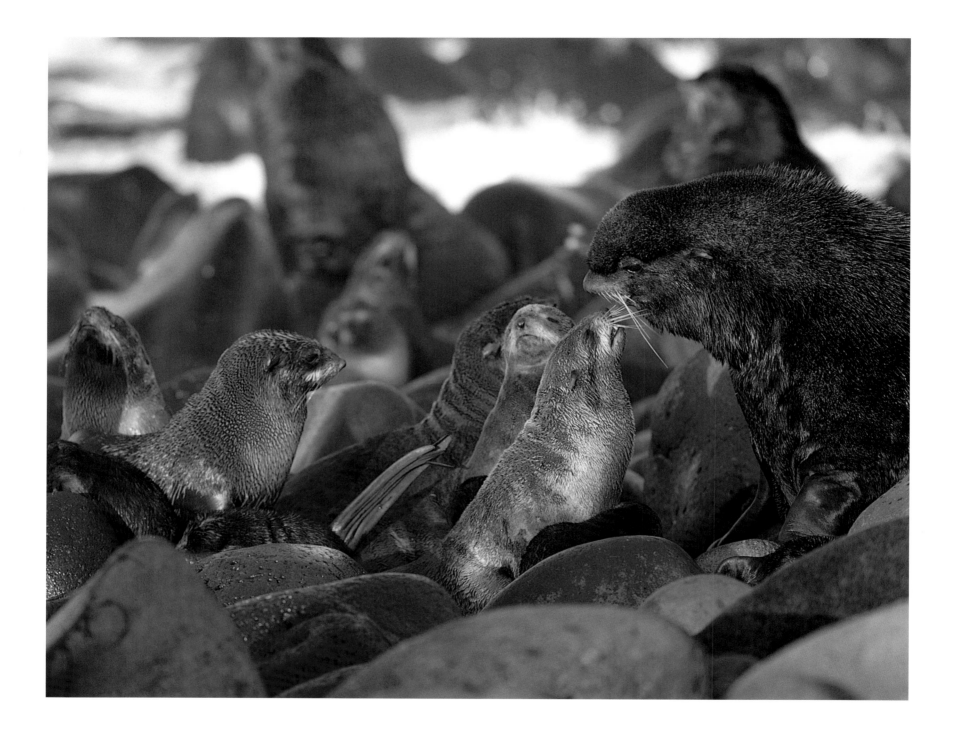

Left: Northern fur seals (*Callorhinus ursinus*), Pribilof Islands

Right: Waterfall, Aleutian Islands

Below: Waterfall, Unalaska Island

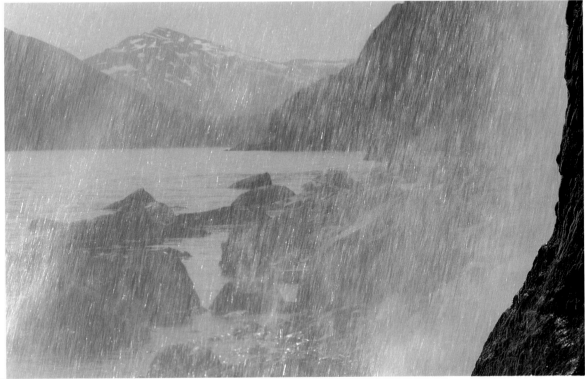

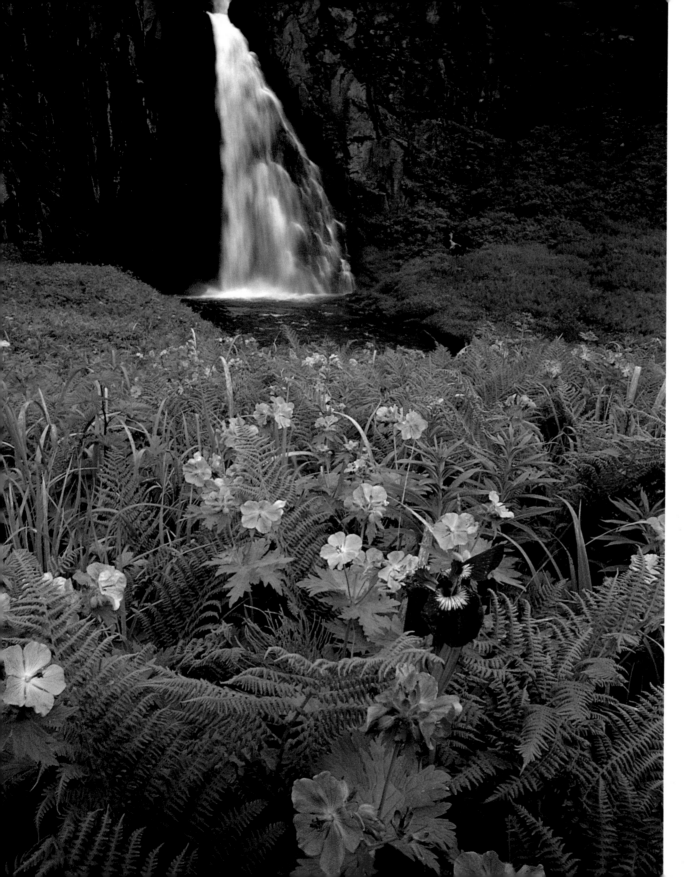

Left: Waterfall, Unalaska Island

Right: Waterfall, Aleutian Islands

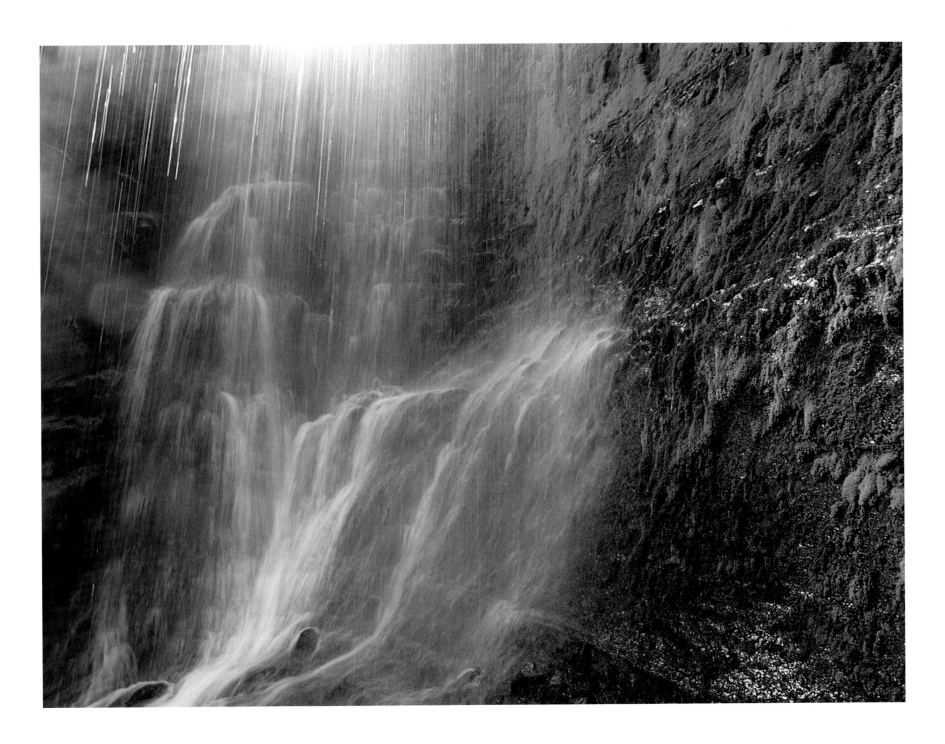

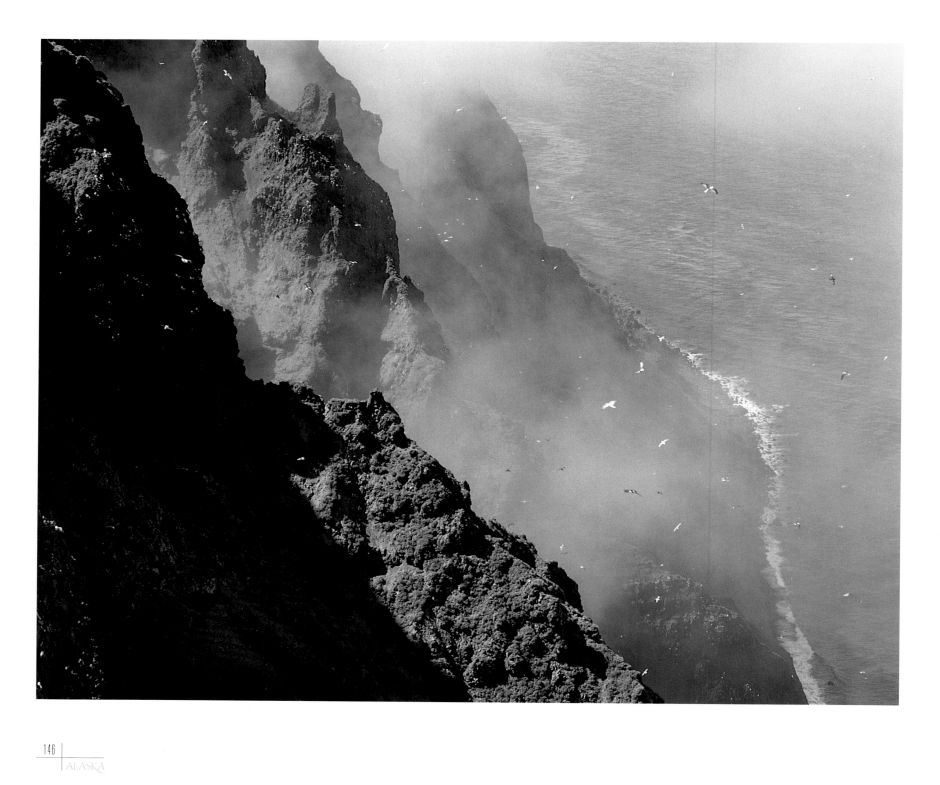

ALASKA

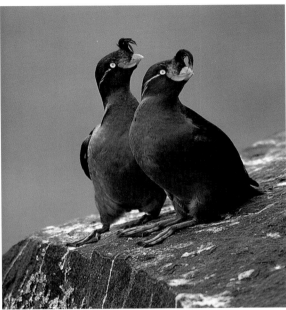

Far left: Saint George Island, Pribilof Islands

Left: Crested auklet (*Aethia cristatella*), Saint George Island, Pribilof Islands

Below: Parakeet aucklet (*Cyclorrhynchus psittacula*), Pribilof Islands

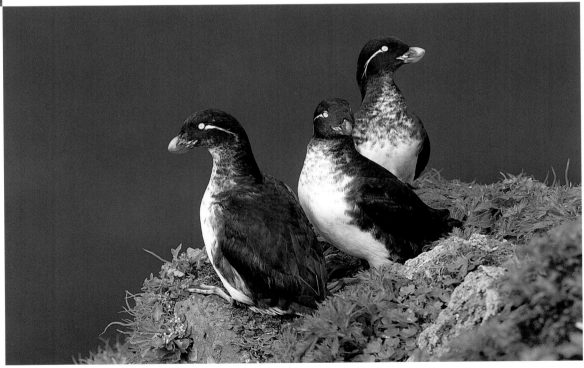

Right: Grasses with dew, Unalaska Island

Below and far right: Fireweed (*Epilobium* sp.), Unalaska Island

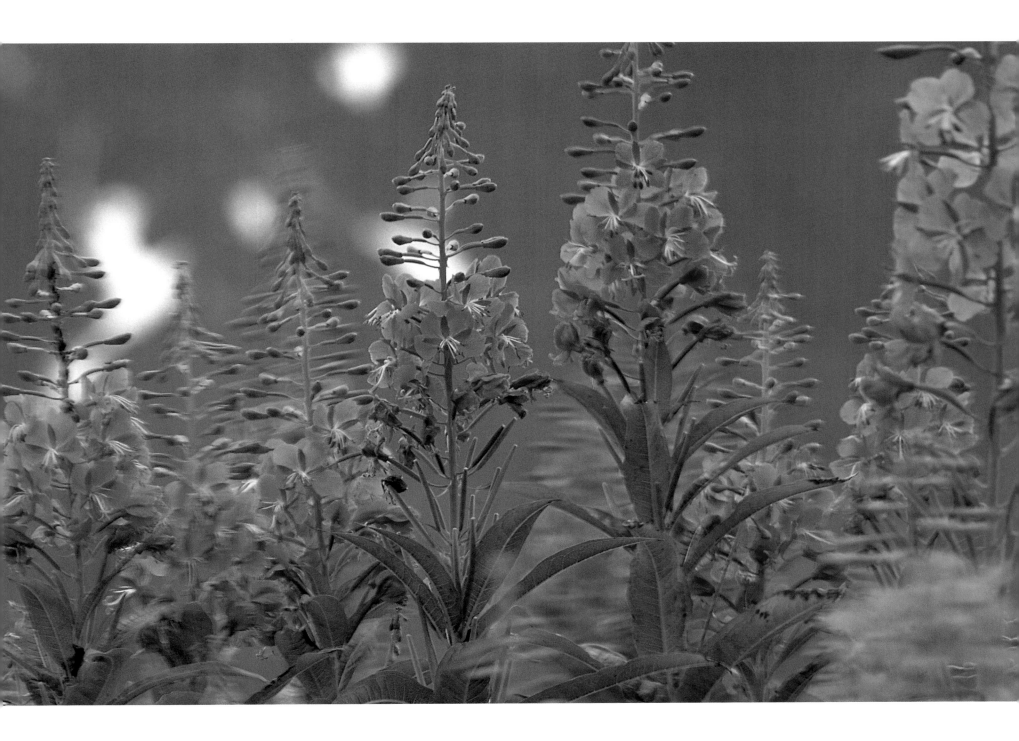

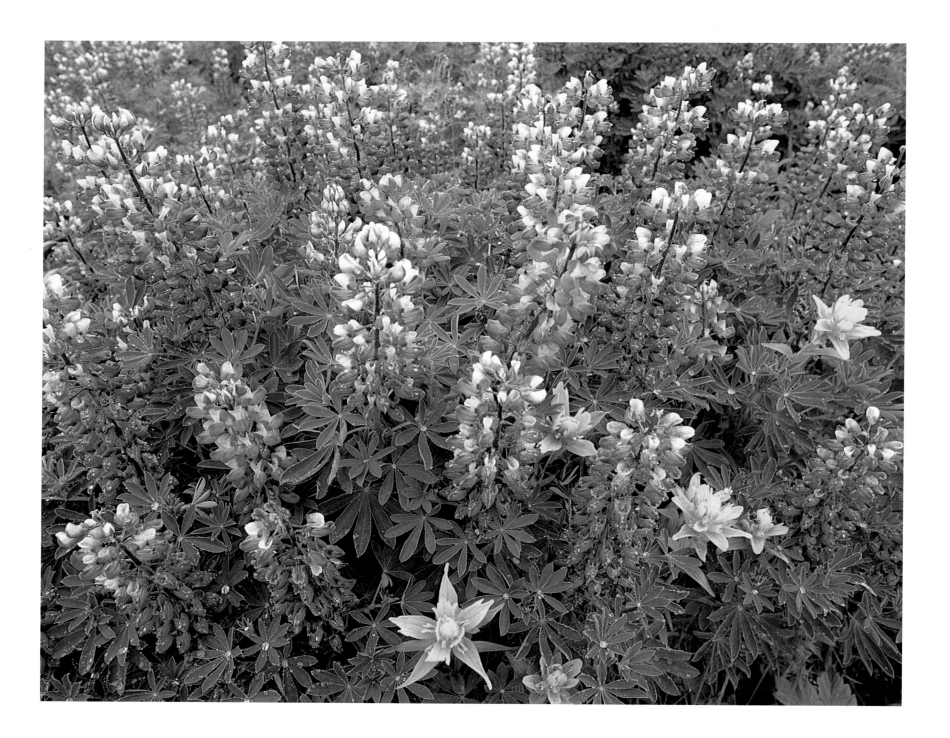

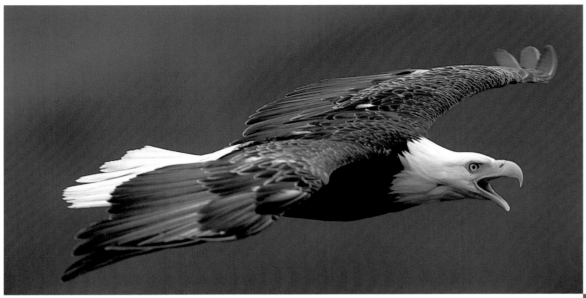

Left: Paintbrush (*Castilleja* sp.) and lupine (*Lupinus* sp.), Unalaska Island

Above and right: Bald eagle (*Haliaeetus leucocephalus*), Unalaska Island

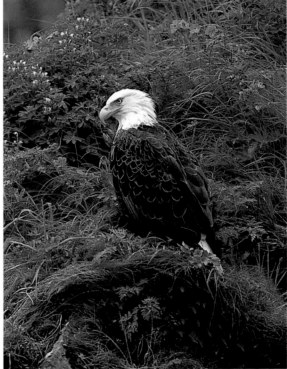

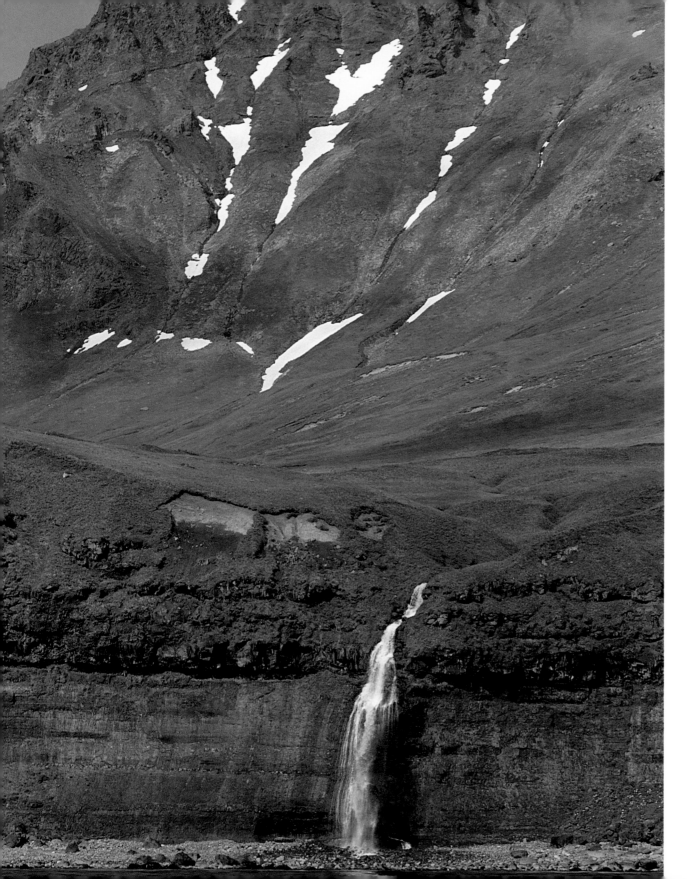

Left: Unalaska Island

Right: Aleutian Islands

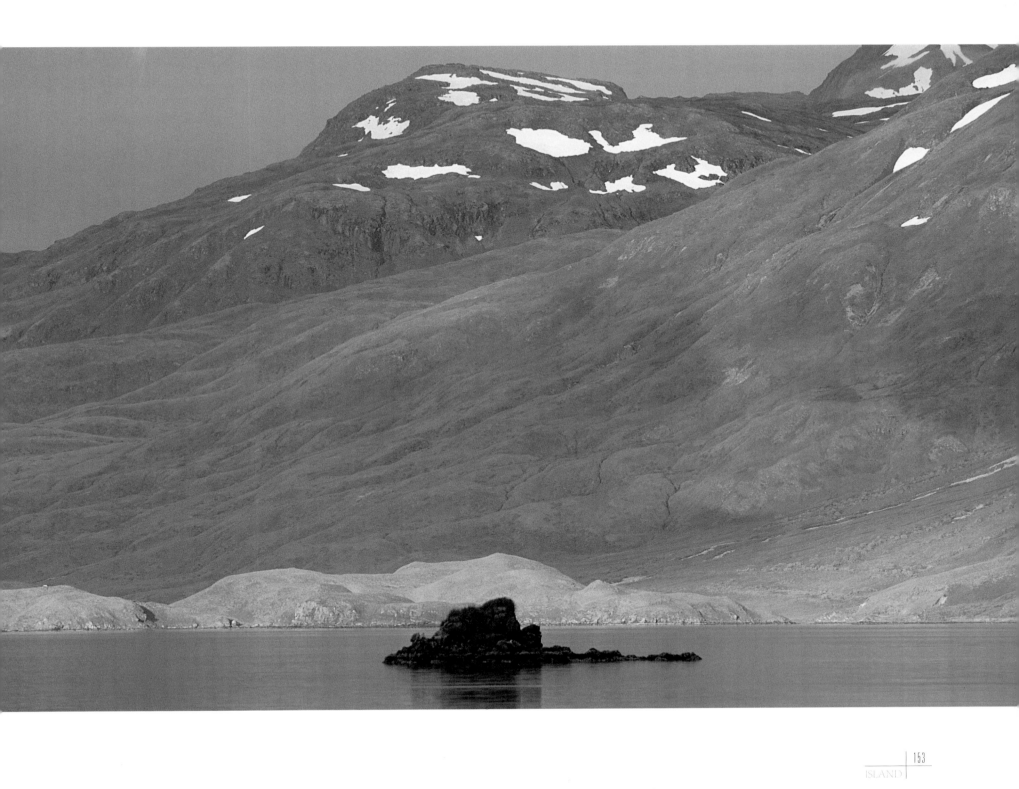

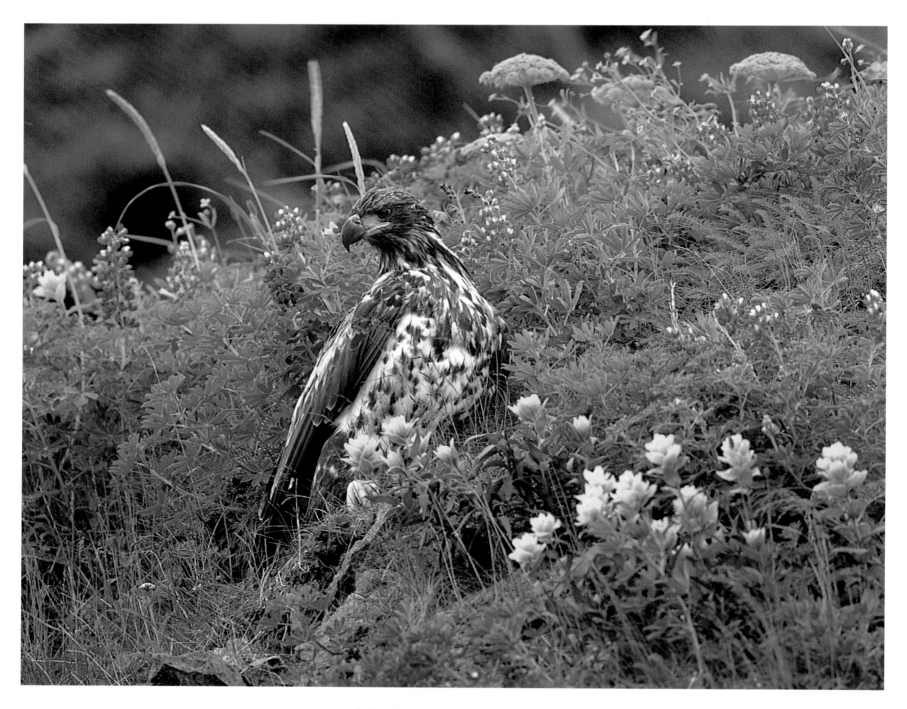

Immature bald eagle (*Haliaeetus leucocephalus*), paintbrush
(*Castilleja* sp.) and lupine (*Lupinus* sp.), Unalaska Island

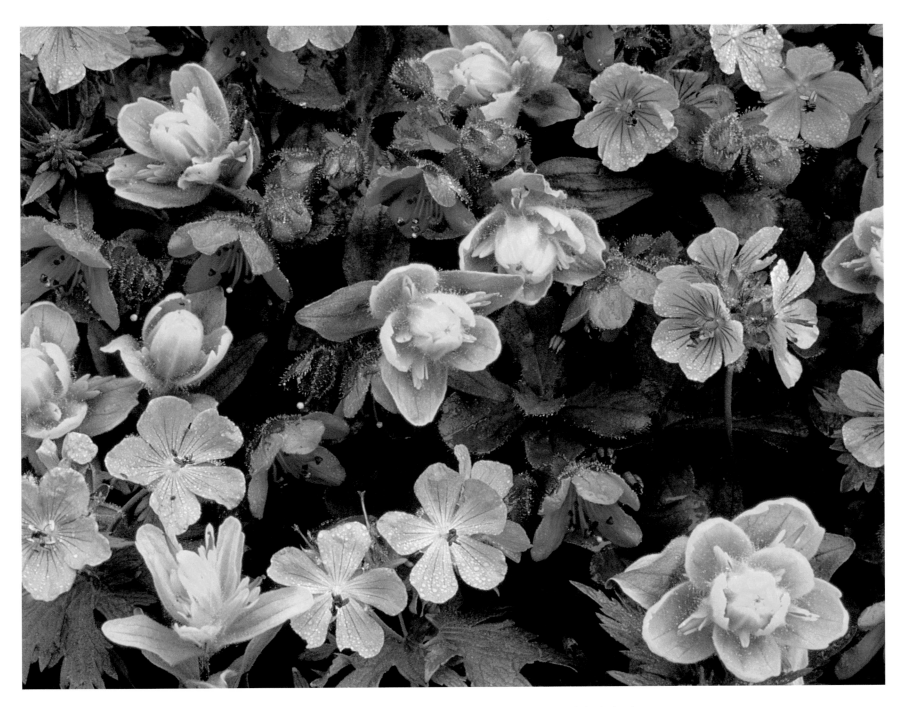

Paintbrush (*Castilleja* sp.), geranium (*Geranium* sp.) and rhododendron (*Rhododendron camtschaticum*) flowers, Unalaska Island

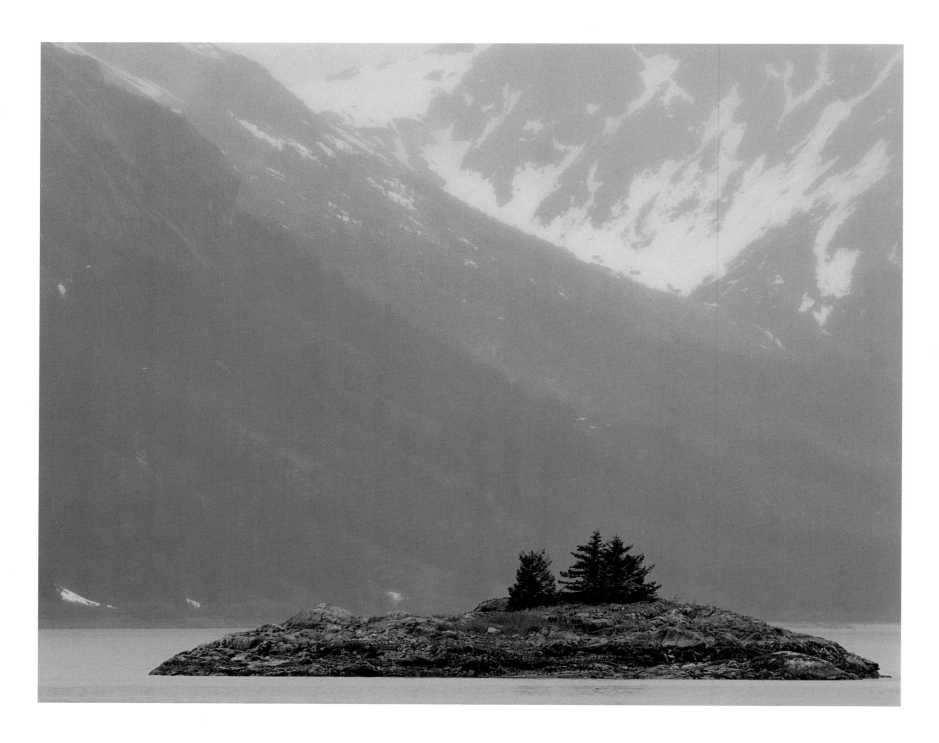

Left: Unnamed island, Southeast Alaska

Right: Sea otter (*Enhydra lutris*), Beartrack Cove

RESOURCE LIST

Alaska Boreal Forest Council
3525 College Rd. #212
P.O. Box 84530
Fairbanks, AK 99708
Tel: 907.457.8453
Fax: 907.457.5185
Email: abfc@polarnet.com

Alaska Center for the Environment
519 W. Eighth Ave. #201
Anchorage, AK 99501
Tel: 907.274.3621
Fax: 907.274.8733
Email: akcenter@alaska.net

Alaska Clean Water Alliance
121 Second Ave.
P.O. Box 1441
Haines, AK 99827
Tel: 907.766.2296
Fax: 907.766.2290
Email: acwa@seaknet.alaska.edu

Alaska Conservation Alliance
(Alaska Environmental Assembly)
750 W. Second Ave. #109
Anchorage, AK 99501-2167
Tel: 907.276.1917
Fax: 907.274.4145
Email: acfinfo@akcf.org

Alaska Conservation Voice
(Alaska Environmental Lobby)
419 Sixth St. #321
P.O. Box 22151
Juneau, AK 99802-2151
Tel: 907.463.3366
Fax: 907.463.3312
Email: kirsten@akvoice.org

Alaska Forum for Environmental
Responsibility
P.O. Box 188
Valdez, AK 99686
Tel: 907.835.5460
Fax: 907.835.5410
Email: afervdz@alaska.net

Alaska Friends of Earth
326 W. Eleventh Ave.
Anchorage, AK 99501
Tel: 907.653.7792 eves
Email: holloway@alaska.net

Alaska Marine Conservation Council
P.O. Box 101145
Anchorage, AK 99510-1145
Tel: 907.277.5357
Fax: 907.277.5975
Email: amcc@akmarine.org

Alaska Nature Heritage Program
University of Alaska
707 A St. #102
Anchorage, AK 99501
Tel: 907.257.2780
Fax: 907.257.2789
Email: ankwb@uaa.alaska.edu

Alaska Public Interest Research Group
(AKPIRG)
P.O. Box 10-1093
Anchorage, AK 99510
Tel: 907.278.3661
Fax: 907.278.9300
Email: akpirg@akpirg.org

Alaska Rainforest Campaign
406 G St. #209
Anchorage, AK 99501
Tel: 907.222.2552
Fax: 907.222.2598
Email: info@akrain.org

Alaska Sealife Center
P.O. Box 1329
Seward, AK 99664
Tel: 907.224.6300/ 800.224.2525
Fax: 907.224.6320
Email: webmaster@alaskasealife.org

Alaska Wilderness Recreation and
Tourism Association
P.O. Box 22827
Juneau, AK 99802
Tel: 907.463.3038
Fax: 907.463.3280
Email: awrta@alaska.net

Alaska Wildlife Alliance
600 Cordova St #3
P.O. Box 202022
Anchorage, AK 99520
Tel: 907.277.0897
Fax: 907.277.7423
Email: awa@alaska.net

Alaska Women's Environmental
Network
750 W. Second Ave. #200
Anchorage, AK 99501-2168
Tel: 907.258.4810
Fax: 907.258.4811
Email: levensaler@nwf.org

Alaska Youth for Environmental Action
750 W. Second Ave. #200
Anchorage, AK 99501-2168
Tel: 907.258.4825
Fax: 907.258.4811
Email: carrp@nwf.org

Alaskans for Juneau
Skip Gray Contact
P.O. Box 22428
Juneau, AK 99802
Tel: 907.463.5065
Fax: 907.780.4854
Email: ak4jnu@alaska.net

Anchorage Waterways Council
P.O. Box 241774
Anchorage, AK 99524-1774
Tel: 907.277.9287
Email: awc@alaska.net/~awc

Arctic Network
P.O. Box 102252
Anchorage, AK 99510-2252
Tel: 907.272.2452
Fax: 907.272.2453
Email: arcnet@igc.apc.org

Center for Alaskan Coastal Studies
P.O. Box 2225
Homer, AK 99603
Tel: 907.235.6667
Fax: 907.235.6668
Email: eeh+@osu.edu

Cook Inlet Keeper
P.O. Box 3269
Homer, AK 99603
Tel: 907.235.4068
Fax 907.235.4069
Email: keeper@xyz.net

Defenders of Wildlife
Alaska Office
114 W. Sixth St.
Juneau, AK 99801
Tel: 907.586.1255
Fax: 907.586.8906

Eastern Kenai Peninsula Environmental
Action Association
P.O. Box 511
Seward, AK 99664
Tel/fax: 907.224.5372
Email: markkhlt@netbox.com

The Great Land Trust
P.O. Box 101272
Anchorage, AK 99510-1272
Tel/Fax: 907.278.4998
Email: glt@alaska.net

Greenpeace Alaska
125 Christensen Dr. #2
Anchorage, AK 99510
Tel: 907.277.8234
Fax: 907.272.6519
Email: dritzman@dialb.greenpeace.org
http://www.greenpeaceusa.org

Gwich'in Steering Committee
P.O. Box 202768
Anchorage, AK 99520
Tel: 907.258.6814
Fax: 907.258.4550
Email: gwichin@alaska.net.

Interior Alaska Land Trust
P.O. Box 84169
Fairbanks, AK 99708
Tel: 907.479.3726
Fax: 907.479.3786
Email: landtrust@ptialaska.net

Kachemak Bay Conservation Society
P.O. Box 846
Homer, AK 99603
Tel: 907.235.2062
Email: kbcs@xyz.net

Kachemak Heritage Land Trust
P.O. Box 2400
Homer, AK 99603
Tel/fax: 907.235.5263
Email: khltbr@xyz.net

Kenai Watershed Forum
P.O. Box 2937
Soldotna, AK 99669
Tel: 907.260.5449
Fax: 907.260.5412
Email: robert@kenaiwatershed.org

League Of Conservation Voters
Education Fund
Alaska Office
750 W. Second Ave. #109
Anchorage, AK 99501
Tel: 907.258.2020
Fax: 907.258.2021
Email: mike@servcom.com

Lynn Canal Conservation, Inc.
P.O. Box 964
Haines, AK 99827
Tel: 907.766.2295
Fax: 907.766.2296
Email: lcc@seaknet.alaska.edu

National Audubon Society
Regional Office
308 G St. #217
Anchorage, AK 99501
Tel: 907.276.7034
Fax: 907.276.5069
Email: jschoen@audubon.org

National Parks and Conservation
Association
329 F St. #208
Anchorage, AK 99501
Fax: 907.277.6723
Email: cdennerl@npca.org

National Wildlife Federation
Alaska Office
750 W. Second Ave. #200
Anchorage, AK 99501-2168
Tel: 907.258.4800
Fax: 907.258.4811
Email: turrini@nwf.org

The Nature Conservancy of Alaska
421 W. First Ave. #200
Anchorage, AK 99501
Tel: 907.276.3313
Fax: 907.276.2584
Email: alaska@tac.org

Northern Alaska Environmental Center
218 Driveway St.
Fairbanks, AK 99701-2906
Tel: 907.452.5021
Fax: 907.452.3100
Email: naec@mosquitonet.com

Oilwatch Alaska
P.O. Box 101553
Anchorage, AK 99510-1553
Tel: 907.277.8910
Email: oilwatch@alaska.net

Prince William Sound Science Center
P.O. Box 705
Cordova, AK 99574
Tel: 907.424.5800
Fax: 907.424.5820
Email: bird@grizzly.pwssc.gen.ak.us

Sierra Club Alaska
Alaska Field Office
201 Barrow St. #101
Anchorage, AK 99501-2519
Tel: 907.276.4048
Fax: 907.258.6807
Email: nw-ak.field@sierraclub.org

Sitka Conservation Society
201 Lincoln St. #4
P.O. Box 316
Sitka, AK 99835
Tel: 907.747.7509
Fax: 907.747.6105
Email: sitconsv@ptialaska.net

The Southeast Alaska Conservation
Council
419 Sixth St. #328
Juneau, AK 99801
Tel: 907.586.6942
Fax: 907.463.3312
Email: seacc@alaska.net

Southeast Alaska Land Trust
119 Seward St. #9
Juneau, AK 99801
Tel/fax: 907.586.3100
Email: setrust@ptialaska.net

Trustees for Alaska
1026 W. 4th Ave. #201
Anchorage, AK 99501
Tel: 907.276.4244
Fax: 907.276.7110
Email: ecolaw@trustees.org

The Wilderness Society
Alaska Regional Office
430 W. Seventh Ave. #210
Anchorage, AK 99501
Tel: 907.272.9453
Fax: 907.272.1670
Email: allen smith@tws.org

Wildlife Federation of Alaska
750 W. Second Ave. #200
Anchorage, AK 99501-2151
Tel: 907.274.3388
Fax: 907.258.4811
Email: wfa@micronet.net

Photographs and Art Wolfe logo copyright ©2000 by Art Wolfe

Text copyright ©2000 by Nick Jans

All rights reserved. No portion of this book may be reproduced or utilized in any form, or by any electronic, mechanical, or other means without the prior written permission of the publisher.

Published by Sasquatch Books
Distributed in Canada by Raincoast Books, Ltd.
Printed in Hong Kong
04 03 02 01 00 5 4 3 2

Cover and interior design: Karen Schober
Map illustration: Jane Shasky

Cover photograph: Early morning light, Portage Glacier, Kenai Peninsula. **Photograph on page 1:** Tufted puffin (*Fratercula cirrhata*), Pribilof Islands; **pages 2-3:** Alaska Range, Denali National Park and Preserve; **pages 6-7:** Stranded iceberg, Icy Bay.

Library of Congress Cataloging in Publication Data
Wolfe, Art.
 Alaska / photos by Art Wolfe ; text by Nick Jans.
 p. cm.
 ISBN 1-57061-217-X (Hardcover)
 ISBN 1-57061-216-1 (Softcover)
 1.Alaska—Pictorial works. 2. Landscape—Alaska—Pictorial works. 3. Natural history—Alaska—
 Pictorial works. 4. Natural history—Alaska. 5. Landscape—Alaska. I. Title. II. Jans, Nick, 1955-

F905.W65 2000
508.798 21—dc21
99-045077

Sasquatch Books
615 Second Avenue
Seattle, Washington 98104
(206) 467-4300
www.SasquatchBooks.com
books@SasquatchBooks.com